Jackie: A Life in Pictures

Jackie
A Life in Pictures

© 2004 PHYB Ltd.
Text © 2004 Yann-Brice Dherbier & Pierre-Henri Verlhac
Photographs and Documents © 2004 as indicated on page 272

Published in the United States by powerHouse Books,
a division of powerHouse Cultural Entertainment, Inc.
68 Charlton Street, New York, NY 10014-4601
telephone 212 604 9074, fax 212 366 5247
e-mail: jackie@powerHouseBooks.com
website: www.powerHouseBooks.com

Published in France by PHYB
45 rue la Boetie 75008 Paris–France
info@phyb.com
www.phyb.com

Library of Congress Cataloging-in-Publication Data

Jackie : a life in pictures / edited by Pierre-Henri Verlhac and Yann-Brice Dherbier.-- 1st ed.
 p. cm.
 ISBN 1-57687-242-4
 1. Onassis, Jacqueline Kennedy, 1929---Pictorial works. 2. Celebrities--United
States--Biography--Pictorial works. 3. Presidents' spouses--United States--Biography--Pictorial
works. I. Verlhac, Pierre-Henri. II. Dherbier, Yann-Brice.
 CT275.O552J33 2004
 973.922'09--dc22

 2004052677

Hardcover ISBN : 1-57687-242-4

Separations, printing, and binding by EBS, Verona

Designed by Atalante Paris–Xavier Barral & Julien Haubert
42 rue Sedaine 75011 Paris–France
www.atalante-paris.fr

A complete catalog of powerHouse Books and Limited Editions is available upon request;
please call, write, or visit our website.

10 9 8 7 6 5 4 3 2 1

Printed and bound in Italy

Cover photograph: Jackie Kennedy with her son, John F. Kennedy, Jr.
by Stanley Tretick (© Corbis Sygma)

Jackie: A Life in Pictures

by Yann-Brice Dherbier & Pierre-Henri Verlhac

pH powerHouse Books
New York, NY

Jackie Kennedy Onassis A biography

by Yann-Brice Dherbier & Pierre-Henri Verlhac

1 Genealogy of the Future First Lady

It was in Southampton, New York on a Sunday, the 28th of July, 1929, that Jacqueline Lee Bouvier was born. According to the physicians' calculations, she came into the world one month prematurely, but weighed 8.8 pounds and was in perfect health. Her mother, Janet Lee Bouvier was twenty-one years of age at the time of Jacqueline's birth.

Janet Lee Bouvier was a third generation American whose family had emigrated from Ireland. Her father, James Thomas Lee, was an alumnus of Columbia University, receiving degrees in both engineering and law. After graduation, he created his own firm, but preferred to invest in real estate and banking. Subsequently, he took command of the New York Central Savings Bank and made a fortune through ambitious real estate projects in New York City during the height of its growth boom. By 1922, Lee's net worth had already reached 35 million dollars. But, from a social point of view, this conservative Republican had suffered as a result of his Irish Catholic origins, which kept him at arm's length from the more elite societies. Thus, he made it a top priority that his daughters entered and were accepted into powerful and privileged circles. For this reason, he sent Janet to the most select private schools, including Sweet Briar and Bernard. Lee also purchased magnificent property in the Hamptons in order to spend his vacations alongside the old, wealthy families of New York.

Janet Lee Bouvier was a brilliant, young cultured woman with great ambition and worldliness. Having been instilled with acute social aspirations by her father, she was determined to marry a rich heir and felt that she possessed the qualities necessary to succeed at this objective. Not only was she intelligent, pretty, and self-confident, but was also very well educated. She was quite energetic and excelled in numerous sports, spoke very good French, and was reputed to be a formidable bridge player.

In 1927, she met John Vernou Bouvier, III, Jackie's future father. He was the perfect choice to help Janet achieve her goal of an elevated social status. John was sixteen years her senior and the descendant of a rich and powerful family of French origin that had first settled in the United States four generations ago. He grew up in New York in a luxurious Park Avenue apartment with twenty-four rooms, then went to study at Yale where he received his diploma in 1914. After having served in the transmission corps during the First World War, he returned to New York. His father, who was very influential, acquired a seat for him on the New York Stock Exchange, where he became an exchange agent.

But John Vernou Bouvier, III, who was nicknamed "Black Jack," was above all a playboy with the looks and charisma of a movie star. An inveterate seducer, he spent without counting, and lead a life of frivolity consisting of fashionable parties, feminine conquests, gambling, and alcohol.

Janet Lee and John Vernou Bouvier were married on July 7, 1928 in East Hampton. However, from the moment of their return from their honeymoon in Europe, Black Jack's demons from the past caught up with him. It was difficult for Janet and close friends of the couple to ignore his indiscretions and alcohol abuse, so much so that the Bouviers quickly consulted their attorneys and financial advisors in anticipation of a divorce. But this prospect was ultimately abandoned when Janet became pregnant.

Shortly after the birth of Jacqueline Lee Bouvier, the family moved into the home of Grandfather Bouvier, on the LaSata estate. It is here that Jacqueline took her first steps, in the luxurious estate built in the middle of a five- to six-acre park consisting of horse farms, French gardens, fountains, and marble statues. Janet took pleasure in pronouncing her daughter's name "Jack-leen," but for Jack, she quickly became Jackie, and henceforth the people closest to her would always use her father's preferred nickname.

Fatherhood had absolutely no effect on Jack with regard to his infidelity or alcohol consumption, and the tension between the couple was palpable. Then came the stock exchange crash of 1929. Not only did Jack's commissions as agent of the stock exchange melt away like snow under a hot sun, but the financial losses of the Bouvier family were devastating. It was Jack's uncle, the financial magnate M.C. Bouvier, who took over the reins of the family empire. He subsequently decided to cease providing funds to Jack, whose lifestyle had always exceeded his income. Janet's father, although concerned about the attitude of his son-in-law, came to the couple's rescue and, at his expense, moved them into an eleven-room apartment at 740 Park Avenue, where they continued to live a life of luxury and wealth.

On the occasion of Jackie's second birthday in 1931, Janet and Jack organized a lavish party for their daughter, who for the first time became the subject of a newspaper article. A reporter from East Hampton wrote, "A future debutante celebrates her second birthday with panache." The young child impressed her guests with her talents for horseback riding, and willingly posed with her pony for the reporter's photographs.

The Great Depression worked havoc throughout the United States, and the couple's relationship continued to deteriorate over the following months. But Janet became pregnant once again, and gave birth to Caroline Lee Bouvier on March 3, 1933, at Doctor's Hospital in Manhattan, the eve of the inauguration of Franklin D. Roosevelt. Jackie was overjoyed with the arrival of her little sister and decided to call her by her middle name.

2 An Education of the Most Rigorous Kind

From the age of five years old, one year before going to school, Jackie was able to read and recite short passages from the *Wizard of Oz* and *Little Lord Fauntleroy*, her two favorite works. She fed on and developed a passion for words and literature utilizing the family library. At the same time, Jackie and her sister, Lee, cultivated a passion for art and dance. They were fascinated by the many works about the history of art and ballet that decorated the family

apartment. Neither one of the sisters would practice classical dance, but they quickly became diligent spectators of ballet.

In the subject of art, they discovered an excellent teacher in the person of their great uncle, M.C. Bouvier, who possessed an impressive collection of antiques and rare objects. They organized guided visits of his collection of paintings, and often asked him to take them to the museum. Jackie subsequently developed an interest in drawing. And it was with a recognized talent that she would fill pads of sketches during a period of three long years.

Jack's uncle died in July of 1935, and left him only a small fraction of his estate. The relationship between Janet and Jack, who were living above their means, had further deteriorated. It was during this period that Janet enrolled Jackie in a school for young girls from upper class families, that she, herself, had attended when she was a child: the renowned Chapin School. Grandfather Bouvier signed the check to pay the registration fee of $575, a sum equivalent to the annual salary of millions of Americans during the Great Depression.

In October of 1935, Jackie became a student at this prestigious institution, where three hundred carefully selected young girls received an education of the highest quality, and where the slightest indiscretion was inadmissible. In addition to the classic subjects, the history of art, the domestic arts, and good manners were taught at the school. Notable musicians, orchestra conductors, inventors, politicians, and diplomats would come to give lectures and encourage the young girls to expand their horizons. Jackie would wear the blue uniform of the Chapin School for the next seven years.

During the summer of 1936, the Bouvier couple reached the breaking point: Black Jack was in debt, and had made no attempt to apply the breaks to his immoral lifestyle. Janet, materialistic and pragmatic, began to worry about their future and social status. The couple agreed on a contractual separation for six months beginning the first of October. Janet took custody of her two daughters, received a comfortable allowance, and retained possession of the apartment located at 740 Park Avenue, which was purchased by her father. Jack, weakened both financially and socially, moved into the Westbury Hotel on Madison Avenue and gradually sank further into alcoholism.

The following summer, after six months of respite, Janet and Jack attempted to save their marriage. However, for all intents and purposes, it was a lost cause. Together, they attended their daughter's first victory at the equine competition at the Southampton Horse Show, then separated for a second time. In September, divorce proceedings were initiated. Although Lee, three years of age, was protected by her sister from any real suffering due to this situation, Jackie was quite disturbed.

Janet began a search for a new husband who could guarantee her financial security and an elevated social status. She became involved in the whirlwind of an intense high society lifestyle that would consume her time and energy for two years. Though she was hardly affectionate and demonstrative with her daughters, she closely monitored their education. She applied herself daily to instill them with good manners, refinement, restraint (discretion), and even a certain social distance becoming of a woman of society. Jack assumed the role of the "laid back" father. When he had custody of the girls, he would take them to the zoo, the movies, to skate at Rockefeller Center, and to eat ice cream in Central Park. Jackie began to favor the Bouvier clan, a fact that at first saddened her mother, and then enraged her.

Brilliant and energetic at school, Jackie was very popular among her classmates, but became equally difficult to control. Agitated, she was often insolent with her professors, and defied her mother through them. One of her teachers, Miss Platt, commented on Jackie, "Very intelligent and very artistic, but a true little devil." It was also at the Chapin School, where she studied from ages six to twelve, that Jackie would enter into a rock solid friendship with Nancy Tuckerman, who she nicknamed "Tucky" and who would later become her personal secretary at the White House.

The principal at Chaplin encouraged Janet to utilize Jackie's horses as a bribery tool by threatening to forbid her riding during vacations if her grades were not satisfactory. This threat had a distinct effect on the youngster who then took on and suffered the same anxieties as her mother of losing her belongings, wealth, and privileges.

Jackie wizened up, and rocketed to the head of the class, a rank she would never relinquish thereafter. She lived a very privileged but troubled youth, and became more and more reserved, even introverted. She sought refuge in books and poetry and continued to draw in abundance. To her mother's great dismay, her blind adulation for the Bouvier clan grew, especially for her grandfather who spoke to her about their French origins and shared with her his love for art.

During the week of Easter 1941, Janet took her two girls to Washington. Jackie was very disappointed about her visit to the White House, commenting, "It was dismal, there was not one brochure to take home, nothing to learn more about this famous building where presidents have lived." But Jackie remembered her visit to the National Gallery as a cultural shock: "It is here where my love of art was born....I felt for the first time one of my greatest pleasures: contemplating a masterpiece."

That week was also Janet's opportunity to officially announce her relationship with Hugh D. Auchincloss, Jr., a renowned banker that she had met in Manhattan the preceding winter. Ten years her elder, he had three children of his own from two previous marriages. This multimillionaire bachelor was an ideal choice. An attorney, he was the descendant of a family that built its fortune as the founders of Standard Oil. He was a staid and sober man who enjoyed his fortune with discretion.

Lee and Jackie did not meet him until the following Christmas. At their mother's request, they called him, "Uncle Hughdie," but did not take to him very well. Hughdie took care of the girls as if they were his own, without so much as attempting to replace their father.

Janet married Hughdie in June of 1942 in Washington, and quickly bore him two children, little Janet in 1945, and little Jamie in 1947.

At the start of 1942, Janet and the girls moved into Hughdie's main residence, Merrywood. This vast estate located in McLean, Virginia was considered one of the most beautiful in the United States. His park of 18.4 acres included a stable, an olympic pool, tennis courts, and luxurious gardens. Merrywood's extreme comfort and its view on the Potomac created an ideal setting for Jackie and Lee, where they would live for almost a decade.

Jackie pursued her studies from 1942 to 1944 at the Holton-Arms School in Washington. Always very studious, she preferred French, Spanish, and literature, but it was through her contact with Ms. Brown, her history of art teacher, that she truly blossomed. During World War II, the usual crowd of domestics employed by Hughdie was reduced to an absolute minimum. Thus, during the summer vacations, Jackie and Lee, always very close, learned under the supervision of their mother to maintain the house and garden, to cook, and even to take care of the farm animals.

At the age of fifteen, Jackie attended the prestigious Miss Porter's School in Connecticut, where she was reunited with her childhood friend, Tucky. Her decision to study at this boarding school was not only predicated upon a desire to distance herself from Hughdie and her family, but also because, in her opinion, Miss Porter's was an excellent stepping stone to the country's best universities. Here, she wrote her first articles in *Salmagundy*, the school newspaper, in which she opposed the learning establishment's administration, that according to her was closing their doors to ethnic minorities.

An excellent student, Jackie participated actively in theater clubs and horseback riding and spent the majority of her free time writing poems and reading. She graduated from Miss Porter's School in June 1947, with an award for literary excellence. In the school's yearbook, under "Describe Your Ambitions," she wrote, "Not to be a housewife."

In July 1947, Jackie would make a significant impression at a debutante's ball held in Newport, Rhode Island. The society reporter, Igor Cassini, wrote, "We are ready to name the Debutante of the Year, Jacqueline Bouvier. She has grace, is cultured and intelligent."

She spent a summer attending parties, then began her freshman year at Vassar College, an elite institution, giving nothing away to the larger universities reserved for men. Although reserved, Jackie worked once again for the school newspaper and became a member of the theater troupe, for which she created costumes. She continued to excel academically, particularly in literature and the history of religion.

3 An Atypical Journey for an Out of the Ordinary Woman

In January of 1948, Grandfather Bouvier's death at the age of eighty-three marked the end of an era for the very heart of the family. He had led the

lifestyle of a prince until his last days, but had incurred much debt, and left only a meager inheritance. Suddenly, Jackie was sharing her mother's concerns once again: if she wanted to continue to live the lifestyle to which she was accustomed, she would have to marry a very wealthy man.

The following summer, Jackie departed for Europe under the auspices of a trip organized by Helen Shearman, her Latin professor at Holton-Arms. Accompanied by three other Vassar students, she left New York aboard the Queen Mary on July 9, en route for England. The visit to London, which had not yet recovered from the bombings, was a shock for the three young women, who were confronted for the first time with an omnipresent poverty. Next, they visited Paris. Spared of bombing sites, the city fascinated them. They visited Notre Dame, the Sainte-Chapelle, the Château de Versailles, and spent long moments at café terraces. From that point, the group visited the French Riviera, then Milan, Venice, Florence, and Rome, returning to the United States at the end of August.

As soon as she arrived home, Jackie attempted to convince Janet to allow her to study for one year in Paris. The negotiations were long and harsh, but ultimately she prevailed. Consequently, she had her transcripts sent from Vassar to Smith College, which offered a foreign study program to a few select students. She succeeded in receiving the European program, and left America on August 24, 1949, to spend a year in France.

After an intensive six-week course in the French language at the University of Grenoble, Jackie moved to Paris to attend history classes at l'Ecole du Louvre. She rented a room on avenue Mozart, at the home of Countess Guyot de Renty, a widow of the war, who lived with her two daughters of twenty and twenty-five years of age.

In Paris, Jackie led an intense social and cultural lifestyle. She went out often and maintained a romantic relationship for several months with the young son of a French diplomat. In March of 1950, Janet and Hughdie came to visit her. They left together to visit Vienna, Salzburg, Munich, and even Dachau at Jackie's insistence as a passionate historian. Upon her return, she finished her classes and received her diploma with honorable mention. She would say later, "I have never worked as hard in my entire life."

After a little adventure in Ireland and Scotland, she returned to the United States at the end of August to begin the fall term at George Washington University. She chose history of art and French as her majors.

During the winter, she decided to submit her candidacy for the Prix de Paris, a competition organized by *Vogue* magazine, which awarded a budding young journalist a six-month commission in Paris, followed by an editing position in New York. The self-portrait she sent to the magazine was resolutely critical, light, and humorous. The competition also required that she write three essays about people she would have liked to meet—she chose Charles Baudelaire, Oscar Wilde, and Serge Diaghilev. In the autumn of 1951, as she was preparing to graduate, *Vogue* contacted her to announce her victory, and ask her when she would be able to move to Paris.

Against all expectations, Janet vehemently opposed her daughter's departure for Europe, fearing a long lasting expatriation. Thus Jackie was forced to decline *Vogue*'s offer, her bad fortune bringing good fortune to the young woman in second place, a student in her senior year at Vassar.

Shortly prior to the Prix de Paris competition, in May 1951 Jackie was invited to Washington for a dinner at the home of Charles Bartlett and his wife. There, she met a young, thirty-three–year-old politician who was serving his third term in the Massachusetts House of Representatives. This war hero and self-assured gentleman showed his interest in her. His name was John Fitzgerald Kennedy, but everyone called him Jack. Jackie was not yet twenty-two years old; she was sensitive to his charm, but did not give access to his advances. In fact, she had been involved in a relationship for several weeks with a young Wall Street broker, John Husted.

On June 7, 1951, the two Bouvier sisters set off for Europe aboard the Queen Elizabeth. On the schedule was an itinerant vacation, which would take them from London to Paris, Venice, Rome, and finally Madrid. This three-month voyage could be categorized under the heading of the arts. They met the philosopher Bernard Berenson in Tuscany, took singing and painting lessons in Venice, and were received by the American ambassador in Madrid. Upon their return, Jackie accepted a position as an investigative photographer with the *Washington Times-Herald* thanks to Hughdie's influence. For her weekly column, she prepared and conducted short interviews of personalities whom she selected and photographed herself. For close to eighteen months, she interviewed not only ministers and senators, but also a housewife, a student, and other illustrious unknowns.

In the fall of '51, her heated romance showed no signs of weakening as Jackie continued to go out regularly with John Husted. At Christmas time, during a dinner at the Westbury Hotel, he asked for her hand. She accepted. The marriage, scheduled for June, was announced in the January 21, 1952, edition of *The New York Times*. However, after several months, Jackie got "cold feet." John Husted was certainly a respectable man and a good marital prospect, but she feared losing her independence and leading a life that was "too peaceful." In the spring, she returned the engagement ring.

4. The Kennedy Years

In May, almost one year to the day after their first meeting, Jackie's and John Fitzgerald Kennedy's paths crossed once again at a dinner with the Bartletts. Immediately, Jack was seduced by her grace, intelligence, and sharp wit. Jackie, herself, found him seductive and energetic. She was impressed by the circles in which he ran, and by his family in particular: Jack's maternal grandfather had been the mayor of Boston, his paternal grandfather, advisor to President Roosevelt, and his father, ambassador to Great Britain.

Jack was also a complex individual, whose notoriety had spread beyond the borders of Massachusetts. He had published a best-seller, *Why England*

Slept, upon his exit from Harvard in 1940, then entered the world of politics and was elected to Congress. He was a man with convictions, a capable and brilliant politician upon whom rested all of the Kennedy clan's aspirations. The fortune accumulated by his father, Joe, provided the means for his race to power and assured him a comfortable income—Joe, in effect, paid him an annual allowance of ten million dollars since he had reached the age of majority. Even so, Jack did not lead an ostentatious lifestyle. He had a simplistic approach to money.

Having a connection with power and wealth, Jack was the definition of an eligible bachelor. But this born charmer with a harrowing sense of humor did not feel ready to invest himself in a long-term relationship, and thus slipped from affair to affair as if there were no tomorrow.

His fiery reputation caused Jackie to be distrustful. But she was seduced by his mind, his sense of humor, and his unique appearance. "One would say in looking at him that he needed a good haircut, and perhaps a balanced meal," she would later say.

Eventually, his charm took its toll and Jackie and Jack began to see each other more frequently. On the Fourth of July, 1952, they spent their first weekend together at Hyannis Port, Massachusetts in the Kennedy-family residence. Joe immediately saw in her an ideal spouse for the political career of his son. And just like his wife, Rose, he was impressed by Jackie's mind, kindness, and temperament. Jack's sisters were less receptive. They found her to be too intellectual, too sophisticated, and too shy. They nicknamed her, "The Debutante."

In November 1952, Jack was elected Senator of Massachusetts at thirty-five years of age. Jackie was subsequently dispatched to Washington by the *Times-Herald* to interview him. On the Senate debating floor, Jack seemed young, but at the same time, at ease with his job.

On January 20, 1953, the couple made their first public appearance at the inaugural ball of President Dwight Eisenhower. Shortly thereafter, Jackie organized a dinner at a New York restaurant to introduce Jack to her father. The two men immediately found that they had many things in common. After all, they shared the same passion for politics, sports, and women.

At the end of May, Jackie was sent to London by her newspaper to cover the coronation of Queen Elizabeth II. After having read her papers in the *Times-Herald*, Jack sent her this telegram: "Articles Excellent, but you are missed. Love, Jack." Upon her return from Europe, he was waiting for her at the airport with a diamond and emerald engagement ring from Van Cleef & Arpels. The next day, Jackie resigned from the newspaper. The engagement party, organized in Hyannis Port, was covered by *Life* magazine, with Jackie featured on the cover.

At the beginning of July, during the last debate session at the Senate, before summer vacation, Jack collapsed, ravaged by a new attack of malaria, which he had contracted during the war. Joe used all of his influence to conceal this

unnerving situation from the press and sent his son to rest on the French Riviera. There, Jack sailed and went out often. He met Gunilla von Post, a young and brilliant twenty-one–year-old Swede, fell under her spell, and tried to seduce her to no avail, but their paths would cross again several months later.

Jack returned to the United States on September 2. The wedding took place ten days later in Newport. It was a full national event. Three thousand people gathered at the church exit to catch a glimpse of the most glamorous couple in the country. Eight hundred people attended the ceremony at the church which normally had half the capacity. The most lavish of receptions was held at Hammersmith Farm, the property of the Auchinclosses, for more than twelve hundred guests. The newspaper headlines read: "Kennedy, the wedding of the year."

Upon their return from their honeymoon in Acapulco, the couple moved to Washington. Initially, they went through a crisis in their marriage. Jackie, who had given up a professional career, found herself confined to the suffocating role of a housewife. Moreover, Jack was often absent, caught up in the grasp of the world of politics. Jackie would later speak of this period in the following terms: "I married a whirlwind. I was alone almost every weekend. Politics, in a way had become my enemy, and we had no family life."

Jack's old demons had caught up with him as his sexual escapades multiplied. Jackie knew it and suffered from it, but never talked about it. At the brink of depression, she opted to react.

Jackie decided to develop an interest in politics so that she could be closer to her husband. In the beginning of 1954, she enrolled in some American history classes at Georgetown University, and translated excerpts and quotations of Voltaire, Rousseau, and Talleyrand, which Jack later used in his speeches. Of course, for the senator's team, Jackie's new infatuation with politics was a gift from heaven: they knew well that she was Jack's best asset and ambassador.

Since his college years at Harvard, Jack lived with daily, intense back pain. In addition to a serious impact that occurred during a football game, he had sustained a war injury in the Pacific. But in 1947, the doctors had diagnosed Jack with Addison's disease, which weakened his immune system to the point that it placed his life in danger.

In October 1954, Jack's back condition had reached a climax. The specialists were categorical—if he did not want to end his days in a wheelchair, he must undergo emergency surgery. They gave him a 50 percent chance of survival. He underwent two operations involving bone grafts of the spine between October 1954 and February 1955, and as a result contracted serious infections. The situation had become so serious that a priest had given him his last rites. But Jackie watched over him tirelessly and slowly nursed him back to health. She held his hand, cleaned his wound, kept him hydrated, and read him newspapers and poetry.

During the three months of convalescence, and under Jackie's counsel, Jack wrote *Profiles in Courage*, for which he won the Pulitzer Prize two years later. During the 1955 summer recess, the young senator departed for Europe, where he was scheduled to meet NATO representatives and political leaders of Poland and France. However, he also arranged a week of romance in Sweden with Gunilla von Post.

Jackie joined him on August 22 on the French Riviera. Together, they traveled to France and Italy, then met Jackie's sister, Lee Radziwill, on the yacht of one of their close friends, the wealthy Greek shipping magnate, Aristotle Onassis. Onboard the Christina, Jack met Winston Churchill, who was also invited to spend a few days.

The Kennedy couple returned to the United States at the beginning of October, and moved into a new house equipped with a pool and stables in McLean, Virginia. At this point, Jack invested himself completely in seeking the democratic candidacy for the 1956 presidential election and was almost always absent. Jackie, who had heard through the grapevine about Jack's affair in Sweden, was feeling more and more neglected and gradually slipped into a new period of depression. At the beginning of 1956, the couple was on the verge of separation. Joe Kennedy, fearing that a divorce would destroy his son's political career, offered Jackie one million dollars, to be discretely invested in funds in exchange for giving her marriage a second chance.

But she declined the offer, thinking that she had a much better reason to believe in the future of her marriage: she was expecting a child. Jack was defeated in his bid for candidacy in 1956, but his campaign had allowed him to thrust his name and face onto the national scene. Disappointed, he departed for the French Riviera and sailed on the Mediterranean with his father. At the time, Jackie was eight months pregnant. She had chosen her child's first name: Arabella. But on August 23, tragedy struck. Due to hemorrhaging, she was transported to the emergency room of Newport Hospital. When she awoke from the anesthesia, it was Bobby Kennedy who advised her that the doctors were forced to perform a caesarian section and her baby was stillborn. Jack did not learn of the news until August 26, when he docked at Genoea. He arrived at his wife's bedside two days later, and found Jackie at the edge of an abyss. She did not forgive him for leaving for Europe after she had insisted vehemently that he stay. The couple then moved to Georgetown in Washington, D.C. and without a doubt, endured the darkest period of their relationship through the end of 1956.

The year 1957 marked a turning point in Jackie's life. She became pregnant in March, then lost her father in August. Despite the emotional shock, her pregnancy proceeded without incident, and she gave birth to little Caroline on November 27, on the eve of Thanksgiving. On December 13, Caroline Bouvier Kennedy's christening was performed by Archbishop Richard Cushing at St. Patrick's Cathedral in New York. The birth was fulfilling for Jackie and rejuvenating for the couple. Jack, campaigning for reelection to the Senate in 1958, revolutionized the political code of conduct by exposing his family to the press. The media latched on to this image of happiness,

youth, and beauty that the Kennedy couple projected. Every time that Jackie accompanied her husband to a meeting, the crowd that came to greet him doubled in volume. She was a major asset to Jack's political career. Not only was she always elegant, smiling, and friendly, but she was also cultivated and multilingual. She would not hesitate to express herself in French during a Cajun festival in Louisiana, in Italian to the immigrants of Boston, or in Spanish to the Puerto Ricans in New York.

In August of 1959, Jackie and her husband met with her sister for a vacation in Europe. Lee, who had married Stanislas Radziwill, a businessman from London, had a child five months earlier. Together, they traveled on Aristotle Onassis' yacht, again joined by Winston Churchill.

On January 2, 1960, Jack announced his candidacy for the Democratic Party nomination in the presidential election and plunged head over heels into an exhaustive campaign, in which Jackie multiplied her well-noticed appearances. In Kenosha, Wisconsin she took the supermarket manager's microphone to address its customers: "Continue your shopping," she said, "I am going to talk to you about my husband, John F. Kennedy. He served his country during the war and in Congress for fourteen years. He is deeply concerned about the well-being of our country, so please vote for him."

Jackie was the object of numerous articles, but also the subject of criticism of the opposing party, who reproached her for her privileged origins, her expensive taste, and the astronomical sums she spent on clothing.

In the spring of 1960, Jackie again became pregnant and withdrew herself from the campaign. At Jack's request, she contacted her classmate at Vassar, Tish Baldrige, to manage his public relations.

On October 19, although seven months pregnant, Jackie traveled to New York to march in a parade with Jack in Manhattan. The crowd was delighted. That same day, Martin Luther King, Jr. was arrested and incarcerated for having participated in a civil rights demonstration. Jack and Bobby Kennedy applied great pressure in favor of his release. They achieved their goal one week later, securing precious votes from the African-American community for the upcoming elections.

John Fitzgerald Kennedy was elected by the smallest margin in history and became the first Catholic president of the United States. Jackie was only thirty-one years old when she became First Lady.

On November 25, 1960, while her husband was flying to Florida, Jackie was rushed to Georgetown University Hospital, where she gave birth to a 6.5 pound little boy. Upon his arrival in Palm Beach, Jack was advised of the birth of John F. Kennedy, Jr. "I am never there when she needs me," he exclaimed before jumping onboard a DC-6, used by the press, and returning to Washington.

Shortly after takeoff, Pierre Salinger, press secretary for the White House, used the plane's loudspeaker to announce the news. No less than three thousand congratulatory telegrams made their way to Washington. John Jr. was christened on December 8 and made the front page of *The New York Times* and many other newspapers. America had definitely adopted the Kennedy family, perhaps more than any other presidential family in history. *Look* magazine called the Kennedys "the new royal American family."

As soon as Jack took office in the beginning of 1961, he sold the house in Georgetown and purchased a country home outside of Washington, where Jackie spent long weekends taking care of the children and horseback riding. Their main residence was the White House, which Jackie undertook to restore in depth. She gathered information on its history, freshened up each room, and made an appeal to the foremost experts to give a new youth to the furniture and antiques. She also made an appeal for contributions to friends and patrons to finance the work and acquisition of new pieces and paintings, that she chose and arranged herself in the presidential residence. On February 14, 1962, Jackie would tour the White House before 60 million viewers, simultaneously televised by CBS and NBC, which attracted an audience of 80 percent of the households equipped with a television.

Jackie inspired a whole new vitality to the presidential palace. She installed a nursery and games for the children in the garden. She hired a new French chef, Rene Verdon, organized sumptuous dinners, and arranged concerts, shows, and ballets. Many V.I.P.'s were invited: Nobel Prize laureates, state officials, conductors, writers, poets, and film celebrities. She found it intolerable that millions of dollars were allotted to the budget of the Pentagon, yet no budget was reserved for the arts; for this reason, she officially endorsed the utility of the minister of culture.

The First Lady entrusted the talented Oleg Cassini with the task of designing her wardrobe. In response, Oleg broke all the conventional rules of fashion. The voluptuous blonde of the 50s gave way to a slim and active brunette. The Jackie style was copied everywhere, but rarely equaled. "It was an epidemic, this wardrobe," Mrs. Gerald Ford would say. Jackie was featured on many magazine covers as the media boosted her popularity to the level of stardom. She became a de facto ambassador of the United States, and often traveled around the world. After a visit to Canada, where the press raved about her suit, colored the same red as the uniform of the Royal Mounted Police, she stayed in Paris from May 31 to June 3, 1961, and once again stole the show from Jack. Later at a press conference he would comment,"I don't think that it would be unnecessary to introduce myself. I am the man who accompanied Jacqueline Kennedy to Paris." Paris had become a second home to Jackie. Her knowledge of the country and its cultural treasures delighted President de Gaulle and the French media. The Kennedys attended an official banquet in the Hall of Mirrors at the Château de Versailles, and Jackie took advantage of her short visit to tour the Jeu de Paume Museum and the Louvre, guided by the minister of cultural affairs, André Malraux.

After the Parisian triumph, the Kennedy couple traveled to Vienna, where they met with Nikita Khrushchev, and finally to London. Other voyages would follow later that year, including trips to Puerto Rico, Venezuela, and Colombia.

With the passage of time, Jackie became more independent. In March of 1962 she and her sister, Lee Radziwill, took an unofficial three-week trip to India and Pakistan, making a stop in Rome, where Pope John XXIII received them. In August of the same year, the two sisters vacationed together on the Radziwill property in Ravello, Italy. Among their guests was the Italian industrial magnate, Gianni Agnelli. These vacations, in the midst of the European jet set, made front page stories. This offended the president, causing him to send a telex to Jackie requesting that she spend less time with Agnelli and more time with her daughter, Caroline.

In October 1962, the Cuban Missile Crisis erupted along with the world's fear of nuclear war. Jackie was encouraged to leave the White House with her children so they could be closer to a nuclear bomb shelter that had been constructed for the presidential family. But she refused to leave her husband. This event would draw the couple closer to each other.

In April 1963, Jackie announced that she was expecting another baby in the fall. She decided to apply the breaks to any official duties in order to take care of herself during the pregnancy. At the same time Jack began his campaign in anticipation of the November presidential elections. He thrust himself once again into a frantic pace attending meetings, greeting crowds of citizens, and traveling throughout the country.

On August 7 he was informed that Jackie, after having fainted, was rushed to the hospital at Otis Air Force Base. When he reached her, she had given birth to a 4.5 pound little boy. Patrick Bouvier arrived into the world six weeks premature with significant respiratory problems. He was transferred to a special unit at the Harvard School of Public Health. The following day, after a long visit with Jackie, he went to his newborn's bedside. At four o'clock that morning, little Patrick's heart stopped beating. For the first time, Jack collapsed in public. His son had not quite lived two days. Jackie, shocked and too weak, could not attend the funeral nor the burial. Jack slipped a medal, a wedding gift from Jackie, into the tiny coffin, and buried his son Patrick in Brookline, Massachusettes.

After this tragic month of August, it was from within the family that the Kennedys found the strength to move on. For their tenth wedding anniversary in September, Jackie gave Jack a new St. Christopher metal. The couple had become as close as ever, embracing in public, sailing together on the weekends, and calling each other several times a day. Lee Radziwill, in Athens with Aristotle Onassis at the time, advised Jackie that Onassis had offered to loan her his yacht to cruise the Mediterranean for a change of scenery. Jack was not at all thrilled with this proposition, because at the time the IRS had initiated several indictments against Onassis. The president feared that the situation could unnecessarily provide ammunition to the press to create scandal. But Jackie was in such a great need of rest that, ultimately, he conceded.

On October 17, Jackie was greeted by her husband and children upon returning from her cruise. The trip had made a visible effect on her, easing her nerves and returning her comfort with herself, so Jack asked her to accompany him to Texas, during an important stage of the campaign. She accepted without hesitation.

The events of November 22, 1963, would rest chiselled into the memories of the entire world for many decades. On that day, President John F. Kennedy, riding through Dallas aboard his motorcade, was assassinated while greeting the huge crowd that had assembled to cheer him.

Later that day, Jackie returned to Washington onboard Air Force One, accompanying the body of her deceased husband. She did not change her pink suit spotted with blood until the next morning. "I want them to see what they did to Jack," she said. She organized the president's funeral herself, which was attended by more than ninety representatives of foreign governments. Her grief and dignity made an indelible impression on the profoundly shocked American people. That same evening, she celebrated John Jr.'s birthday at the White House, then Caroline's two days later.

Jackie prepared her departure from the White House, saying a few words to each of those who had worked for her and her husband. On November 29, she called the *Life* reporter Theodore White, and asked him to come meet with her. She told him, in her own words, the story of John F. Kennedy. The article made a great impact, and Jackie received more than 800,000 letters of support. In secret, she had the bodies of Arabella and Patrick transferred to Arlington National Cemetery, wanting them to rest close to their father. During the night of December 4, she attended the reburial.

5 After the White House

Bobby Kennedy took the young, thirty-four–year-old widow and her two children under his wing. He helped her face the tragedy and to start anew. In January 1964, Jackie declined President Lyndon B. Johnson's offer of a position as United States ambassador to Paris. She wanted to stay close to her family and moved to a colonial style house in Georgetown with her children. But soon thereafter, an influx of tourists invaded her street. She had become a national idol—and a favorite of the press. Her slightest acts and gestures were espied, her press agents harassed and sometimes hired for interviews. The paparazzi were relentless. She would escape the masses by increasing her trips to ski in Vermont and sunbath in the Caribbean, Palm Beach, or the Mediterranean.

In July she decided to move to New York, where she hoped to find a little more peace and anonymity. She purchased an apartment for $250,000 at 1040 Fifth Avenue with a view of Central Park and The Metropolitan Museum of Art, which she would keep until her final days. She decorated her nest located on the fifteenth floor in the style of a chic Parisian apartment, emphasizing her antiques (i.e. the Louis XVI desk which she had acquired with Jack), and carefully arranged her hundreds of books.

In the autumn she began her travels again. At the heart of the international jet set, she would attend flamboyant parties on yachts and other luxurious

properties. From 1964 through 1967, she traveled to Aspen, Acapulco, Lake Placid, London, Sun Valley, Gstaad, Rome, Florence, Dublin, Buenos Aires, Montreal, Madrid, Seville, Angkor, and Honolulu, among several other destinations. During this escape from reality and her memories, she described herself as lonely and not very happy. However, she was involved in a relationship for two years with an architect, Carl Warnecke, ten years her senior, with whom she shared some of her travels.

Once again, it was Aristotle Onassis who came to her rescue. Ari, as his friends called him, had been with Maria Callas for several years, but admitted that he was attracted to Jackie since their first cruise in 1963. He compared her to a diamond: "cold, with sharp edges, fiery and burning under the surface." They saw each other frequently from the beginning of 1968. Ari even proposed to her several times, to which Jackie graciously declined.

At the age of sixty-two, Ari was a charismatic billionaire and a formidable businessman. A self-made man, he had left his native land, Greece, to make his fortune in Argentina by creating a fleet of cargo ships. He spoke fluent English, French, and Italian, and divided his time between Paris, Monaco, his suite in The Pierre Hotel in New York, and his privately owned isle of Skorpios in Greece. He visited with the V.I.P.'s of the world, whom he would invite on the Christina, his luxurious yacht. He was an extremely generous man to those he loved, and protective, even paternal, with regard to women. He was one of the rare men capable of being involved with Jackie without fearing that he would be crushed by the memory of John Fitzgerald Kennedy.

Facing Jackie's trials and tribulations, he offered her love, comfort, and security on his isle of Skorpios. A wedding was soon on the horizon.

Ari had a rocky relationship with his son Alexander and his daughter Christina and was faced with the task of resolving the question of his estate. Thus he entered into a prenuptial agreement with Jackie, providing for her a two million dollar gift on the day of their marriage and an inheritance capped to 25 percent of this assets. In addition, as a wedding gift he gave her the Lesotho, a forty-karat diamond.

On October 20, 1968, an intimate wedding was held on Skorpios. Disapproving of her choice, the press broke away from Jackie, giving up its national icon. Ms. Callas, hurt, commented: "Jackie did well giving her children a grandfather. Ari is about as handsome as Cresus."

The happy couple settled in Greece. Jackie took on the assignment of redecorating the Onassis yacht and the house on Skorpios, which she had repainted pink—a "Pink House" after the White House, she would joke. With regard to Ari, he proved to be loving and generous with Caroline and John Jr. He showered them with gifts, and protected them as much as he could from the outside world. His own children avoided Jackie as often as possible during the first months of their relationship. This did not help in closing the gap between the father and his children so, little by little, Jackie undertook to develop a true friendship with Christina. In the spring of 1969, the differences between Jackie and Ari were becoming noticeable. He was

attached to his island, she wanted to return to New York. He traveled everywhere for business, she wanted to stay close to the children—that year they were apart for more than one hundred forty days. She loved art, he was but a speculator of art. He was the inveterate jet-setter, but fundamentally she preferred spending time at home and reading. As time passed, Jackie's main residence became her apartment on Fifth Avenue. Her schedule revolved around the children and her charitable activities (i.e., as substitute teacher at the Greeting Center for Abused Children in the heart of Spanish Harlem).

In May 1970 Ari found himself on the front page of the tabloids, photographed at Maxim's in the company of Ms. Callas. Immediately, Jackie flew to Paris, and had herself photographed at the same restaurant with her husband. Four days later, Ms. Callas attempted suicide. She swallowed a fistful of sleeping pills and was rushed to an American hospital.

Months passed, and the relationship between the Onassis couple became strained. They spent less and less time together. On January 23, 1973, Alexander Onassis crashed while piloting his small, private plane. His father was devastated. Deprived of an heir to oversee his self-made empire, he said that he no longer had a reason to live. For Ari, this nourished a strange suspicion that Jackie brought bad luck to his loved ones. In 1974, he amended his will and reduced his wife's inheritance by $250,000.

In New York, Jackie organized her life around the children, and became involved in multiple causes including the preservation of Grand Central Station, threatened by its owners to be converted into office space. She offered her presence and her support to facilitate the raising of funds for charitable works.

In February 1975, life took yet another tragic turn. Ari was suffering from vision and speech problems. The doctors diagnosed myasthenia, a progressive muscular disease. Jackie accompanied him to Paris, where he hoped to rest and receive care, surrounded by his two sisters, Merope and Kalliroi. On March 12, the doctors advised Jackie that Ari's health had improved and that she could return to New York to see her children.

Three days later, Ari died at the age of sixty-nine due to a sudden onset of pneumonia. Distraught, Jackie came back to France to attend the funeral. Christina, who inherited her father's fortune, estimated at more than one billion dollars, on her own initiative gave Jackie 26 million dollars.

6 An Editor Is Born

On July 29, 1975, Jackie celebrated her forty-sixth birthday. "I have lived my life through men. Now I realize that I can't be satisfied with that," she said to a friend. Wealth was not enough. She wanted to succeed in a professional career, and editing seemed to be a preferred area of interest considering her impressive literary background and her passion for writing—"She reads more than all the people I know put together," Truman Capote commented. Through the advice of her friend, Tish Baldrige, she

contacted Tom Guinzburg, a mutual friend and top executive at Viking Press. They reached an agreement and Jackie began her career as associate editor on September 22.

She rapidly found her place among her colleagues, who initially were skeptical, but were quickly impressed by Jackie's dexterity and energy. They appreciated that she conducted herself as a motivated employee and understood that editing was not just a new hobby, but truly a passion that she wanted to make her profession. During the same period, Jackie met Maurice Tempelsman, a wealthy diamond merchant and financial consultant specializing in the management of fortunes, whose clients included finance magnates and heads of state. He was an intelligent, energetic, and discreet man. Although they would be seen dining together, Jackie protected their relationship, to the best of her ability, from photographers' eyes.

Jackie published her first book in 1976, titled *Remember the Ladies: Women in America, 1750–1815* by Linda G. DePauw. The book dealt with the evolution of the status of women and marked the beginning of a long and fruitful career as an editor that would last for twenty years.

In 1976, her stepfather Hughdie passed away, and Jackie became closer to her mother, from whom she had distanced herself over the years. She made sure that Janet was comfortable, giving her a gift of one million dollars so that she could continue to live in the manner to which she was accustomed. Janet remarried three years later at the age of seventy-one, to a wealthy, retired banker and moved to Southampton where she would die in 1989.

At the end of 1977 Jackie experienced a falling out with the CEO of Viking Press who, without consulting her, had decided to publish a dubious novel set in the future about an assassination plot on president Edward Kennedy. It was then falsely leaked to the press that Jackie had given her endorsement. While Jackie had been trying to keep her lives as a Viking editor and a Kennedy relative separate, this suggestion infuriated her. She resigned immediately and obtained a position as associate editor at Doubleday.

In 1979 she attended the grand opening of the John F. Kennedy Library and Museum at the University of Massachusettes at Boston, an idea that she had brought out in 1964, and for the construction of which she had raised more than ten million dollars thanks to an appeal for contributions. It was her close friend, the architect I.M. Pei, who drew the plans for the magnificent site.

That same year, she discreetly celebrated her fiftieth birthday, then invited 125 guests to a surprise party at a fashionable club in Manhattan for her daughter Caroline's twenty-fifth birthday.

At the beginning of the 1980s, Jackie had become a recognized editor for producing numerous bestsellers. She enjoyed cultivating special relationships with her authors, and thoroughly enjoyed contact with them. She refused to publish her own memories, stating, "I want to live my life, not consign it....I want to savor my life, not write about it." Jackie multiplied her editorial successes at Doubleday, getting involved in every stage of the process, from the choice of its covers to the promotion of its authors. Simultaneously, her relationship with Maurice Tempelsman continued to be enriching and mutually satisfying. Faithful and caring, he gave her the impression that she counted more than anyone else in the world and protected her private life. Jackie, who regularly engaged in horseback riding, yoga, and jogging in Central Park at the time, felt that her independence was well respected by Maurice. He furthermore became closer as time passed to John and Caroline, for whom he became a close confidant. Though of secondary importance, he also helped Jackie's fortune grow, giving her peace of mind with regard to her children's future. John Jr. was now grown and referred to simply as John. He graduated from Brown University with a degree in history, then completed law school at New York University and passed the bar exam. Voted the sexiest man of the year by *People* magazine, this 6.3 foot strapping young man had become America's darling; as the country saw in him the potential of a future leader. His sister, Caroline, was also an accomplished woman. Having graduated from Radcliffe, she studied law at Columbia University, then was employed as executive producer at The Metropolitan Museum of Art, New York. She married an architect, Edwin Schlossberg, with whom she had two kids in 1988 and 1990.

Entering the 1990s, Jackie was a venerated woman, mother, and grandmother. In June 1993, she took a final trip to France with Maurice Tempelsman, where they visited Arles and traveled along the Rhône. When she returned to the United States, she was exhausted. She went back to work at Doubleday, and continued to take care of her grandchildren on the weekends. But her exhaustion worsened. In November, after a fall from a horse that was followed by a short loss of consciousness, she had some medical tests performed, accompanied by Maurice. The doctors diagnosed Jackie with cancer.

After a lavish Christmas, Maurice took her on a short cruise in the Caribbean. Upon their return, Jackie began an intense and exhausting course of chemotherapy and radiation and was forced to stop working for several weeks. Rumors of her condition started to circulate, so she made an official statement to satisfy the international press. On March 22 she signed a long and complex will, in which she did not forget to bequeath generous gifts to all those who had helped and supported her throughout her lifetime: Nancy Tuckerman, her governess and cook, her housekeeper at the White House, her accountant, etc. She additionally requested that she be buried at Arlington Cemetery next to Jack, Arabella, and Patrick.

Subsequently, her condition deteriorated. She was rushed to the hospital on May 16, but as soon as she regained consciousness, Jackie requested that she be driven back to her home. Jackie passed away on May 19, 1994, shortly after 10 P.M., surrounded by her children and Maurice, with whom she shared the last twenty years, and amidst all of her memories accumulated over the course of an exceptionally fulfilling and eventful life. America was in mourning, and the following day the *New York Daily News* headline read, "WE MISS HER."

"She was the most inquiring mind we'd had in this school in thirty-five years! Otherwise, I mightn't have kept her."

Ethel Stringfellow, headmistress at the Chapin School

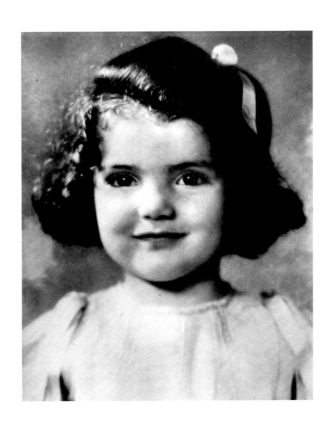

1933 / Long Island, NY / Studio portrait of Jacqueline Lee Bouvier at the age of four

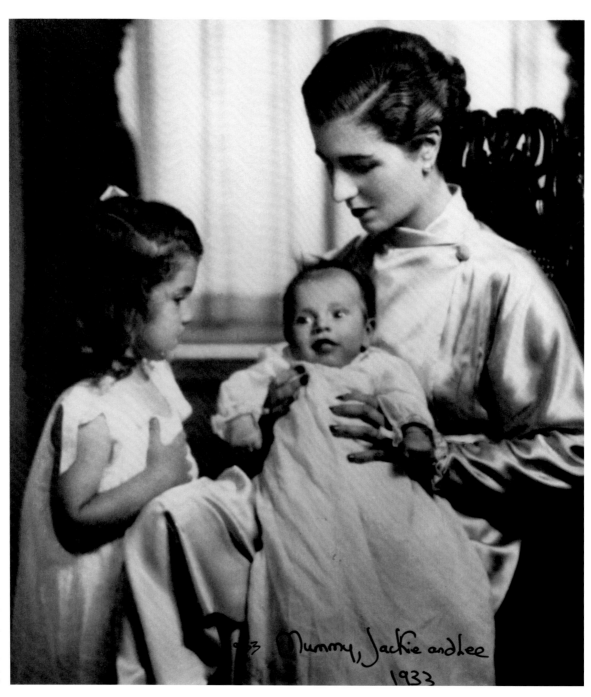

1933 Mummy, Jackie and Lee 1933

June 1933 /
Long Island, NY/
Jacqueline Bouvier with
her tiny sister, Caroline
Lee Bouvier, who was born
on March 3, 1933, with
their mother

August 1933 / Long Island, NY /
Jackie holding the tiny hand of her
baby sister, Lee, outside their parents'
summer house in East Hampton.
Lee was only a few months old
and Jackie was about three.

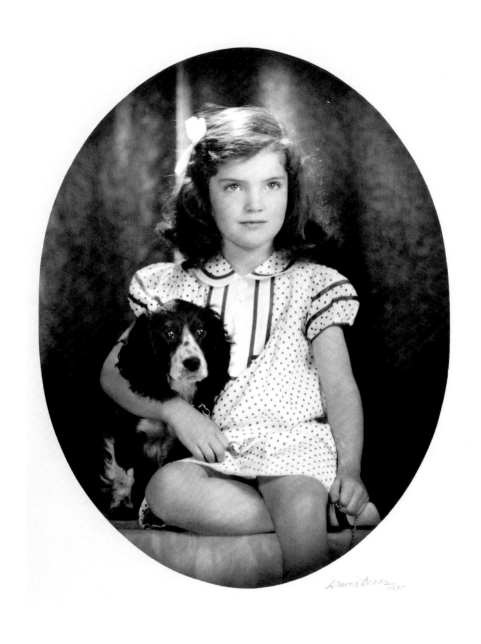

1935 / East Hampton, Long Island, NY / Portrait of Jacqueline Lee Bouvier at six years old

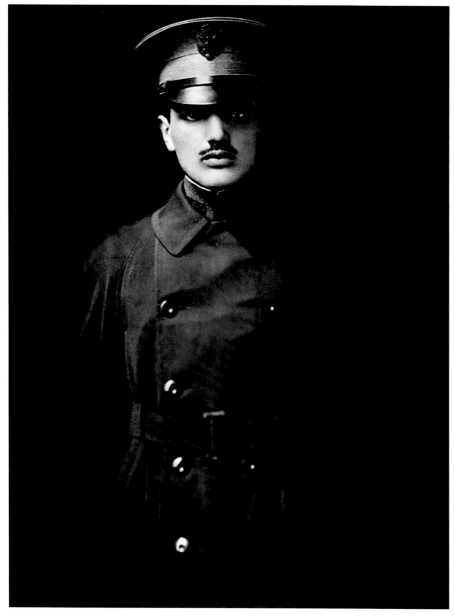

1914 / Jackie's favorite photograph of her father, John Vernou Bouvier III. John graduated from Yale during World War I and served as a Second Lieutenant in the United States Coast Artillery. He followed the Bouvier family tradition by becoming a member of the New York Stock Exchange in 1919. He was nicknamed "the Sheikh" by his friends.

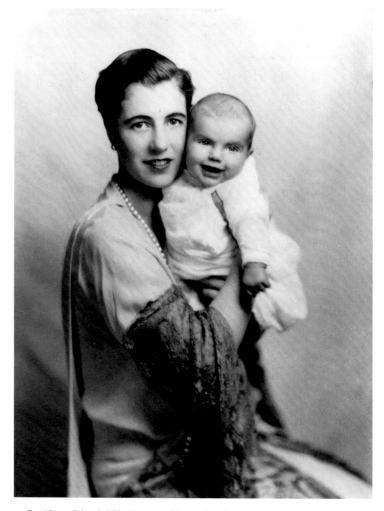

1930 / Long Island, NY / Portrait of Jacqueline Lee Bouvier with her mother, Janet Lee Bouvier

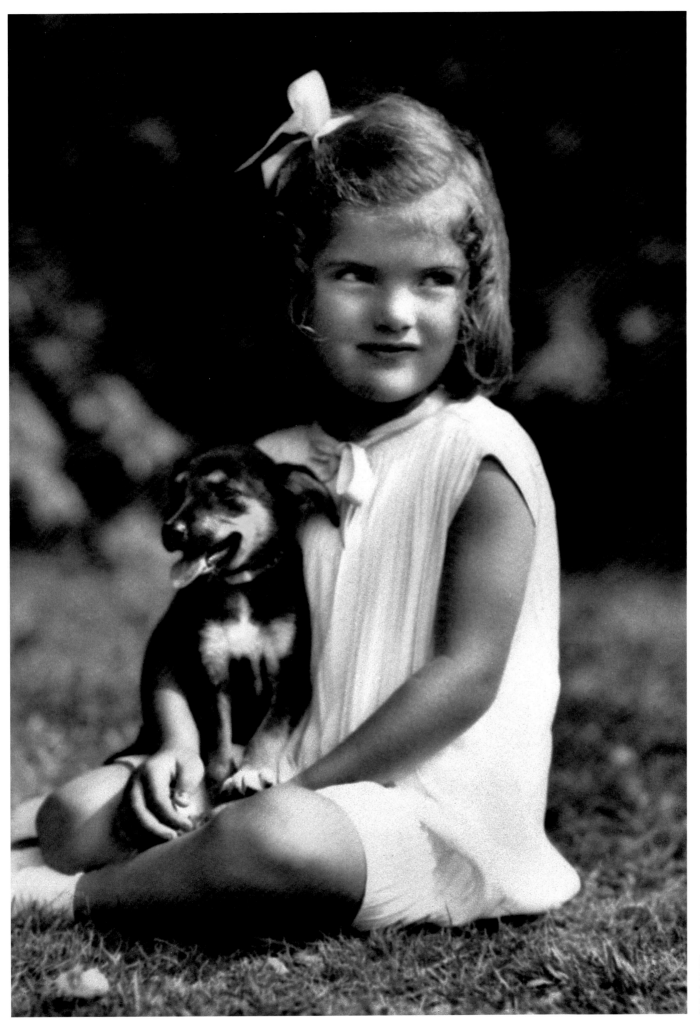

1934 / Southampton, Long Island, NY / Portrait of young Jacqueline Lee Bouvier at the age of five

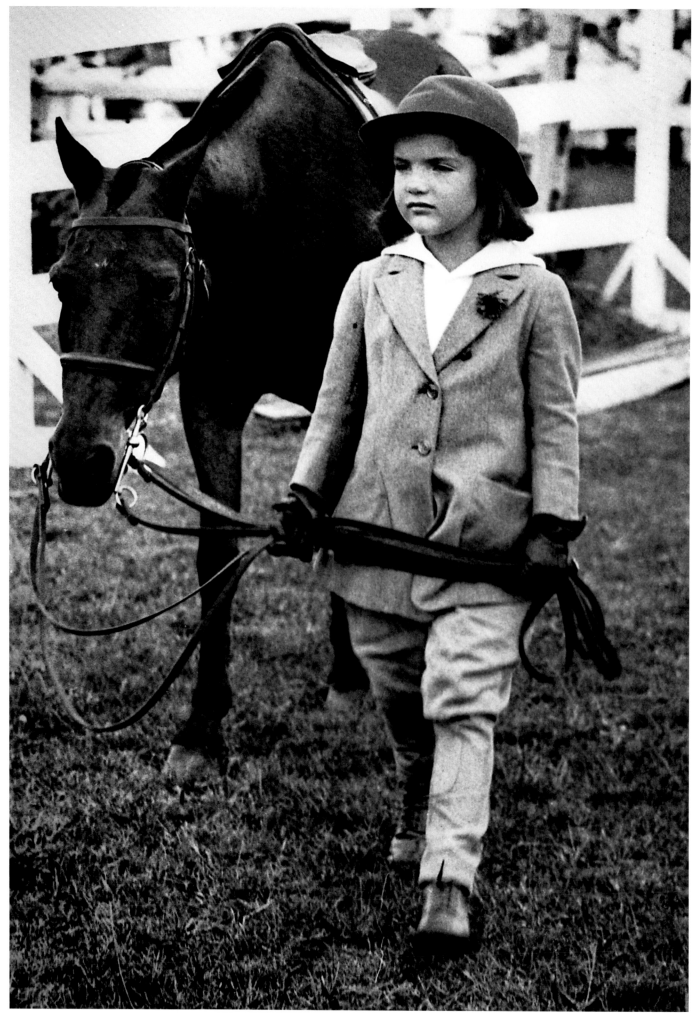

August 12, 1934 /
Southampton, NY /
Jacqueline Lee Bouvier
leading her pony from the
paddock after competing at
the Sixth Annual Horse Show
of the Southampton Riding
and Hunt Club

August 12, 1934 /
Southampton, NY /
John Bouvier standing with
his wife and daughter
Jacqueline at the Sixth Annual
Horse Show of the
Southampton Riding
and Hunt Club

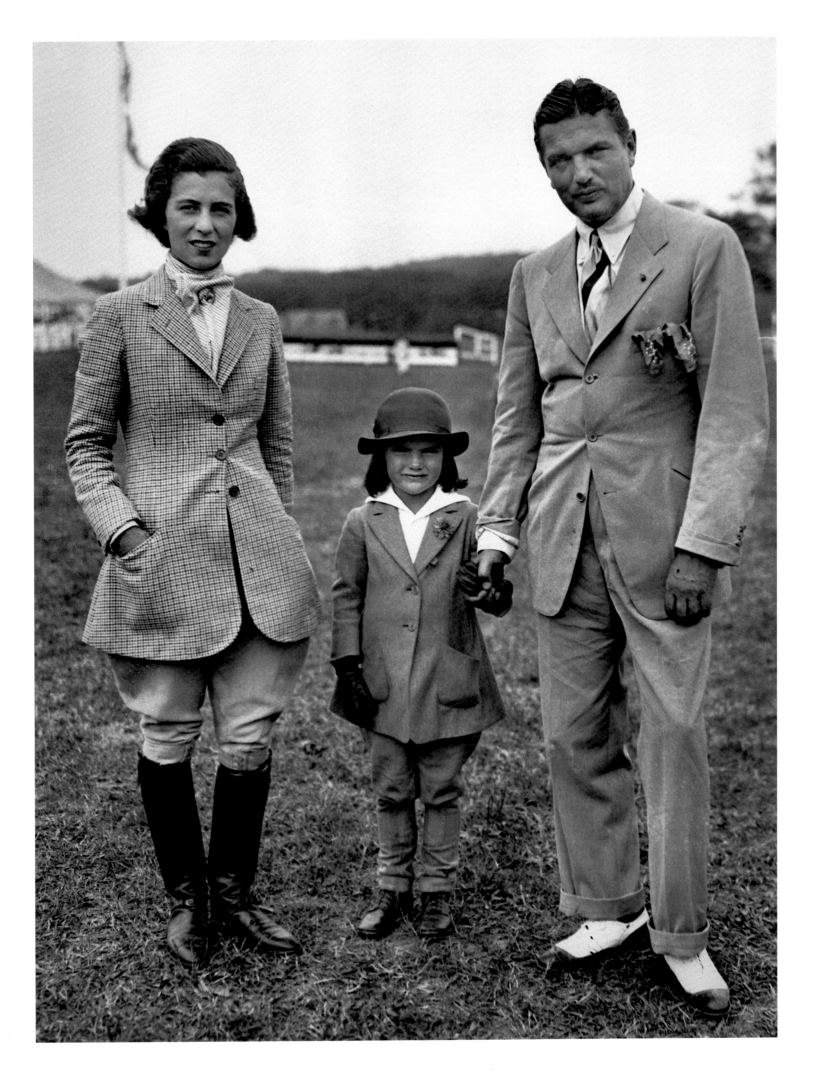

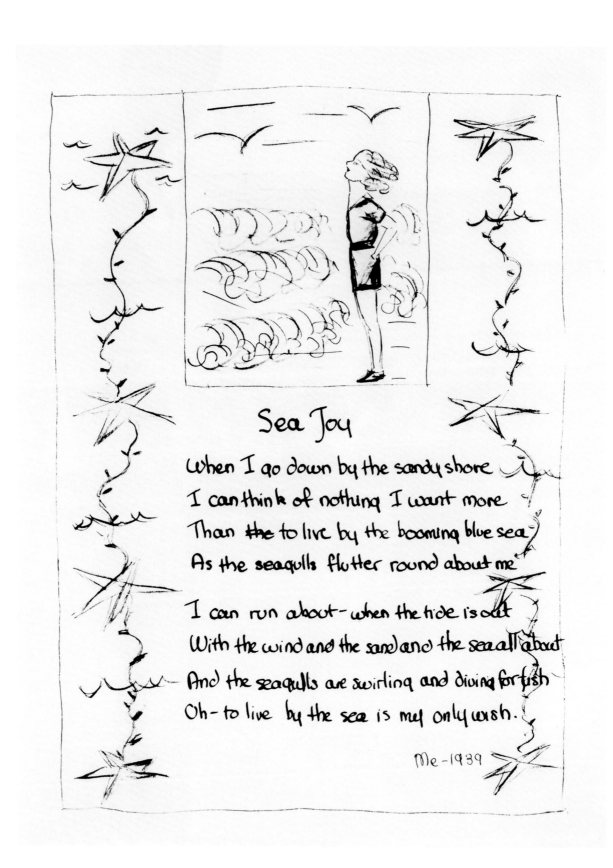

Sea Joy

When I go down by the sandy shore
I can think of nothing I want more
Than ~~the~~ to live by the booming blue sea
As the seagulls flutter round about me

I can run about – when the tide is out
With the wind and the sand and the sea all about
And the seagulls are swirling and diving for fish
Oh – to live by the sea is my only wish.

Me – 1939

1939 / East Hampton, NY / When she was ten, Jacqueline Lee Bouvier wrote and illustrated "Sea Joy," a poem reflecting her passion for the sea. Her love both of writing and the sea were two lifelong interests she and John F. Kennedy would later share.

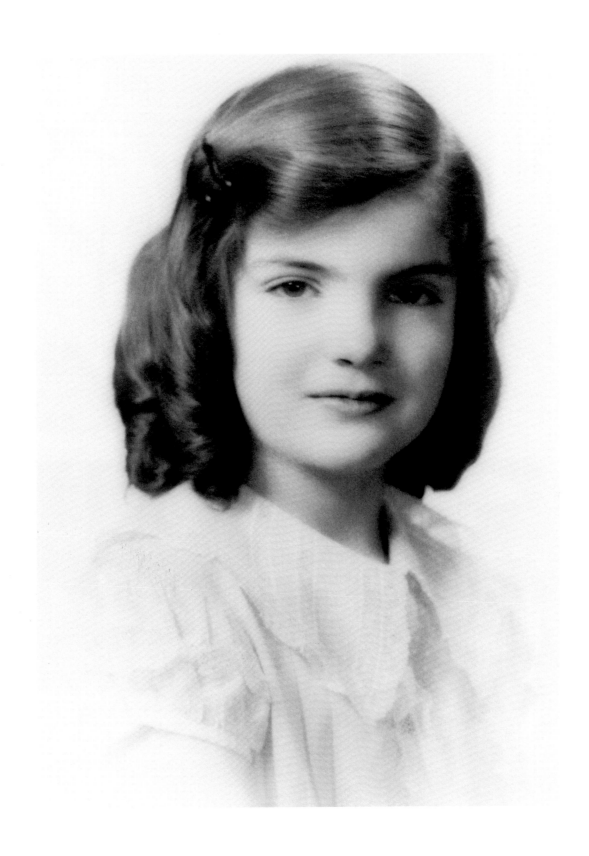

1939 / East Hampton, NY / Portrait of Jacqueline Lee Bouvier at the age of ten

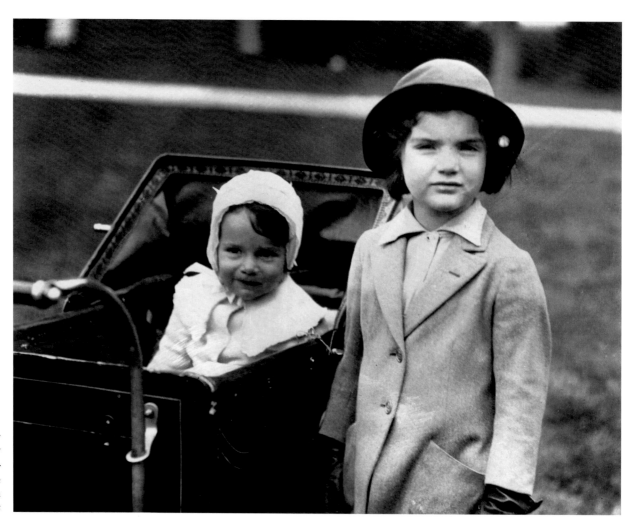

June 1, 1935 /
East Hampton, NY /
Jacqueline Lee Bouvier
standing by Caroline Lee
Bouvier, seated in a
baby carriage

January 1, 1935 / East Hampton, NY / Jacqueline, six years old, and her sister, Lee Bouvier, playing
with their pet bull terrier, Regent, at a dog show

1942 / New York, NY / Jackie at the Chapin School. After kindergarten,
Jackie started the first grade at the Chapin School on East End Avenue in
New York. One of her teachers, Ms. Platt, thought Jackie was a darling
child, the prettiest little girl, very clever, very artistic, and "a true little
devil." She was efficient and finished her work on time, and then had
nothing to do until her classmates finished theirs.

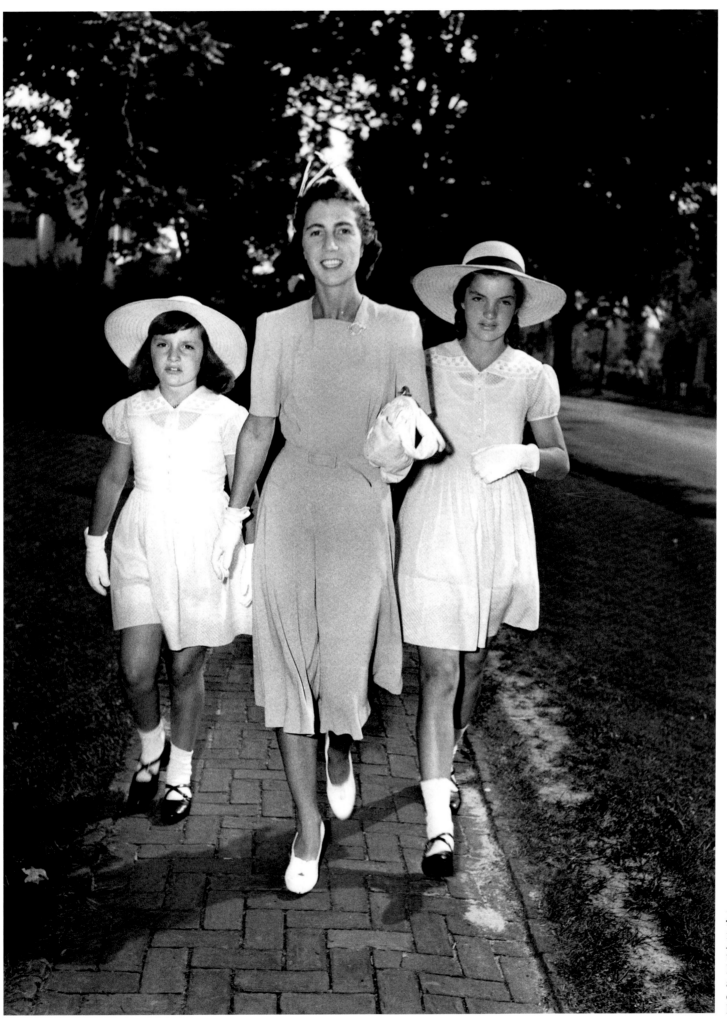

July 26, 1941 /
East Hampton, NY /
Jacqueline, Lee, and
their mother, Mrs. Janet
Lee Bouvier, walking
along a brick sidewalk
on their way to the
Krech-Jackson wedding

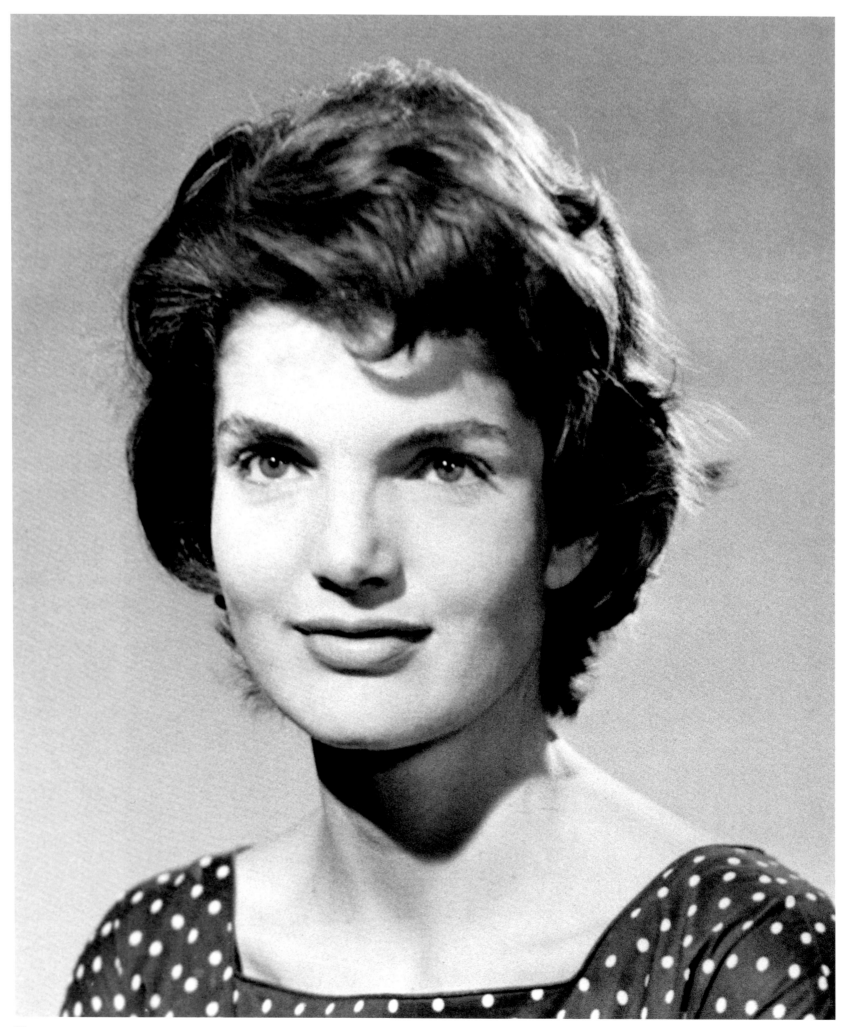

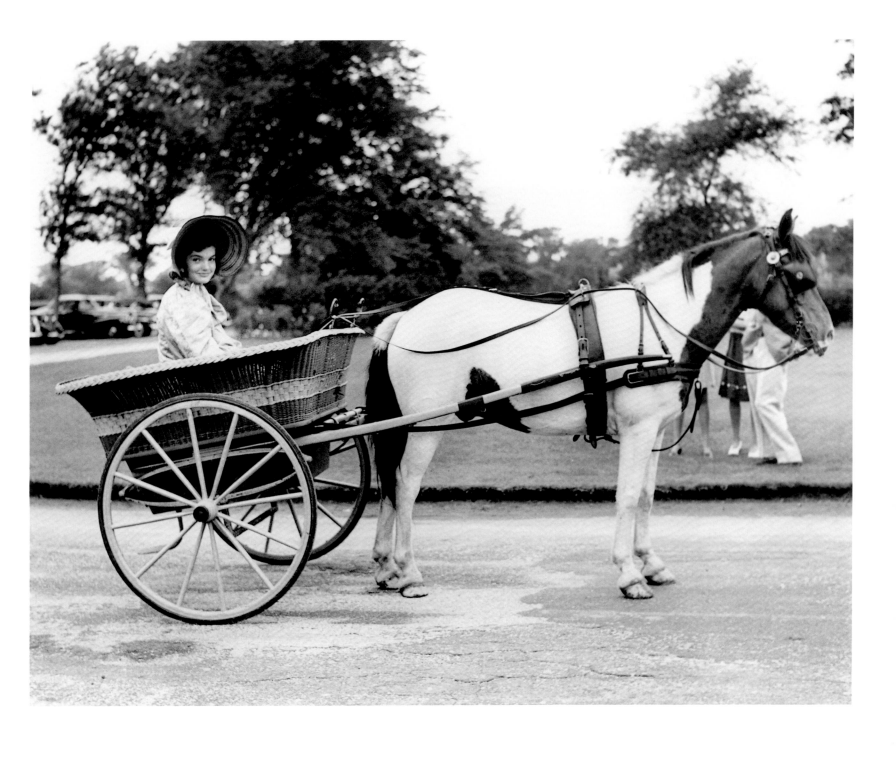

1953 / Studio portrait of Jacqueline Lee Bouvier

August 15, 1942 / Jacqueline Lee Bouvier driving a horse cart

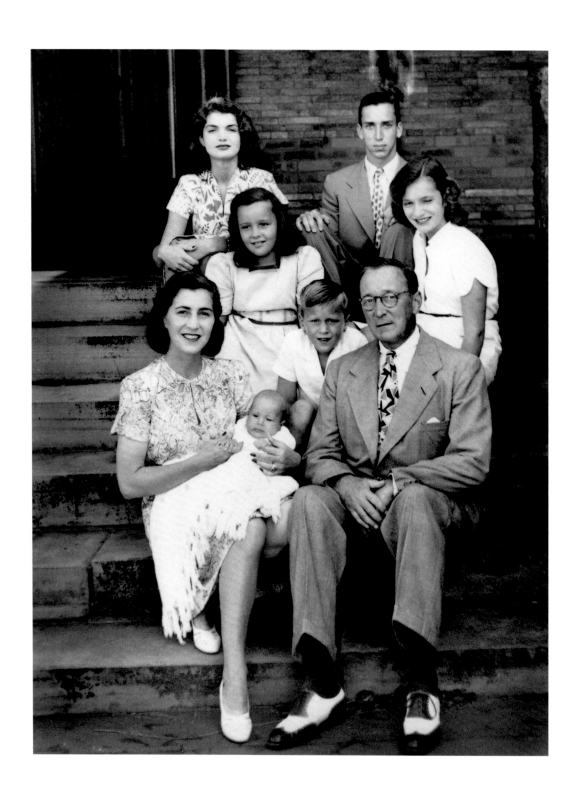

December 1945 / Newport, RI / The 1945 Christmas greeting card from Janet and her second husband, Hugh D. Auchincloss, Jr. Jacqueline Lee Bouvier is at the top with her stepbrother Hugh Auchincloss (known as "Yusha"). Middle row: Nina Auchincloss (stepsister, now Mrs. Newton I. Steers), Thomas Auchincloss, Caroline Lee Bouvier
Bottom row: Mrs. Auchincloss holding her baby, Janet Jennings Auchincloss, and Jackie's stepfather, Uncle Hughdie

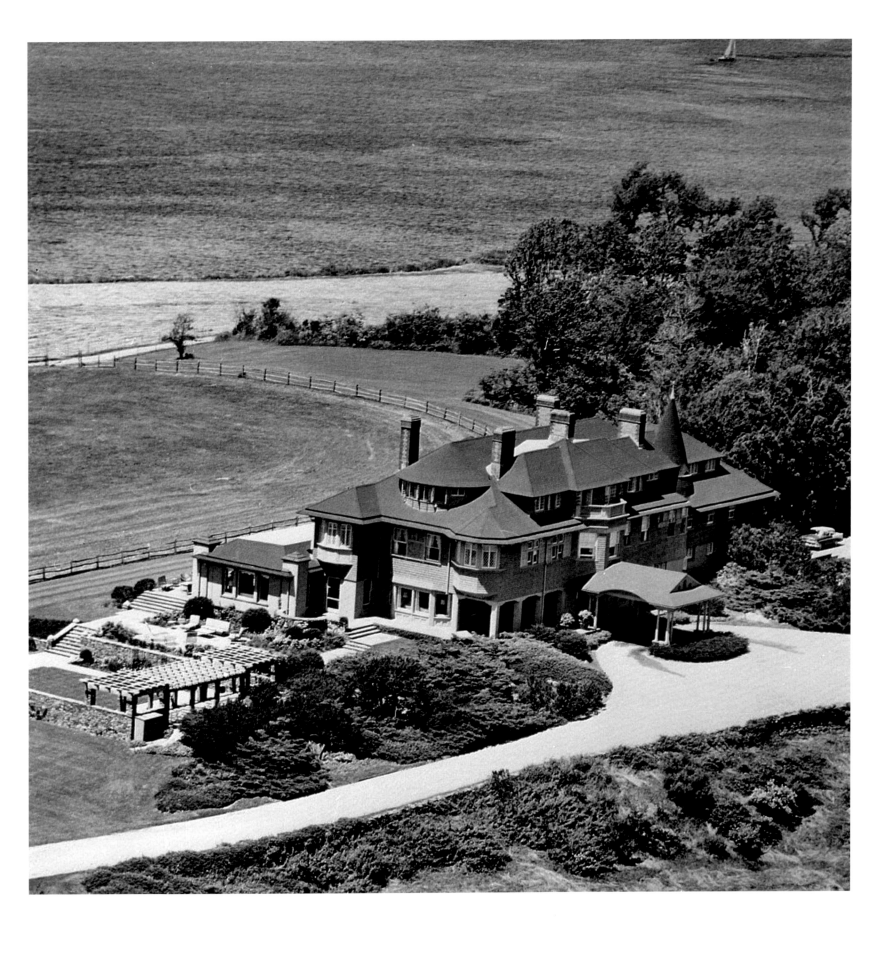

September 22, 1961 / Newport, RI / Aerial view of Hammersmith Farm, where Jackie and John F. Kennedy used to vacation. In the background is the east entrance of Narragansett Bay. The estate is on the famous "Ocean Drive."

JACQUELINE LEE BOUVIER
"MERRYWOOD"
MC LEAN, VIRGINIA
"Jackie"

Favorite Song: Lime House Blues
Always Saying: "Play a Rhumba next"
Most Known For: Wit
Aversion: People who ask if her horse is still alive
Where Found: Laughing with Tucky
Ambition: Not to be a housewife

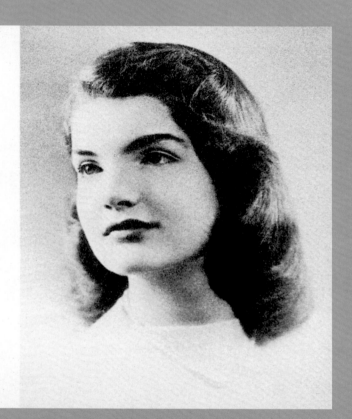

1947 / Farmington, CT / Extract from Jacqueline Lee Bouvier's yearbook at Miss Porter's School. Jackie loved the school as she was allowed to bring her beloved horse, Danseuse, with her and she graduated with an A average. "Tucky," Nancy L. Tuckerman, was her roommate. Tucky later became Jackie's social secretary at the White House and later helped to run her New York office.

July 1947 / Newport, RI / At Newport's fashionable Seaside Clambake Club, Jacqueline Lee Bouvier shares honors with Rose Grosvenor, a fellow debutante, at a dance. The Clambake Club is one of the town's most cherished institutions. The dance honoring Jacqueline and Rose was mostly for the young and was the climactic event of the local social season. Earlier in the summer, Jackie had made her official bow to the social world at an afternoon reception given at Hammersmith Farm, the summer place of her mother and stepfather, Hugh D. Auchincloss. She shared the spotlight at the reception with her half brother, James Lee Auchincloss, who was a few weeks old and had been christened the same day.

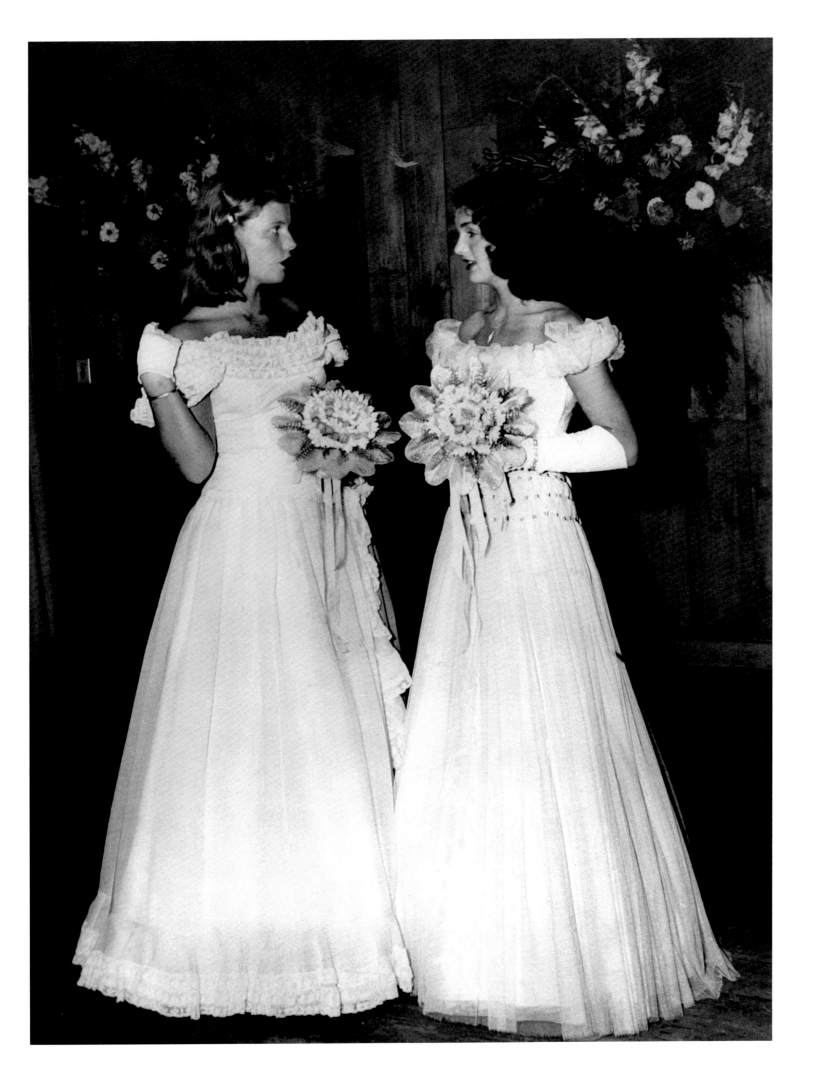

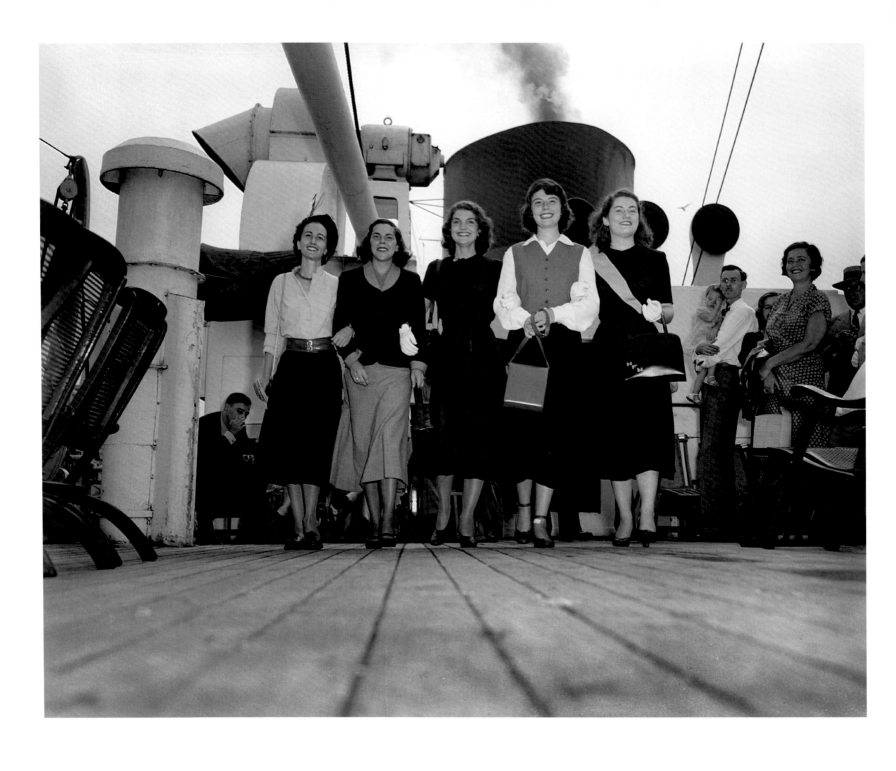

August 24, 1949 / New York, NY / Jacqueline Bouvier with her friends from the Smith College foreign study program on the deck of the De Grasse, en route to France where they lived for one year. From left to right: Elizabeth Curth, Margaret Snyder, Jacqueline Bouvier, Mary Ann Freedman, and Hester Williams

1945 / Newport, RI / Snapshot of Jacqueline Lee Bouvier, as a sixteen-year-old baby-vamp, taken with the canvas cover of a Newport tennis court in the background

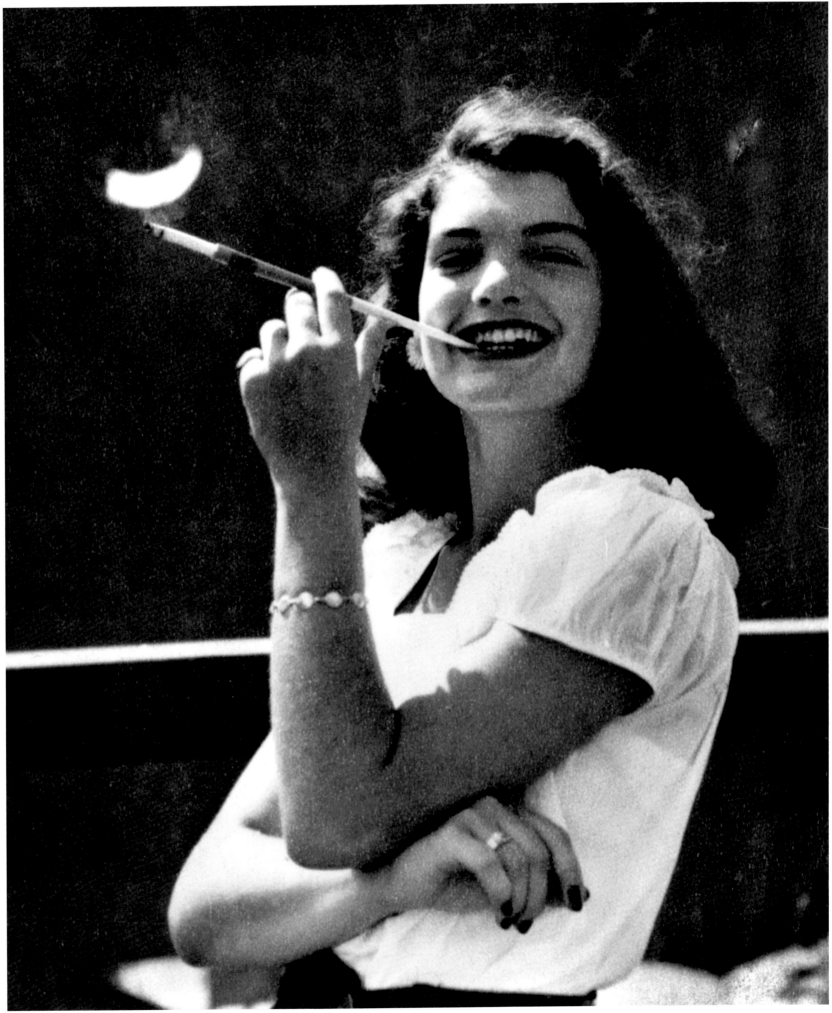

Jacqueline Bouvier: A self-portrait
George Washington University
First Quiz

A self-portrait written from the author's viewpoint is likely to be a little biased. Written from the viewpoint of others it would probably be so derogatory that I would not care to send it in. I have no idea how to go about describing myself but perhaps with much sifting of wheat from chaff I can produce something fairly accurate.

As to physical appearance, I am tall, 5'7", with brown hair, a square face and eyes so unfortunately far apart that it takes three weeks to have a pair of glasses made with a bridge wide enough to fit over my nose. I do not have a sensational figure but can look slim if I pick the right clothes. I flatter myself with being able at times to walk out of the house looking like the poor man's Paris copy, but often my mother will run up, inform me that my left stocking seam is crooked or the right-hand top coat button about to fall off. This, I realize, is the Unforgivable Sin.

I lived in New York City until I was thirteen and spent the summer in the country. I hated dolls, loved horses and dogs and had skinned knees and braces on my teeth for what must have been an interminable period of time to my family.

I read a lot when I was little, much of which was too old for me. There were Chekhov and Shaw in the room where I had to take naps, and I never slept but sat on the window sill reading, then scrubbed the....

Putting them in chronological order, I would say that the three men I should most like to have known were Charles Baudelaire, Oscar Wilde and Serge Diaghilev. They followed close upon each other in the three quarters of a century from 1850–1925. They came from three different countries and specialized in three different fields: poetry, playwrighting and ballet, yet I think a common theory runs through their work, a certain concept of the interrelation of the arts, and through their lives, a belief that beauty in art has nothing to do with the questions of good or evil.

Baudelaire and Wilde were both rich men's sons who lived like dandies, ran through what they had and died in extreme poverty. Both were poets and idealists who could paint their sinfulness with honesty and still believe in something higher. The Frenchman, an isolated genius who could have lived at any time, used as his weapons venom and despair. Wilde, who typified the late Victorian era, could, with the flash of an epigram, bring about what serious reformers had for years been trying to accomplish.

Baudelaire in his sonnet Correspondences developed the theory of synthesis of art, a tendency to associate the impressions given by one of the senses with those of another. He speaks of perfumes "green as prairies, sweet as the music of oboes, and others, corrupted, rich and triumphant."

The George Washington University
in virtue of authority granted by
The United States of America
has conferred upon
Jacqueline Lee Bouvier
the Degree of
Bachelor of Arts

together with all the Honors, Rights and Privileges belonging to that Degree.
In Witness Whereof, this Diploma is granted bearing the seal of the University
Given at Washington in the District of Columbia this thirtieth day
of May in the year of our Lord nineteen hundred and fifty-one

Henry Grattan Doyle
Dean of Columbian College

Cloyd H. Marvin
President of the University

May 13, 1951 / Washington, DC / Jacqueline Lee Bouvier earned a bachelor of arts degree at George Washington University in 1951 with a degree in French literature. Ten years later, she returned as the First Lady when her husband, John F. Kennedy, delivered a commencement address on May 3, 1961, in the University Yard. After receiving George Washington University's honorary degree, he mentioned that it had taken his wife two years to get her degree and "it took me only two minutes, but we are both grateful."

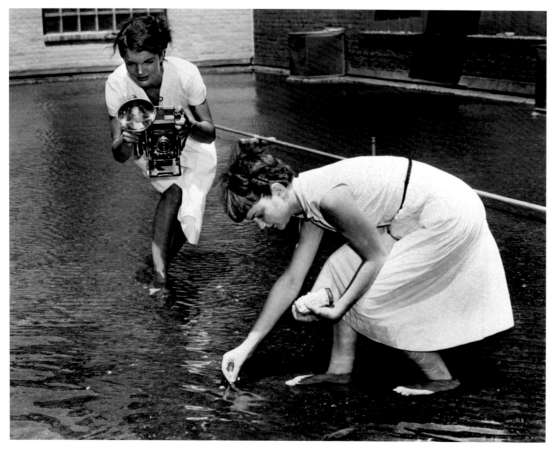

1952 / Washington, DC / Jacqueline Lee Bouvier photographing Dale Chestnut feeding goldfish on the rooftop pond of the Washington Times-Herald building. In 1951 Jacqueline took her first job as the "Inquiring Camera Girl" for this newspaper. Part of Jackie's job was to go around the city of Washington asking citizens questions on the issues of the day.

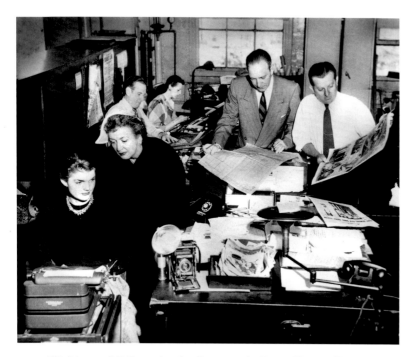

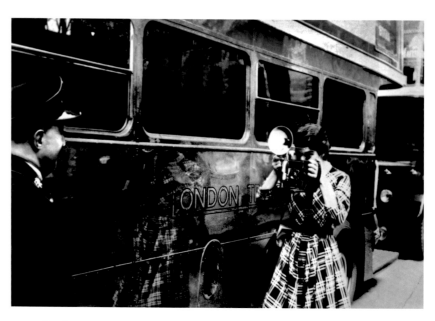

1952 / London, England / As the "Inquiring Camera Girl" for the *Times-Herald*, Jacqueline selected the subjects of her column, which included pieces on John F. Kennedy, Richard Nixon, and a London bus driver.

1952 / Washington, DC / Jacqueline Lee Bouvier at the *Times-Herald* offices. While covering the queen's coronation in London for the *Times-Herald*, she received a telex from John F. Kennedy saying he missed her, and asking her to come back to America.

December 1, 1953 / Washington, DC / Jacqueline Kennedy posing with a Speed Graphic press camera during her stint as an inquiring photographer for the *Washington Times-Herald*

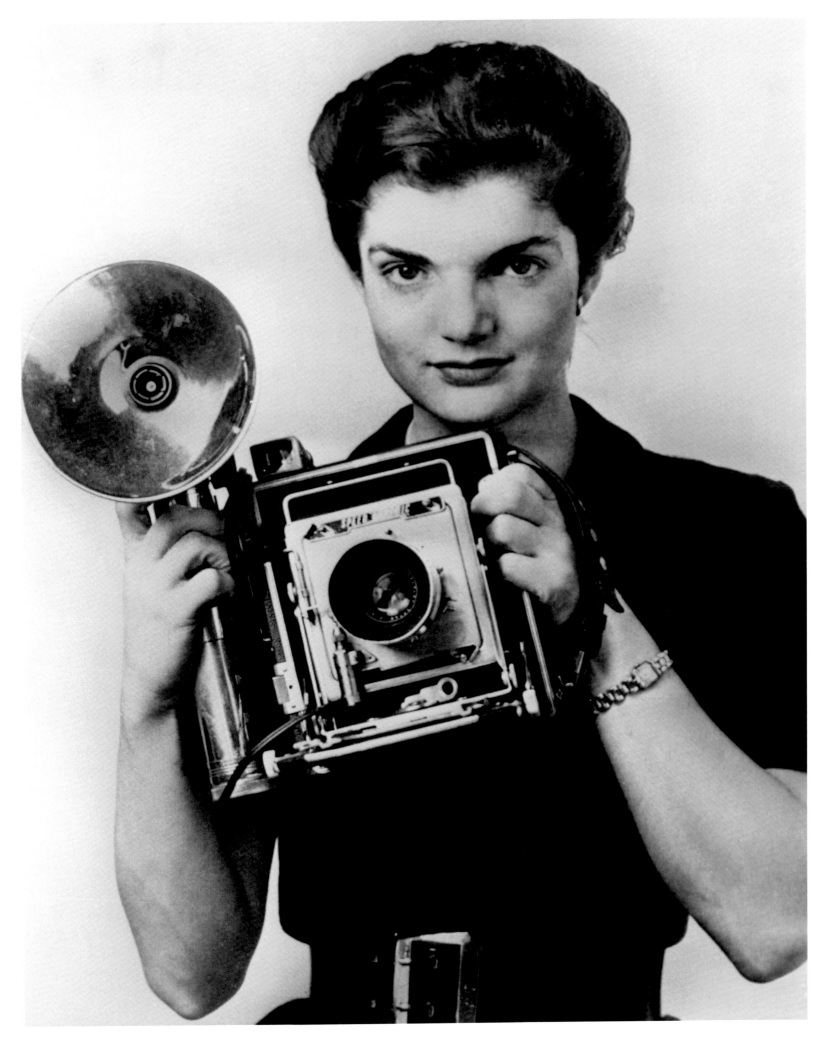

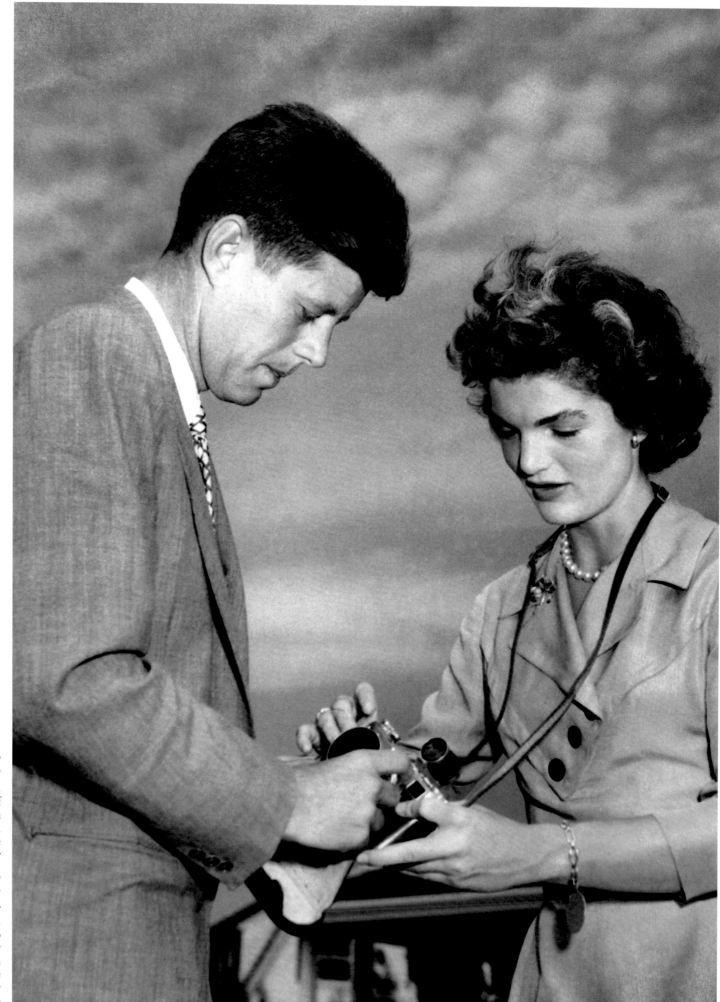

July 20, 1953 /
Hyannis Port, MA /
Senator John F.
Kennedy of
Massachusetts with
his fiancée,
Jacqueline Lee
Bouvier

July 7, 1953 /
Hyannis Port, MA /
Jackie Bouvier
kneeling on floor,
listening to
John F. Kennedy
as he chats with an
unseen sibling at the
Kennedy family
summer house

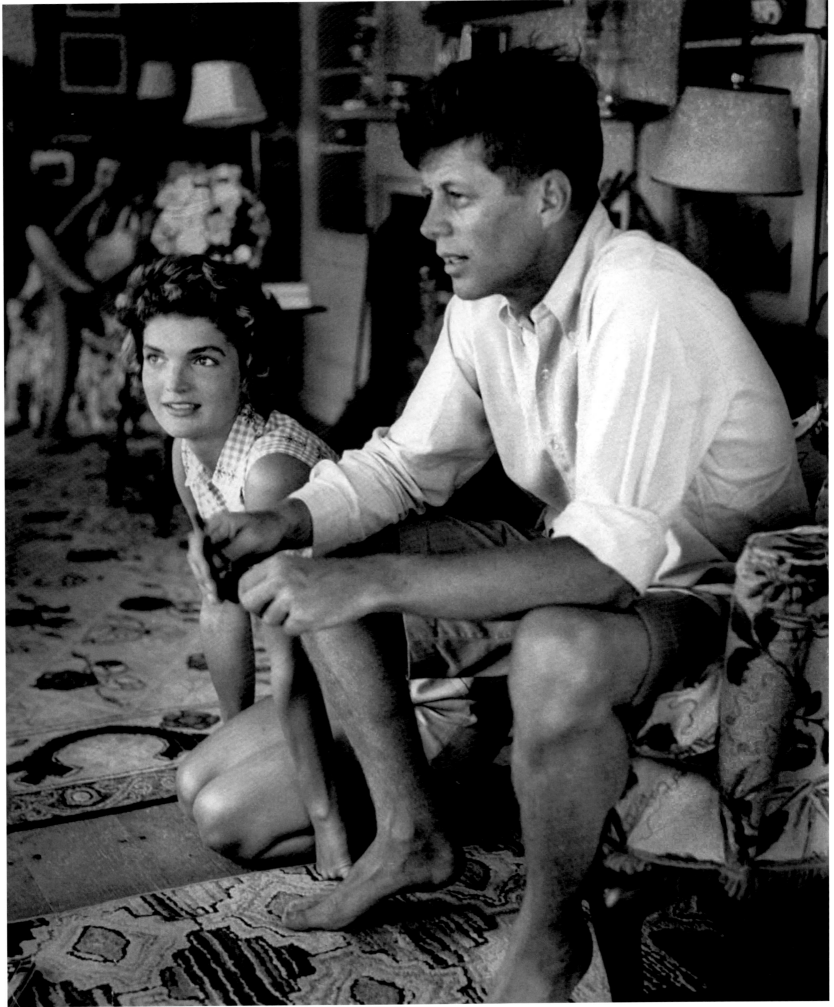

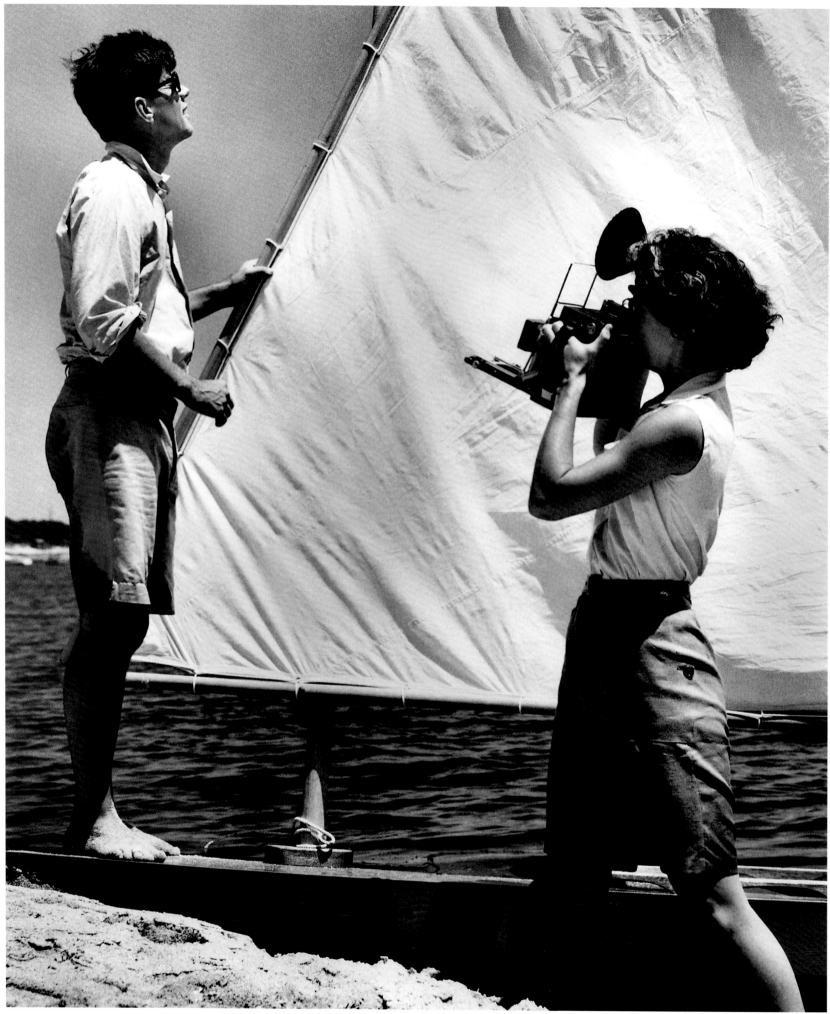

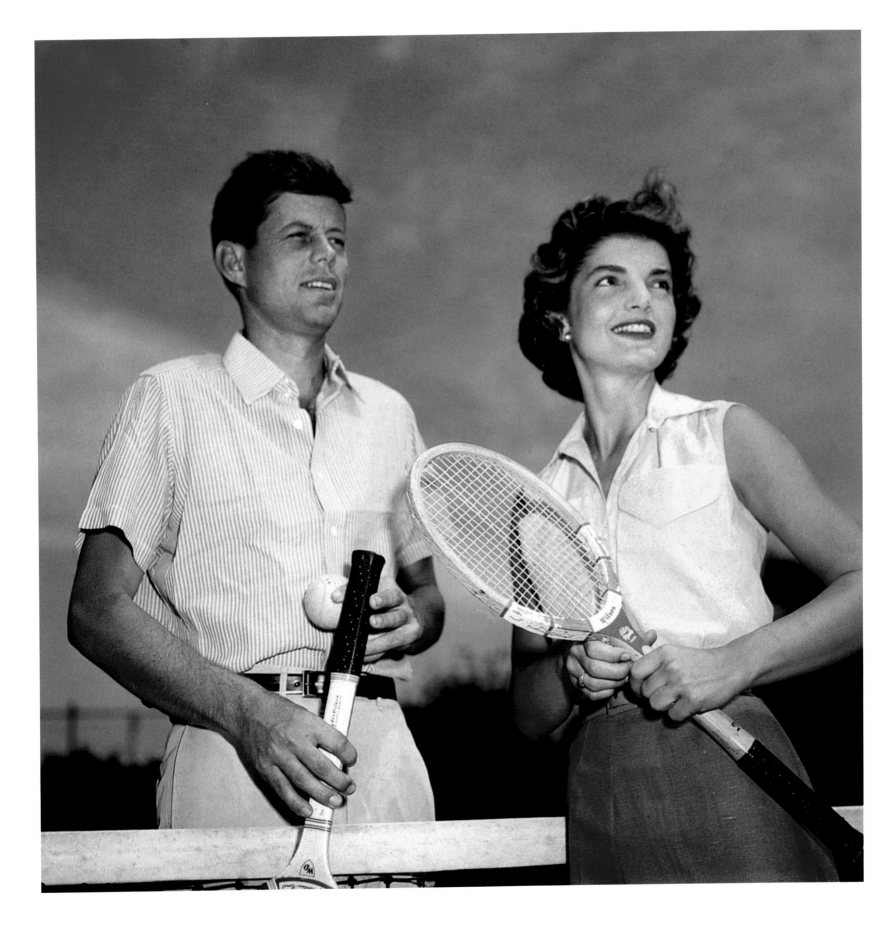

June 28, 1953 / Hyannis Port, MA / Senator John F. Kennedy with his fiancée, Jacqueline Lee Bouvier, relaxing at the Kennedy's summer house

June 27, 1953 / Hyannis Port, MA / Senator John F. Kennedy and his fiancée, Jacqueline Lee Bouvier, at a tennis match

MR. AND MRS. HUGH DUDLEY AUCHINCLOSS

REQUEST THE HONOUR OF YOUR PRESENCE

AT THE MARRIAGE OF MRS. AUCHINCLOSS' DAUGHTER

JACQUELINE LEE BOUVIER

TO

THE HONORABLE JOHN FITZGERALD KENNEDY

UNITED STATES SENATE

ON SATURDAY, THE TWELFTH OF SEPTEMBER

AT ELEVEN O'CLOCK

SAINT MARY'S CHURCH

SPRING STREET

NEWPORT, RHODE ISLAND

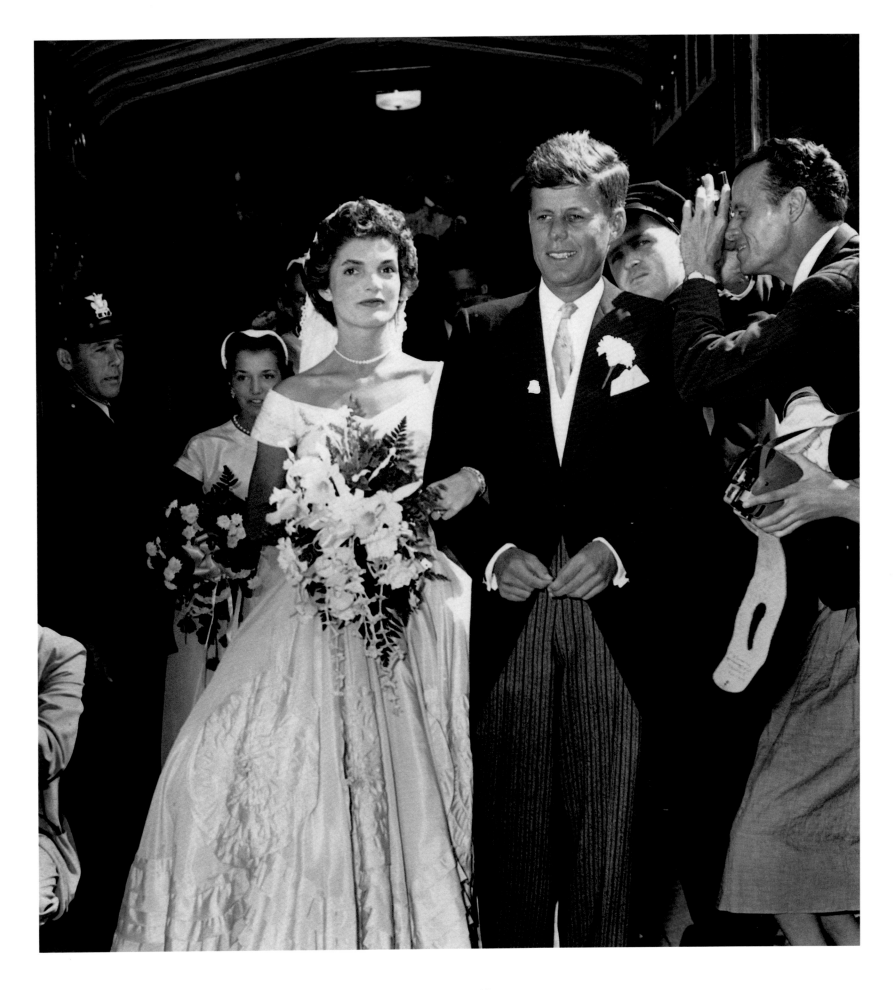

September 12, 1953 / Hammersmith Farm, RI / Announcement of John and Jackie Kennedy's wedding

September 12, 1953 / Hammersmith Farm, RI / John F. Kennedy and his wife, Jacqueline, during their wedding reception, attended by more than 1,200 guests on the estate of the bride's mother and stepfather. Robert Kennedy was the best man.

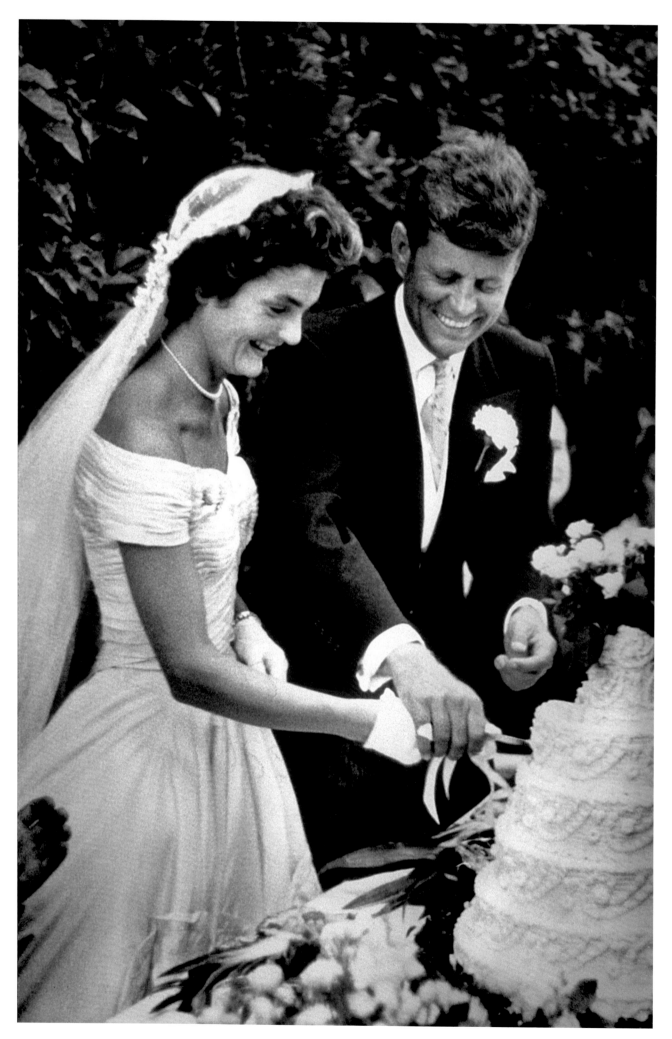

September 12, 1953 /
Hammersmith Farm, RI / Jackie and
John Kennedy cutting their
wedding cake

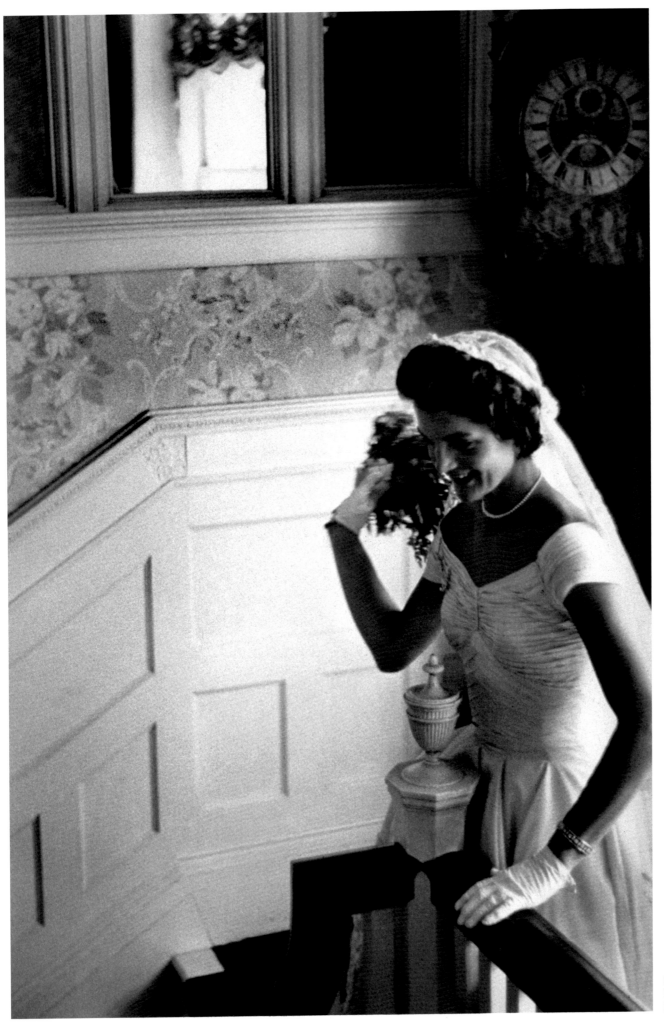

September 12, 1953 /
Hammersmith Farm, RI / Jackie
Kennedy at her wedding reception

45

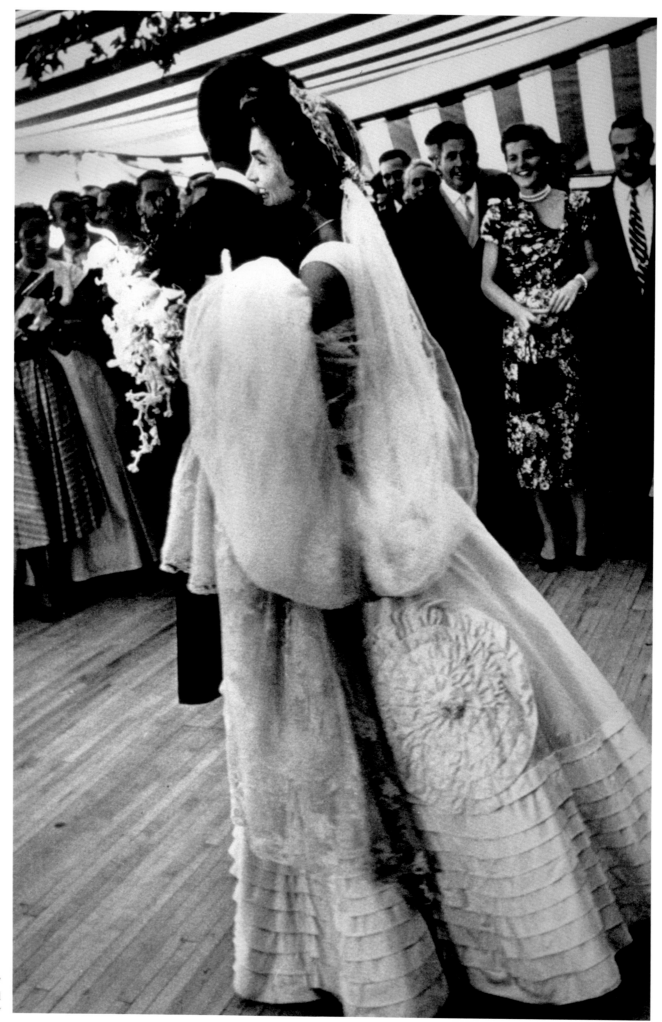

September 12, 1953 /
Hammersmith Farm, RI / Mr. and
Mrs. John F. Kennedy's wedding party

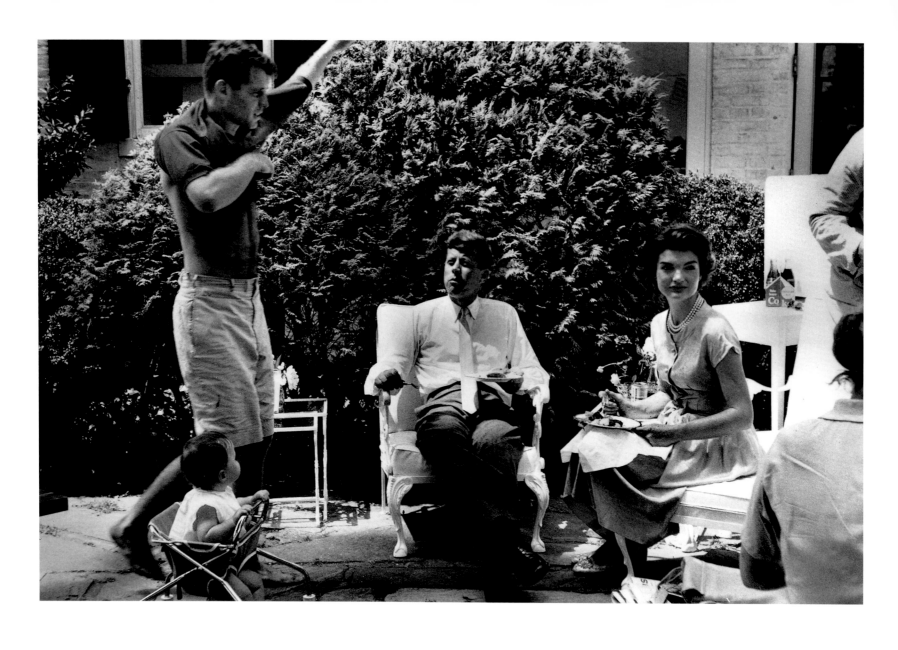

June 3, 1957 / Hickory Hill, CT / Jacqueline Kennedy and her husband relaxing with Robert Kennedy. Following the loss of Jackie's stillborn baby, this white brick Georgian mansion in Virginia was sold to Robert Kennedy because the nursery reminded Jackie of her misfortune.

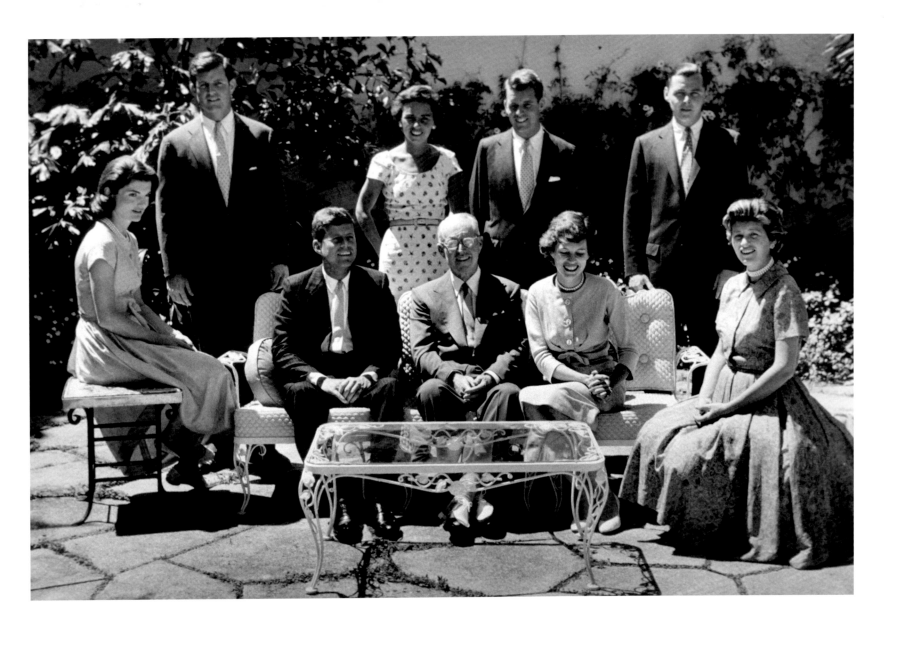

May 17, 1957 / Palm Beach, FL / Family photograph of the Kennedy clan. Standing, from left to right: Edward M. Kennedy, Ethel Skakel Kennedy, Robert F. Kennedy, Steven E. Smith
Seated, from left to right: Jacqueline Bouvier Kennedy, John F. Kennedy, Joseph P. Kennedy, Sr., Eunice Kennedy Shriver, Jean Kennedy Smith

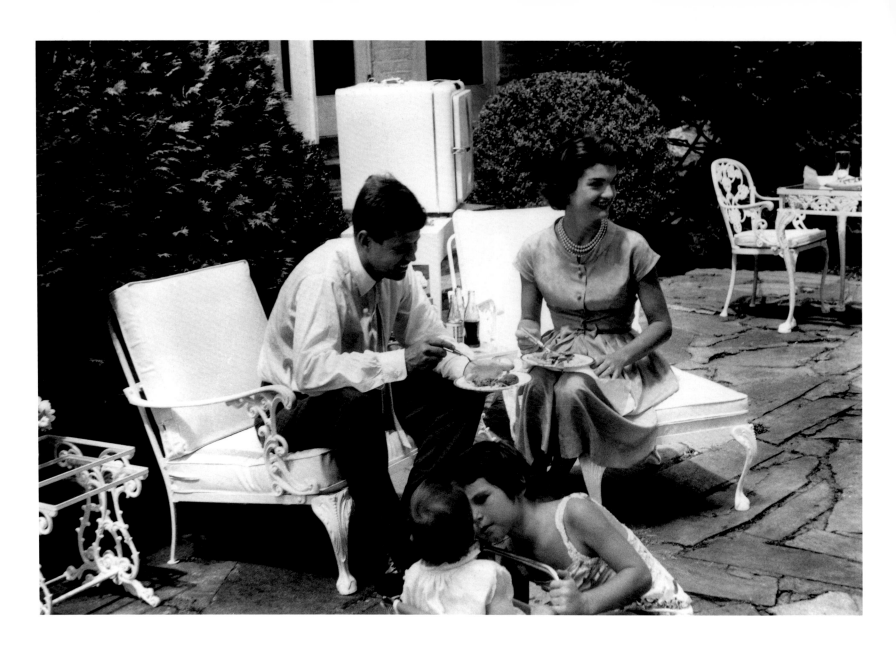

June 3, 1957 / Hickory Hill, CT / Jacqueline Kennedy and her husband relaxing on the weekend

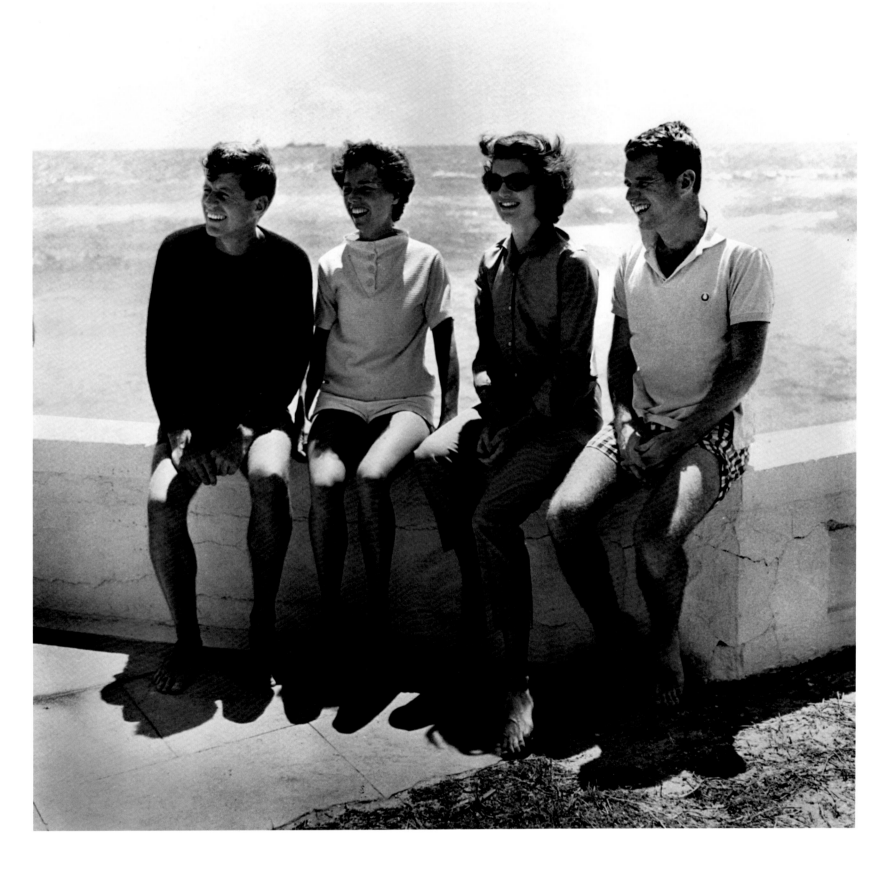

April 23, 1957 / Palm Beach, FL / John, Ethel, Jacqueline, and Robert Kennedy at the beach

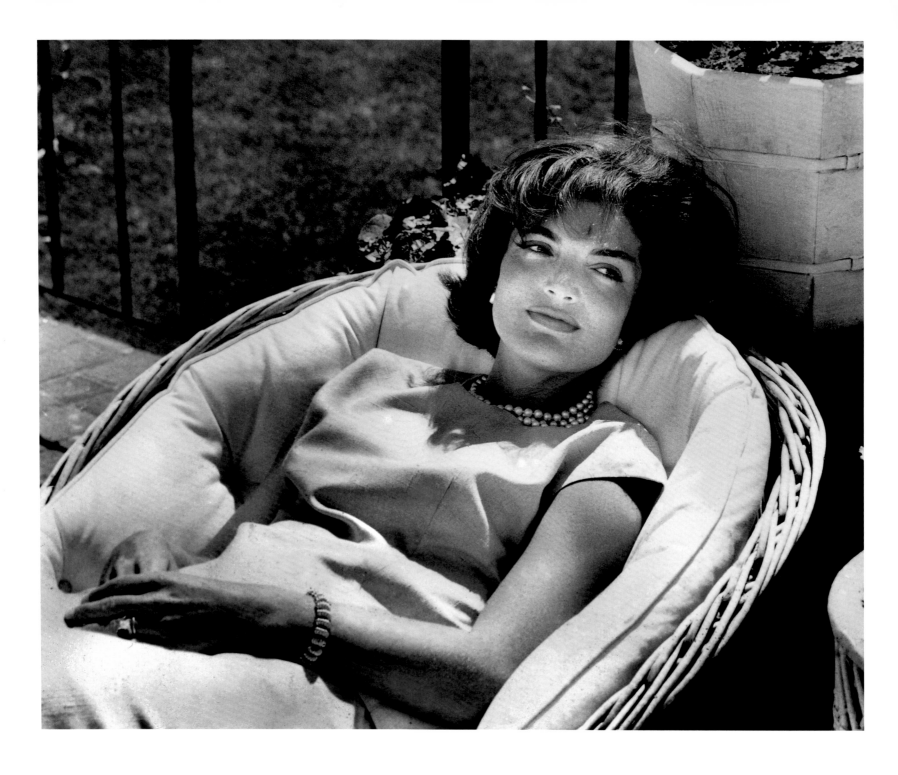

August 21, 1959 / Hyannis Port, MA / Portrait of Jacqueline Kennedy at the age of thirty

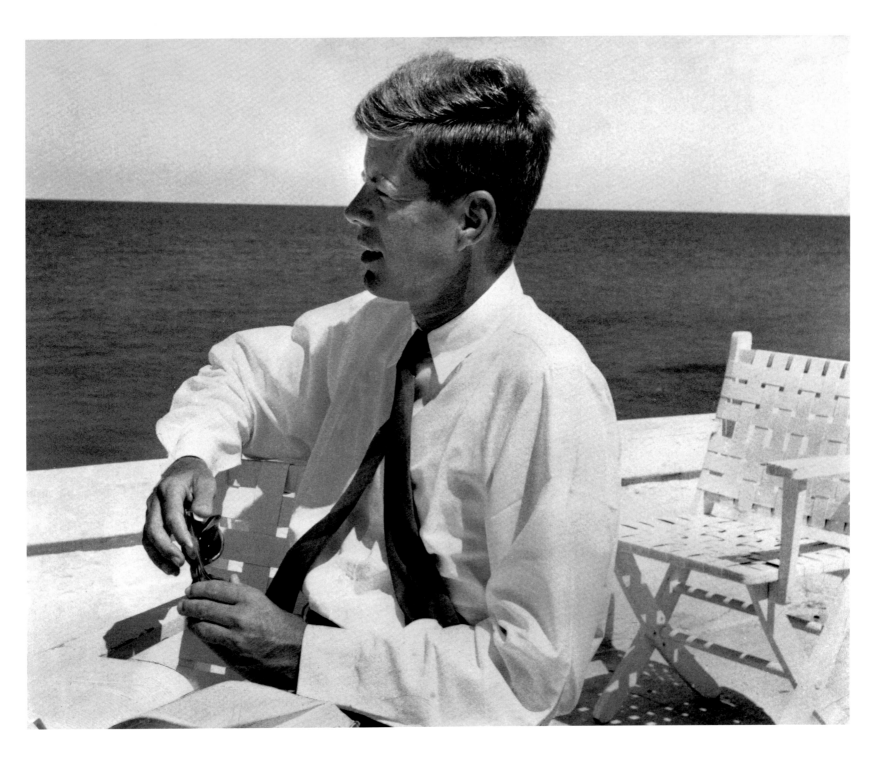

May 22, 1955 / Palm Beach, FL / Senator John F. Kennedy near the conclusion of a period of convalescence following his 1954 back surgery

"I want to live my life, not record it." Jackie

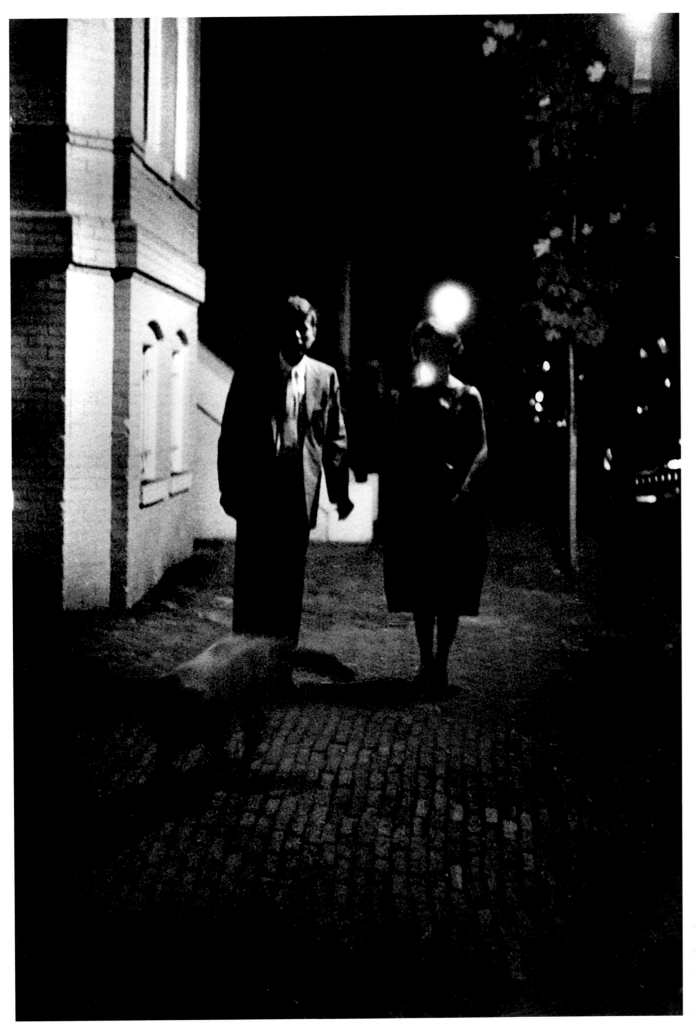

May 17, 1957 / Georgetown, Washington, DC / Senator John F. Kennedy and his wife taking a walk at night. After their wedding in September 1953, the Kennedys had four different Georgetown addresses in eight years.

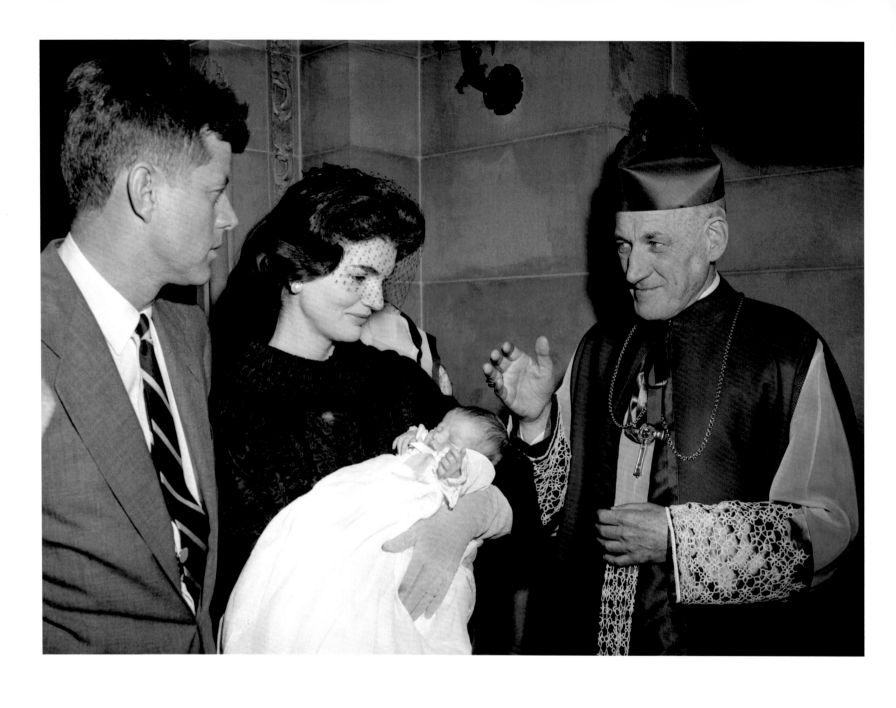

December 13, 1957 / New York, NY / Archbishop Richard Cushing of Boston giving his blessing to Caroline Bouvier Kennedy after the baby was baptized at St. Patrick's Cathedral. The baby was born at New York Hospital on November 27, and was their first child.

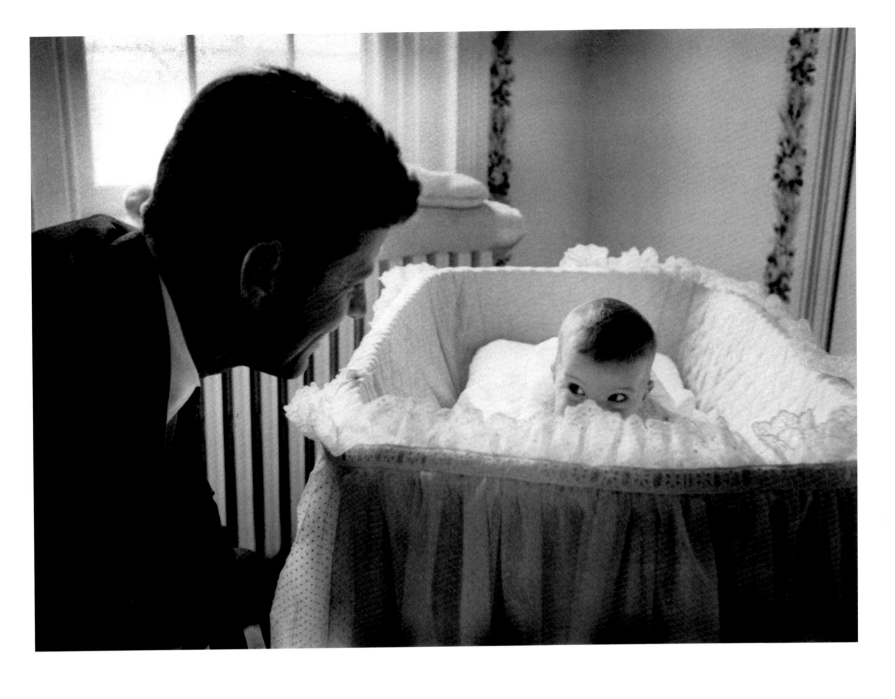

March 25, 1958 / Georgetown, DC / Senator Jack Kennedy admiring his darling baby daughter, Caroline, as she lies in her crib in a nursery at their Georgetown home

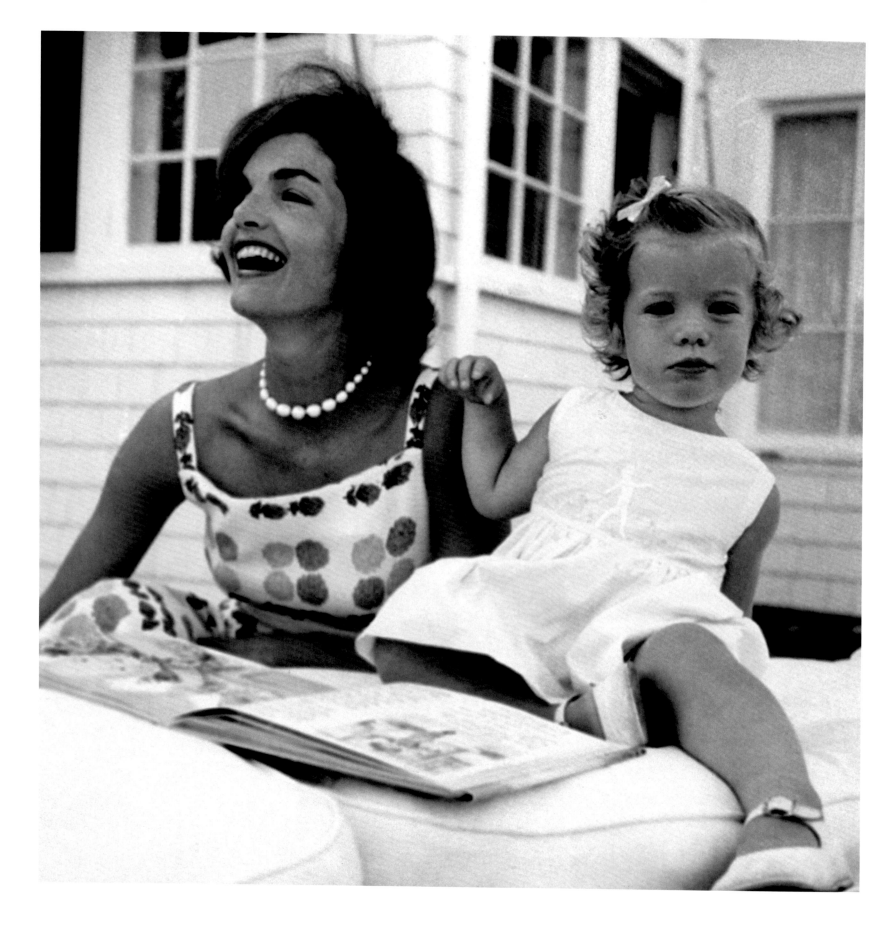

August 21, 1959 / Hyannis Port, MA / Jackie Kennedy and her daughter, Caroline

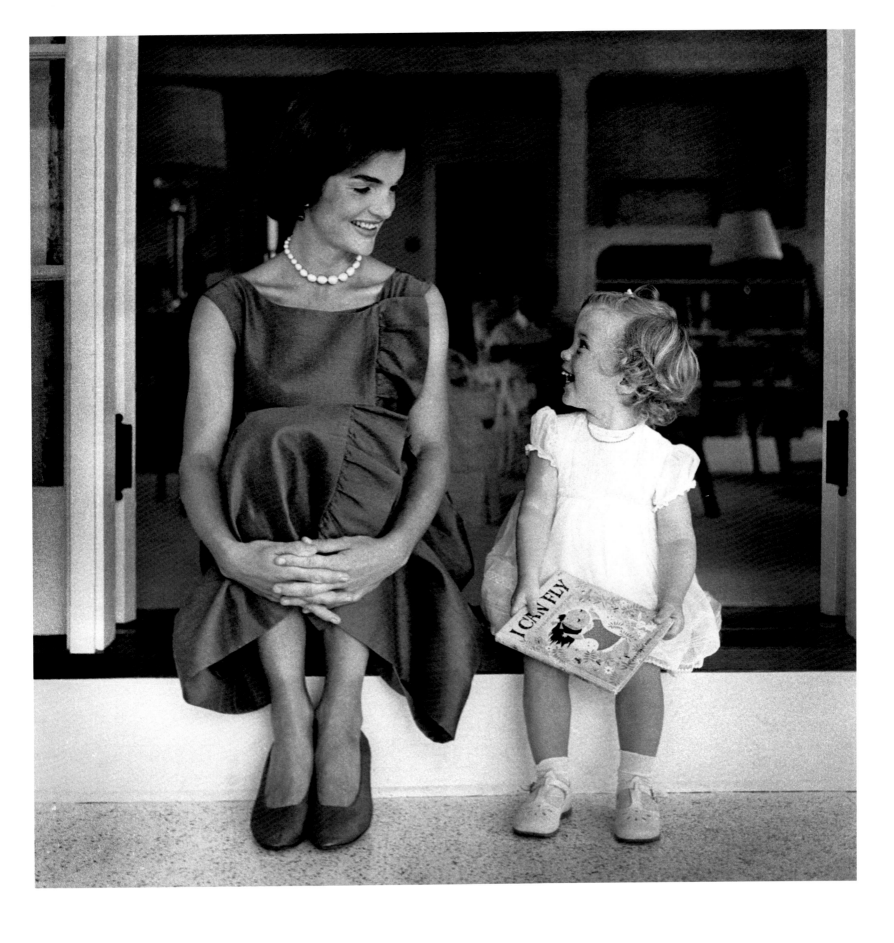

August 26, 1960 / Washington, DC / Sharing a happy moment with Caroline, Jackie appears in a cheerful mood during a visit to Washington. She is expecting her second child in December, one month after Caroline's third birthday.

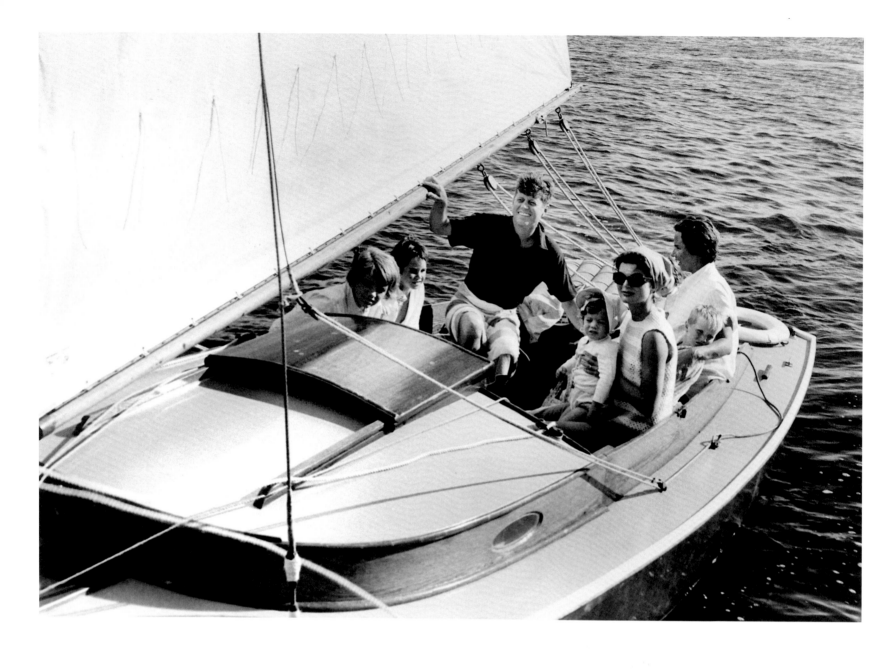

August 21, 1959 / Hyannis Port, MA / Jackie Kennedy and family sailing

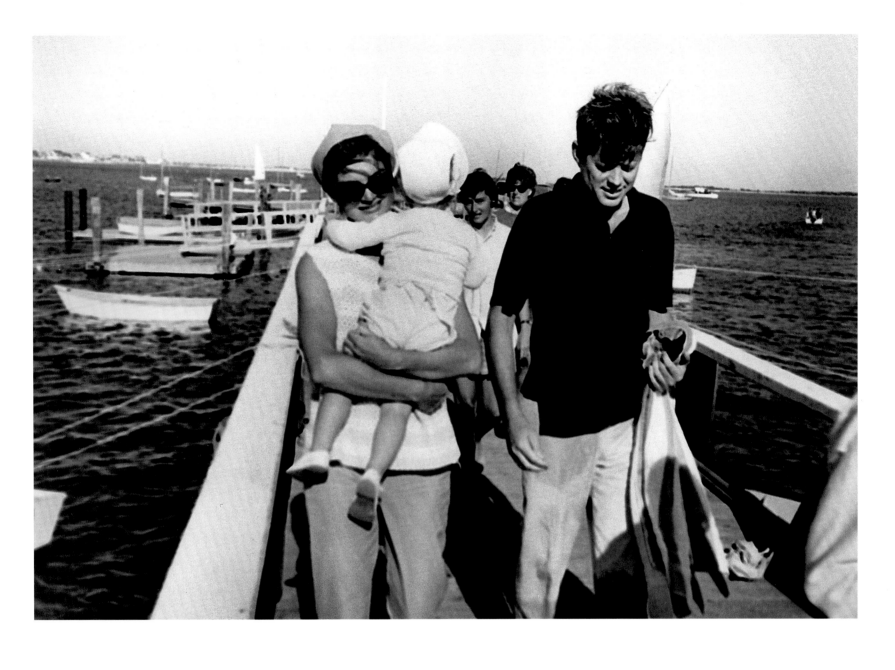

August 21, 1959 / Hyannis Port, MA / Jackie, John, and Caroline Kennedy return from sailing in Hyannis Port

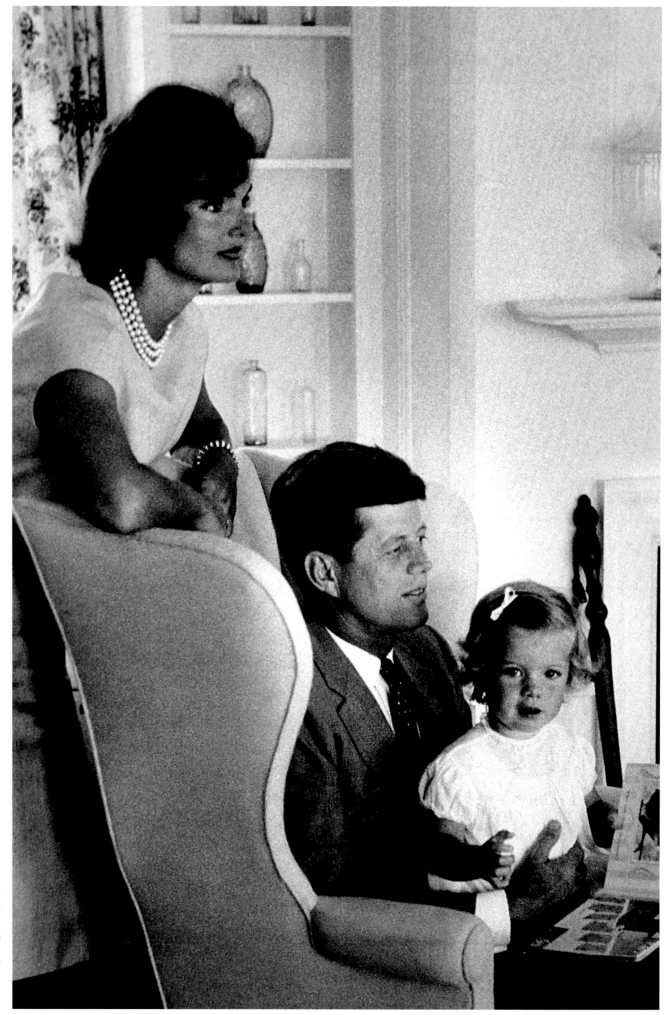

August 21, 1959 /
Hyannis Port, MA /
Jackie Kennedy with her husband
and their daughter

1960 / Hyannis Port, MA /
Series of photographs of Jackie
Kennedy with her daughter as the
family of a presidential candidate

"If you bungle raising your children, I don't think whatever else you do matters very much." Jackie

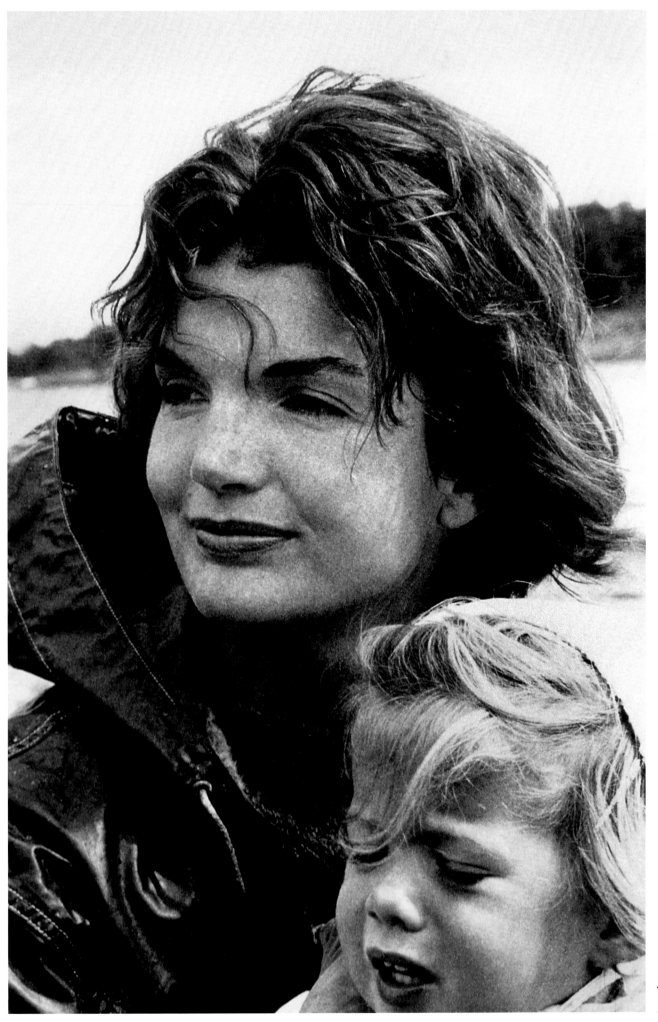

January, 1960 /
Hyannis Port, MA / Jackie
and Caroline Kennedy

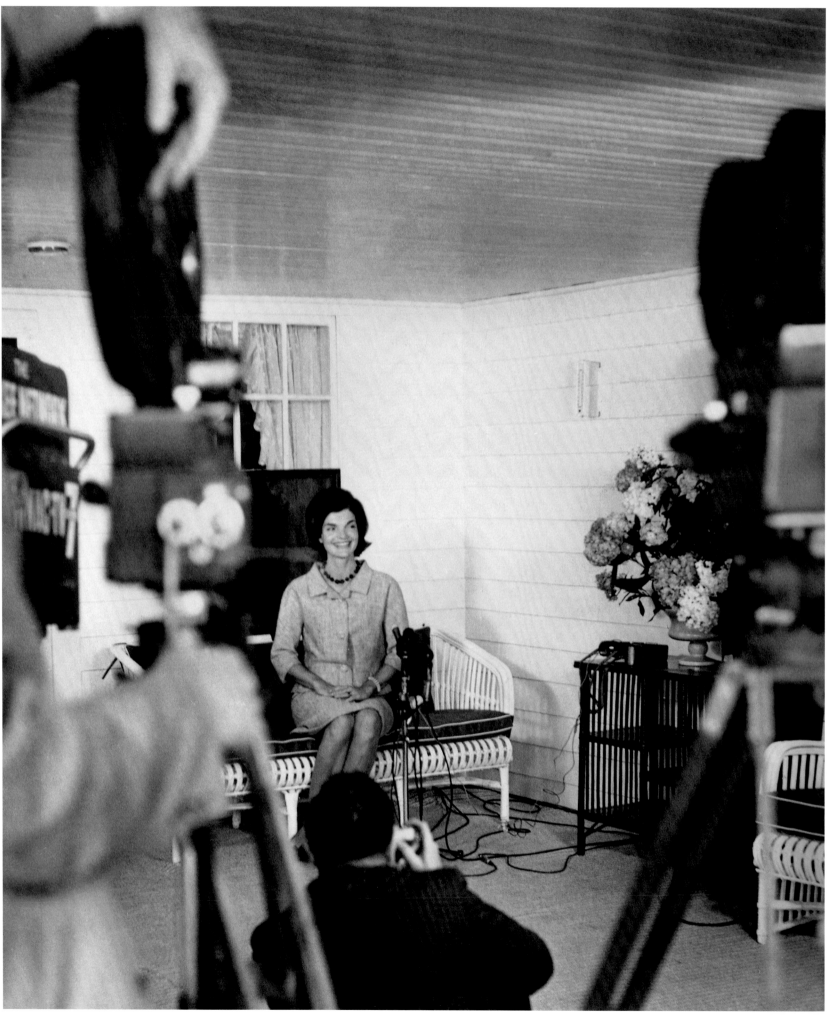

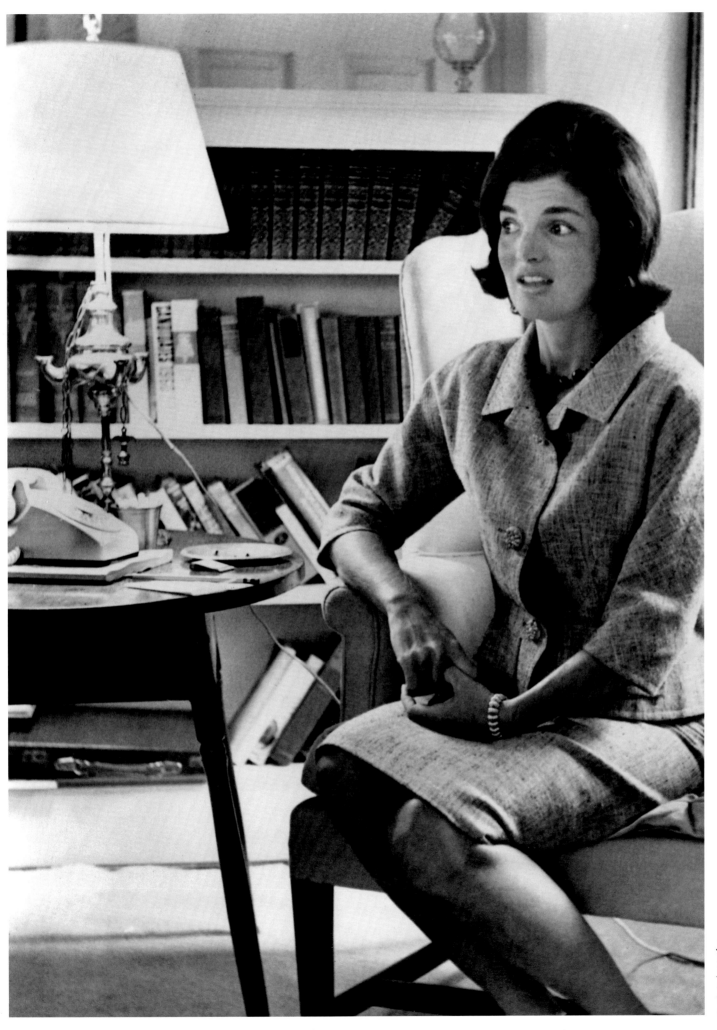

July 14, 1960 /
Hyannis Port, MA /
Jackie Kennedy giving
an interview during
the 1960 presidential
election

67

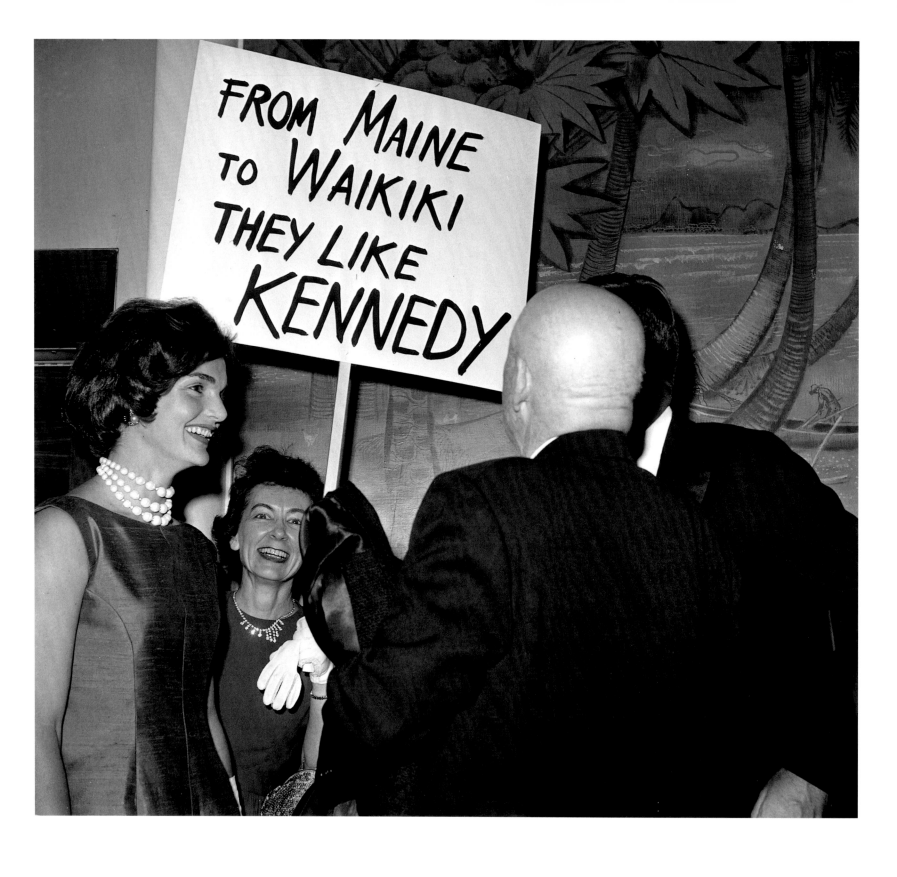

January 7, 1960 / Washington, DC / Jacqueline Kennedy laughing as House Speaker Sam Rayburn reads a Kennedy campaign sign at the Women's National Press Club's "Welcome to Congress" party

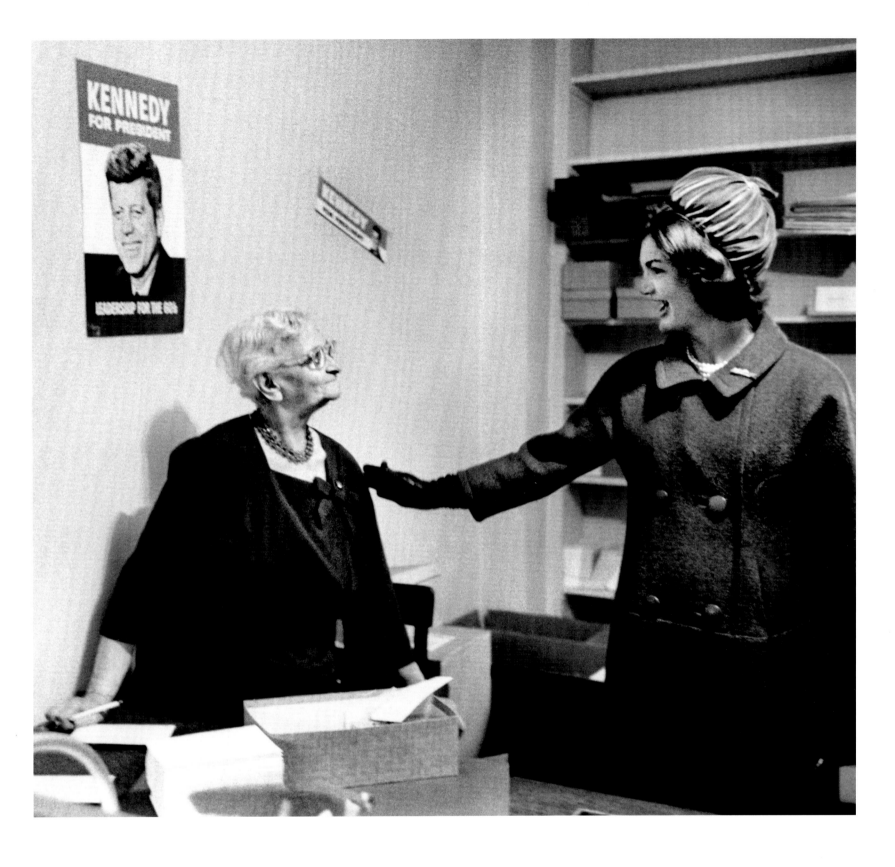

1960 / Washington, DC / Jackie Kennedy greeting a voluntary worker in a campaign office

April 4, 1960 /
Washington, DC / Jackie smiling as
her husband appears on television

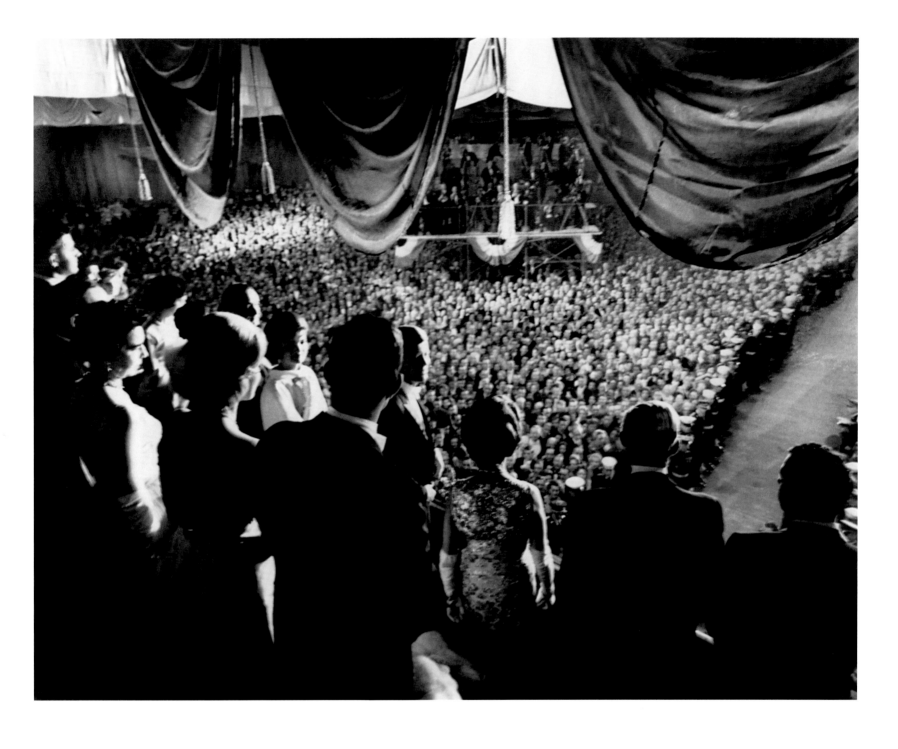

January 20, 1961 / Washington, DC / President Kennedy and the First Lady at the Inaugural Ball at the National Guard Armory. The president and the First Lady are visible at the front of the balcony.

"I feel as I have just turned into a piece of public property. It's really frightening to lose your anonymity at thirty-one." Jackie

America's First Lady

JAQUELINE KENNEDY

February 13, 1962 / Washington, DC / Jackie and her children in a sleigh pulled by Caroline's pony, Macaroni, on the White House South Lawn

"The one thing
I do not want to be called
is First Lady.
It sounds like a saddle
horse." Jackie

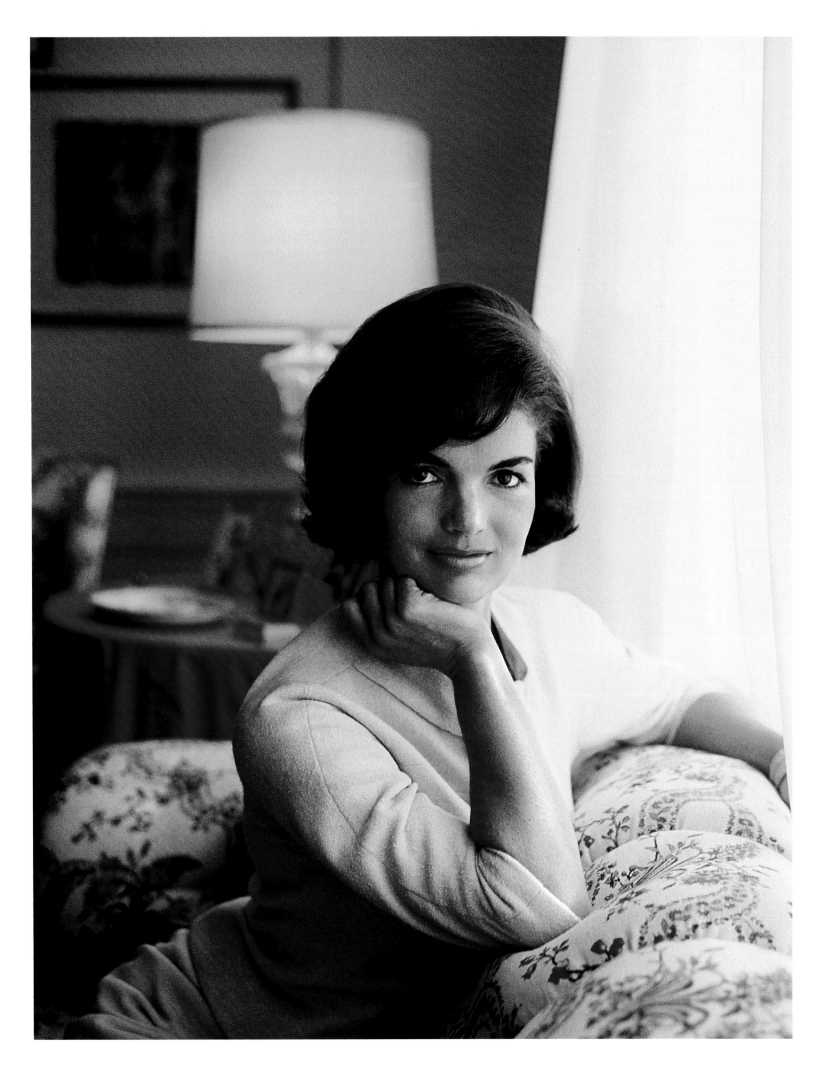

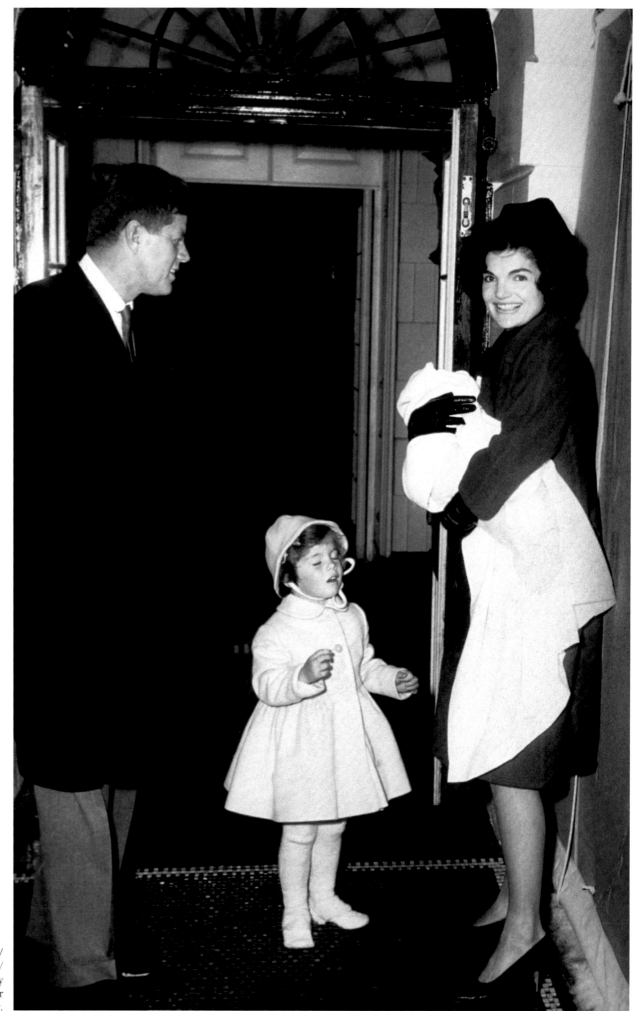

February 4, 1961 /
Washington, DC /
Jackie and John F. Kennedy
with their daughter, Caroline, and their
newborn son, John Jr.

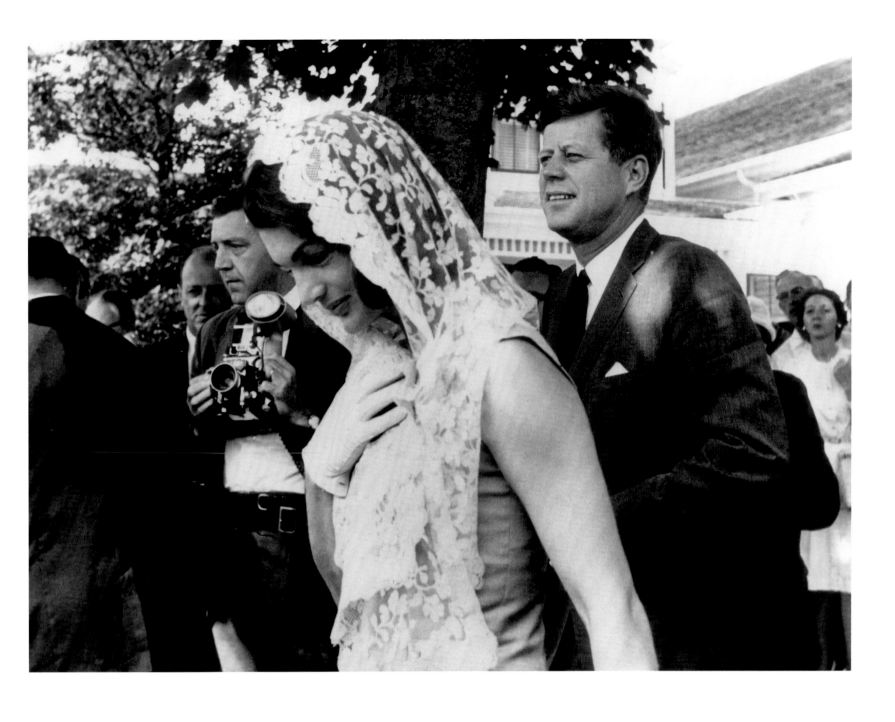

August 15, 1961 / Hyannis Port, MA / President Kennedy and the First Lady entering the St. Francis Xavier churchyard prior to attending Mass

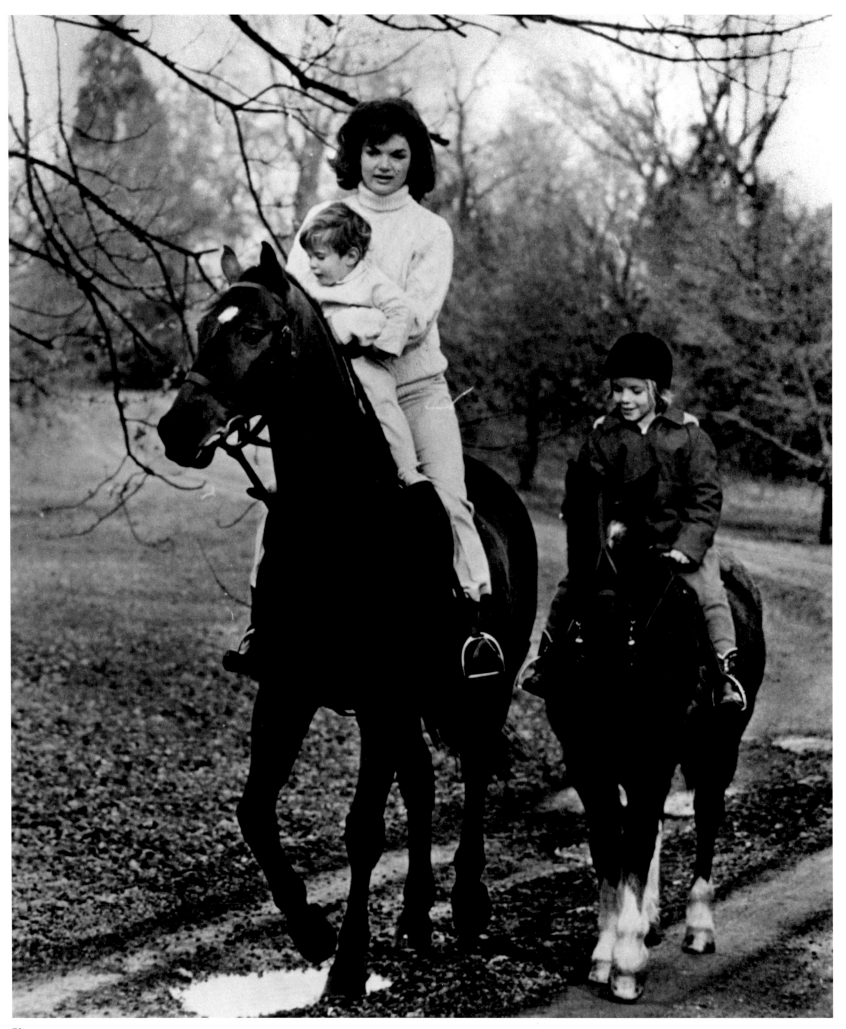

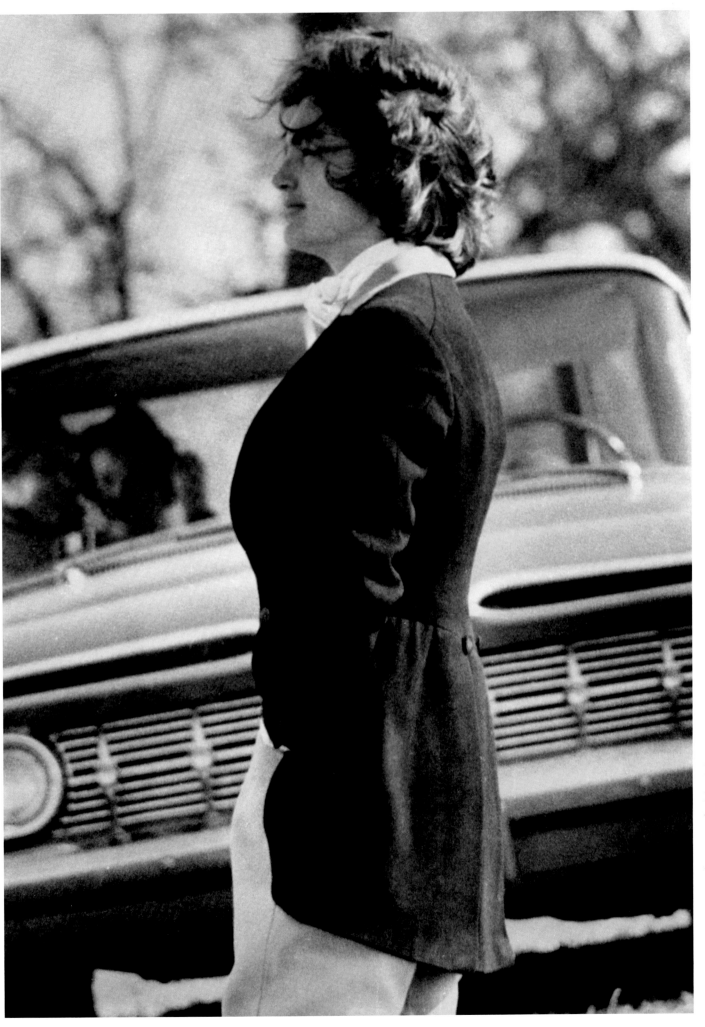

November 19, 1962 /
Glen Ora Farm,
Middleburg, VA /
Jackie riding with her
children. This portrait was
released by the White
House for the birthdays of
John and Caroline in
November 1962.

March 26, 1961 /
Upperville, VA /
Jackie Kennedy at
the Piedmont Fox Hounds
races, while her husband
is in Key West, Florida,
conferring with British
Prime Minister Harold
MacMillan

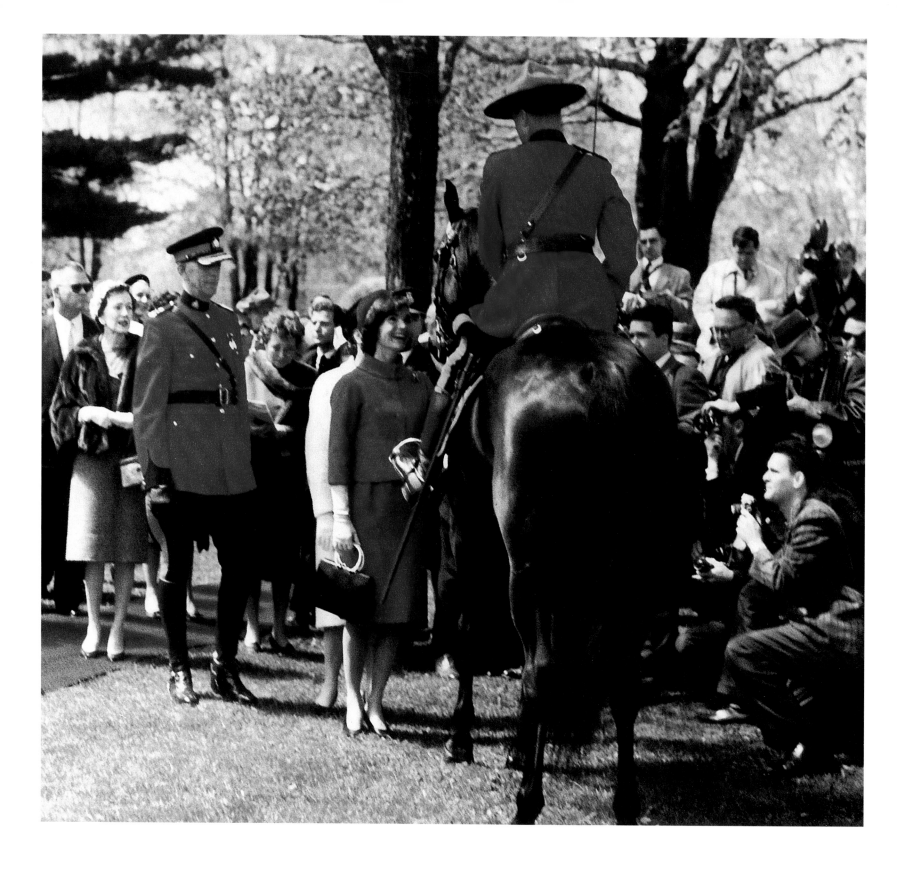

May 19, 1961 / Rockcliffe, Ontario, Canada / Jacqueline Kennedy on her first official foreign trip, with Commissioner Harvison during an equestrian performance given in her honor by the Royal Canadian Mounted Police. Everybody noticed her red suit, specially designed by Jackie's wardrobe designer, Oleg Cassini, which mirrored the uniforms of the Mounted Police.

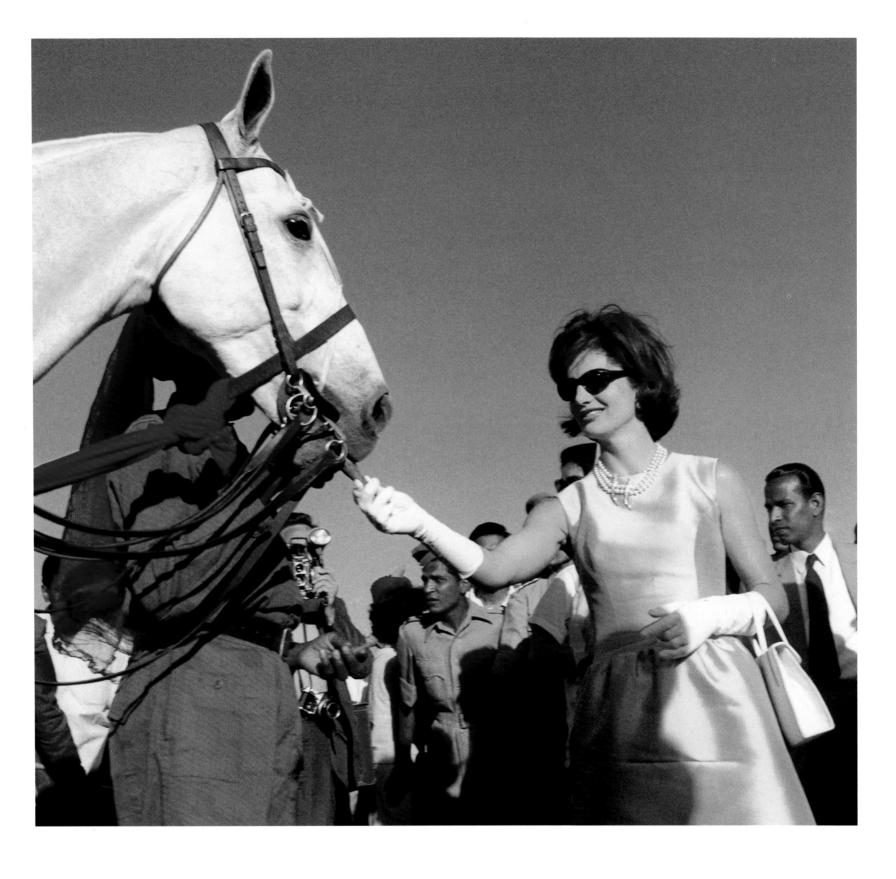

March 12, 1962 / New Delhi, India / Jackie Kennedy during a trip taken to India and Pakistan with her sister, Lee Radziwill

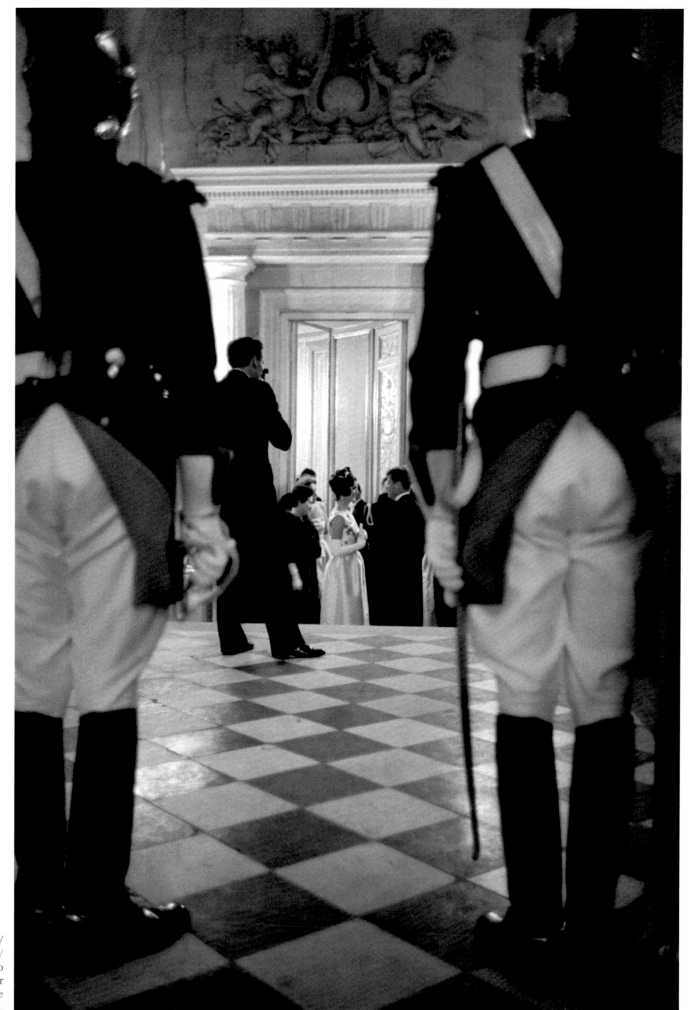

June 1, 1961 /
Versailles, France /
The Kennedys' state visit to
France culminated with a dinner
at Versailles, overseen by the
Garde Républicaine.

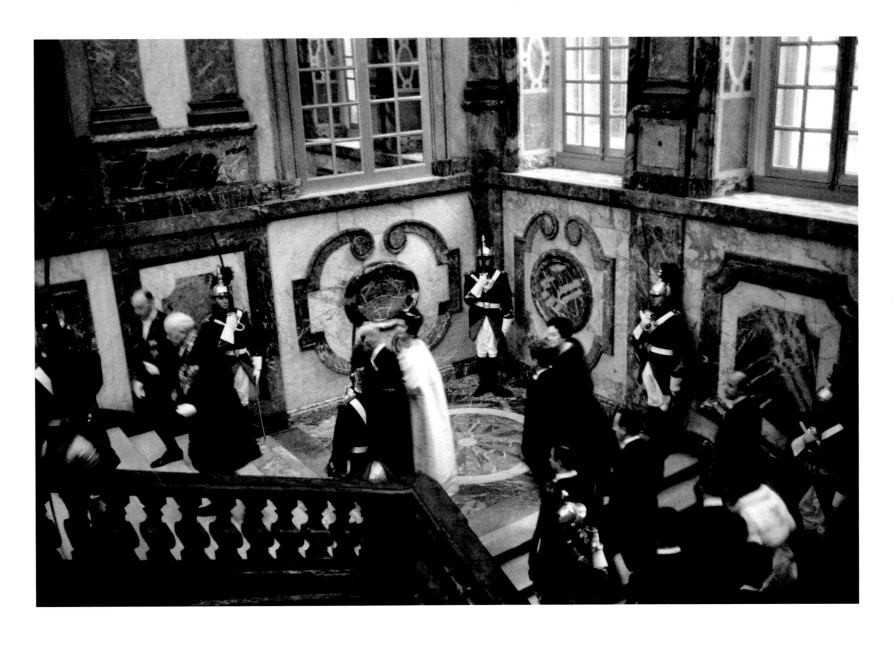

June 1, 1961 / Versailles, France / The arrival of Jacqueline Kennedy at the Château de Versailles accompanied by General de Gaulle, president of France. When he assumed the presidency of the Fifth Republic, General de Gaulle felt that the Elysée Palace was unsuited to the role. His advisers suggested alternatives: the Invalides Hotel, the Louvre, the Château de Vincennes, and even Versailles, which de Gaulle himself judged "somewhat exaggerated." He nevertheless launched the tradition of glamorous parties at Versailles featuring a dinner in the Hall of Mirrors and a performance at the Opera. Versailles thus honored Nikita Khrushchev in 1960, John F. Kennedy in 1961, and King Hassan II of Morocco in 1963.

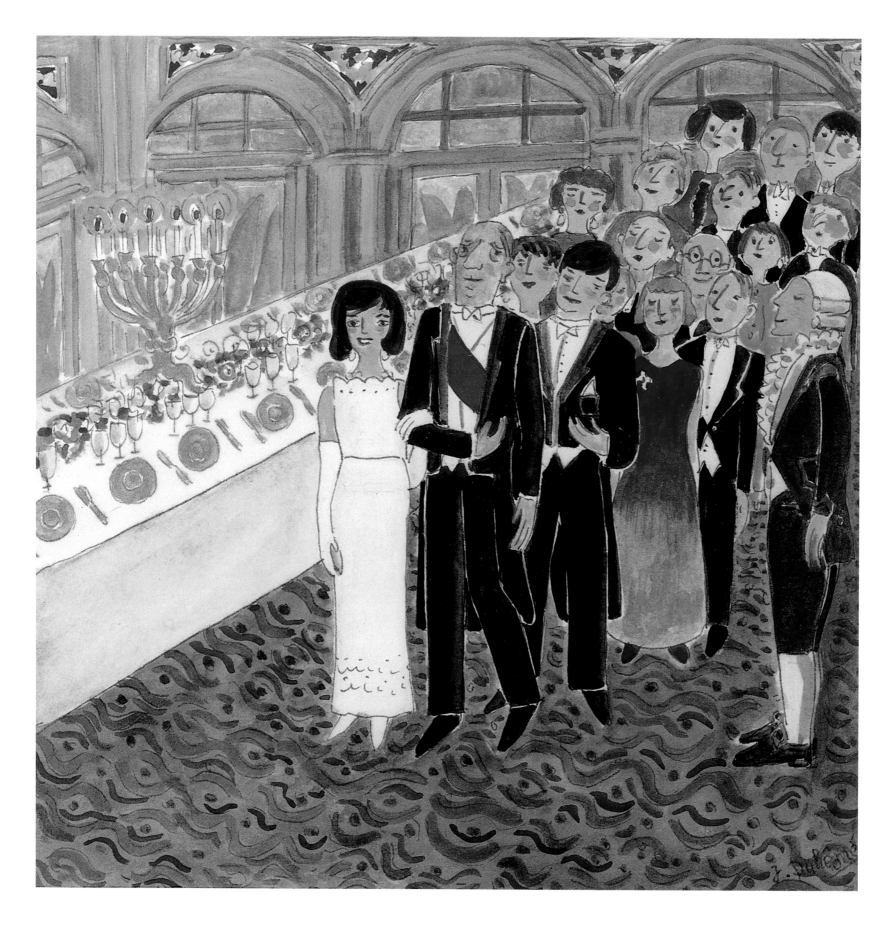

June 1961 / Paris, France / A painting of Jacqueline and John F. Kennedy with President de Gaulle having dinner at the Elysée Palace, by Jacqueline Duhême. A student of the French master Matisse, Duhême was originally commissioned by *ELLE* magazine to illustrate President and Mrs. Kennedy's state visit to Paris. Later, Mrs. Kennedy invited Duhême to accompany her on her tour of India and Pakistan via Rome. The paintings include Mrs. Kennedy's audience with Pope John XXIII, her luncheon with Queen Elizabeth II, her visit with the Indian prime minister Jawaharlal Nehru, and her moonlight visit to the Taj Mahal.

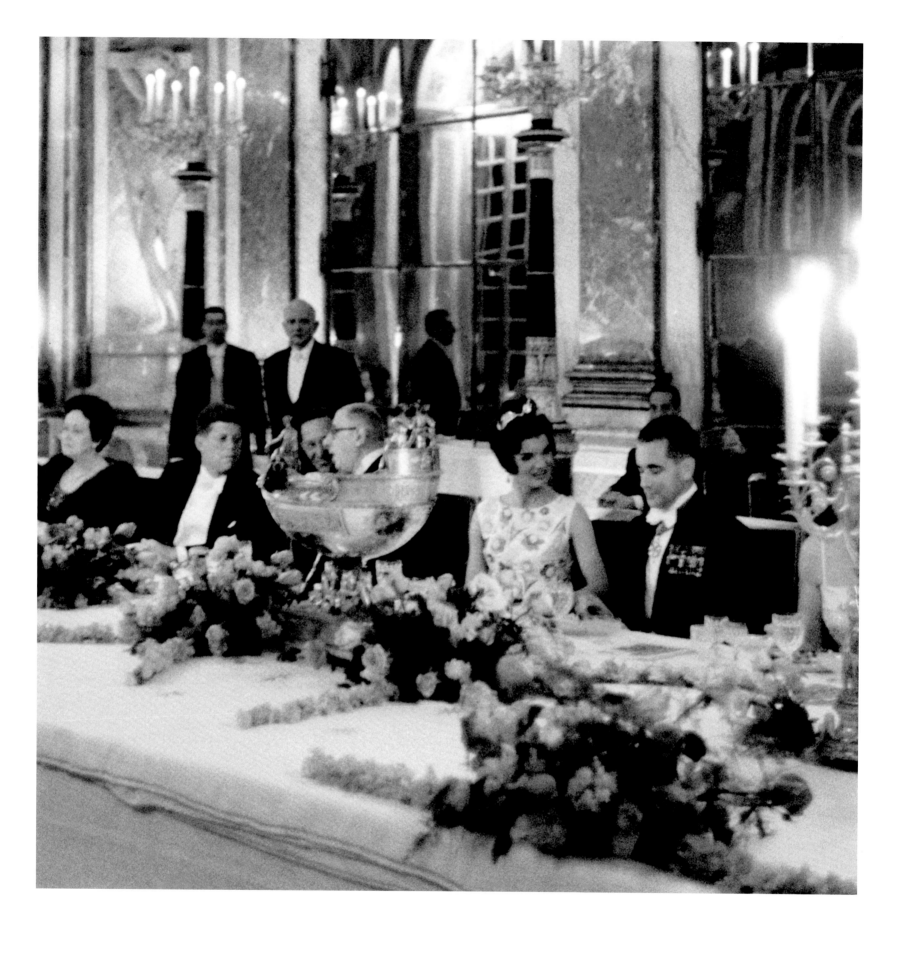

June 1, 1961 / Versailles, France / From left to right: Yvonne de Gaulle, President Kennedy, President de Gaulle, Jacqueline Kennedy, and Jacques Chaban-Delmas, the president of the National Assembly

June 8, 1961 / Athens, Greece / Jackie at the Odeion of Herodes Atticus on the Acropolis during a performance of Euripides' *Iphigenia in Aulis*. Herodes was born in Marathon and is best known for having restored many ruined cities in Greece, and building the theater in Athens, the stadium in Delphi, and the baths in Thermopylae.

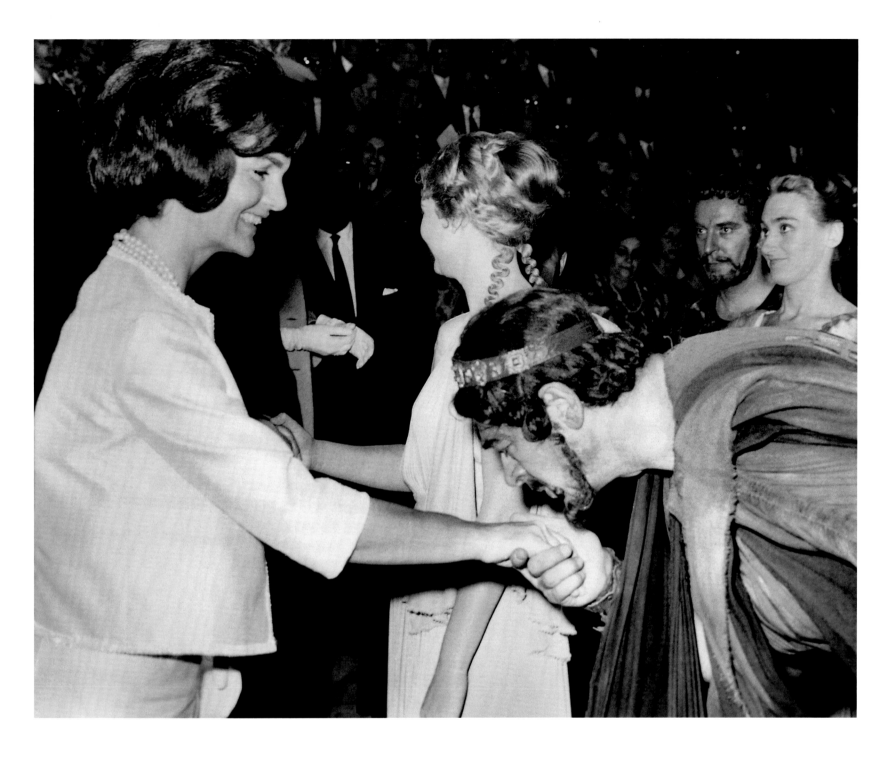

June 8, 1961 / Athens, Greece / Jackie Kennedy and Mr. Thanos Kotsopoulos, leading actor of *Iphigenia in Aulis*, after the performance

ISAAC STERN

211 CENTRAL PARK WEST, APT 19-F
NEW YORK 24, N.Y.

July 16, 1961

Mrs. John F. Kennedy
The White House
Washington, D. C.

Dear Mrs. Kennedy,

Before leaving on tour again, I wanted to thank you for your gracious thoughtfulness to me at The White House last week.

After leaving and realizing how long I had spoken almost uninterruptedly, I feared I might have outworn my welcome. But it would be difficult to tell you how refreshing, how heartening it is to find such serious attention and respect for the arts in The White House. To many of us it is one of the most exciting developments on the present American cultural scene.

I hope that I can be of help to you from time to time and that whatever suggestions I may make for personal action on your part will abuse neither your confidence nor willingness to help.

Looking forward to meeting you again before too long, I am

Cordially yours,

Isaac Stern

July 16, 1961 / Washington, DC / A letter from the legendary violinist Isaac Stern to Jackie Kennedy following his invitation to the White House

November 13, 1961 / White House, Washington, DC / Pablo Casals plays for a state dinner honoring Governor Luis Muñoz Marín of Puerto Rico. Broadcast nationally by NBC and ABC radio, a recording was distributed commercially. This performance, which included Mendelssohn's Piano Trio No.1 in D Minor, was perhaps the most celebrated concert given at the White House during the Kennedy years.

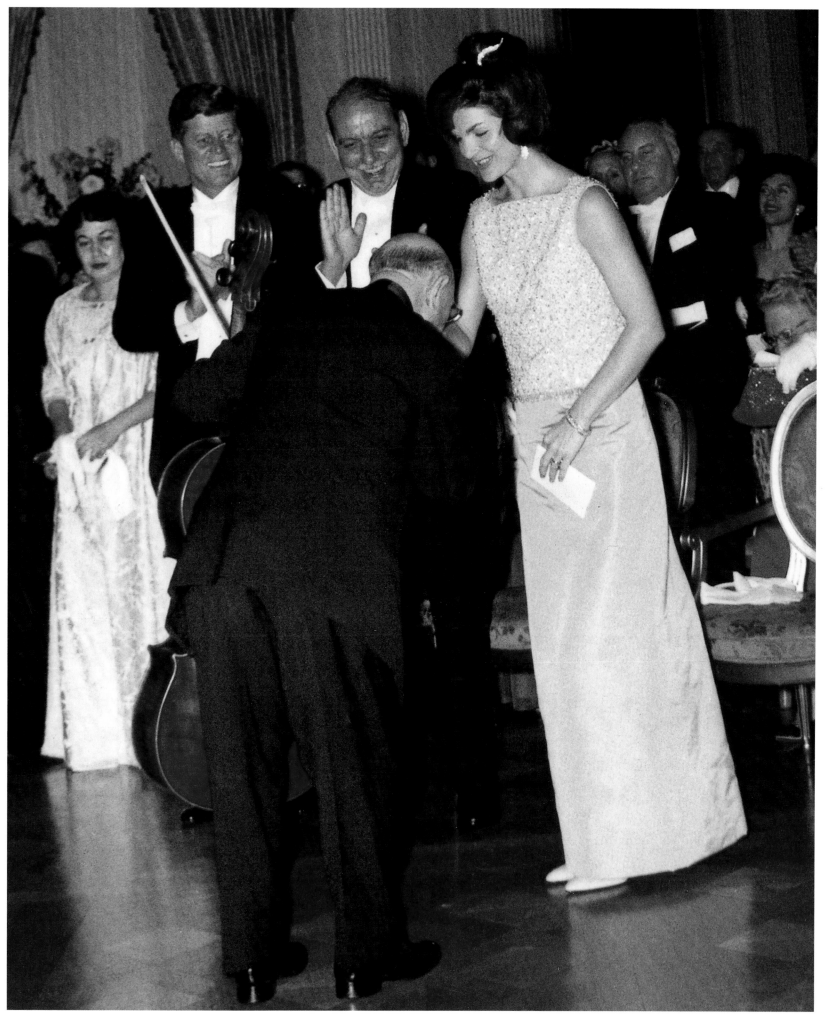

1. Memo to JFK

 Abou Simbel Temple

Agnelli's request Gianni Agnelli is interested because a FIAT
engineer has invented a way to cut entire temple out
& float it on new lake. ~~Italy has~~ It will cost
30 million. Italy has ~~offered~~ offered 3 million
which is more than her share in Unesco – FIAT
however offered to subcontract it all to Westinghouse –
thinking money could be raised that way – but
they were not interested.

US cannot pay I said US could not possibly pay the difference.
It would be a miracle if they could even pay 3 million –
as there was an 8 billion tax cut planned this year
and unsympathetic chairmen of Rules & Appropriations
Committees – so just to give up hope of getting the
money from us.

Presidents support desired: Agnelli said in that case – if the President would
just indicate his interest in saving the temples –
– it would be the greatest help and they could
then approach Foundations + other members of Unesco.

Importance of Abou Simbel – It is the major temple of
the Nile – 13th century B.C. It would be like letting
the Pantheon be flooded. On it is the oldest Greek
inscription in the world – which is sort of a Rosetta stone.

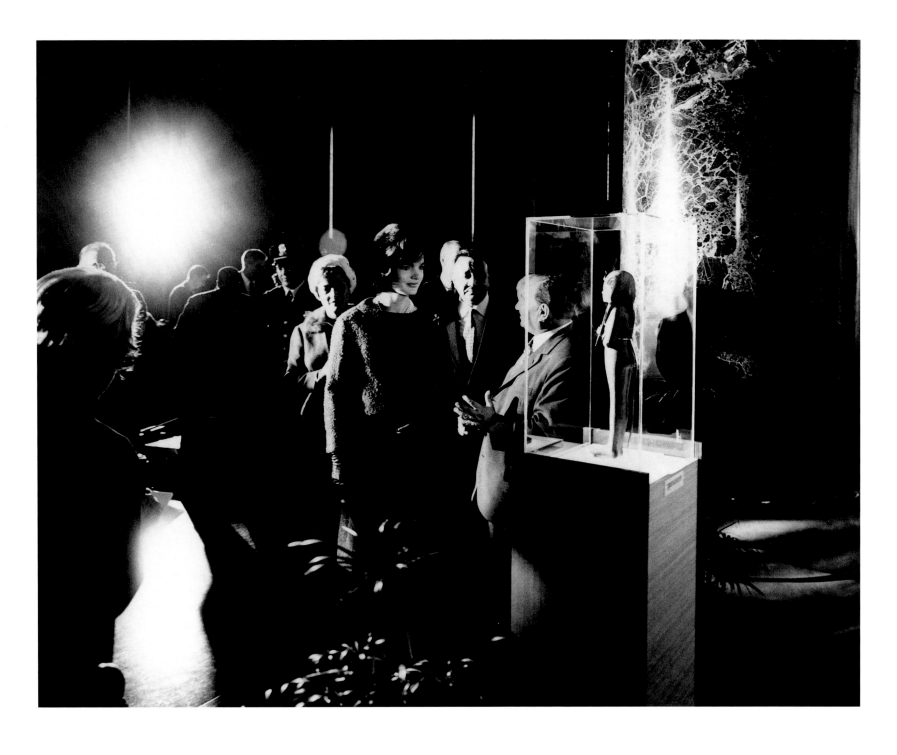

April 7, 1961 / Memo to JFK / Abou Simbel Temple

Agnelli's request: Gianni Agnelli is interested because a FIAT engineer has invented a way to cut entire temple out and float it on new lake. It will cost 30 million. Italy has offered 3 million which is more than her share in UNESCO. FIAT however offered to subcontract it all to Westinghouse—thinking money could be raised that way—but they were not interested.

U.S. cannot pay: I said U.S. could not possibly pay the difference. It would be a miracle if they could even pay 3 million—as there was an 8 billion tax cut planned this year and unsympathetic chairmen at Rules & Appropriations Committees—so just to give up hope of getting the money from us.

President's support desired: Agnelli said in that case—if the President would just indicate his interest in saving the temples—it would be the greatest help and they could then approach Foundations and other members of UNESCO.

Importance of Abou Simbel: It is the major temple at the Nile—13th century B.C. It would be like letting the Parthenon be flooded. On it is the oldest Greek inscription in the world—which is sort of a Rosetta stone.

November 3, 1961 / Washington, DC / Jackie Kennedy at the opening of an exhibit of objects from the tomb of Tutankamen, at the National Gallery of Art, Washington

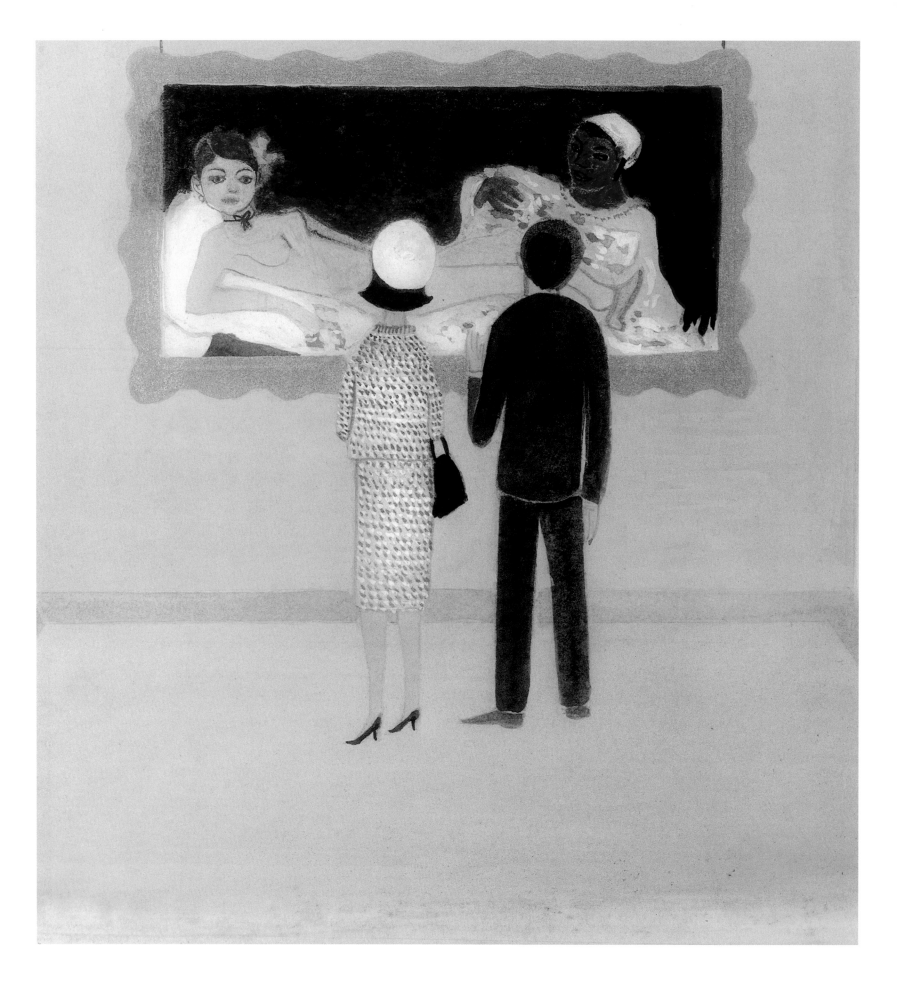

1960 / Painting by Jacqueline Duhême of Mrs. Kennedy and André Malraux looking at the Manet painting. "Olympia"

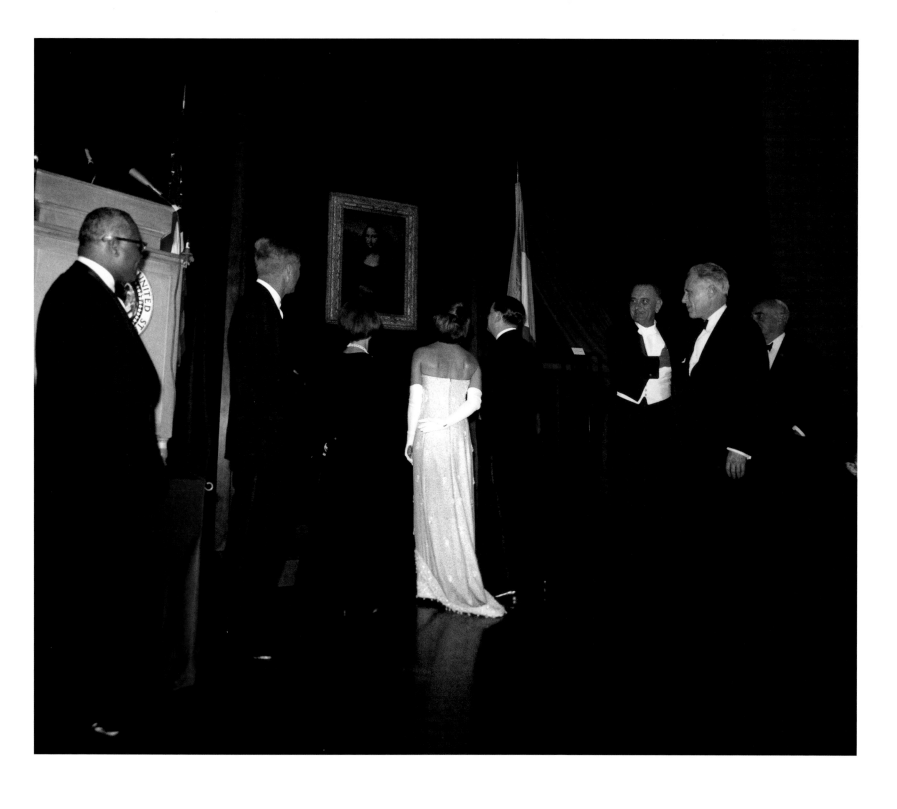

January 8, 1963 / Washington, DC / President Kennedy, Mrs. Malraux, French Minister of Cultural Affairs André Malraux, Jackie Kennedy, and Vice President Lyndon Johnson at the unveiling of the "Mona Lisa" at the National Gallery of Art in Washington. André Malraux and Jackie were close friends, and worked together to make possible the presentation in New York of the famous painting, which left the Louvre for the first time since its acquisition by the museum.

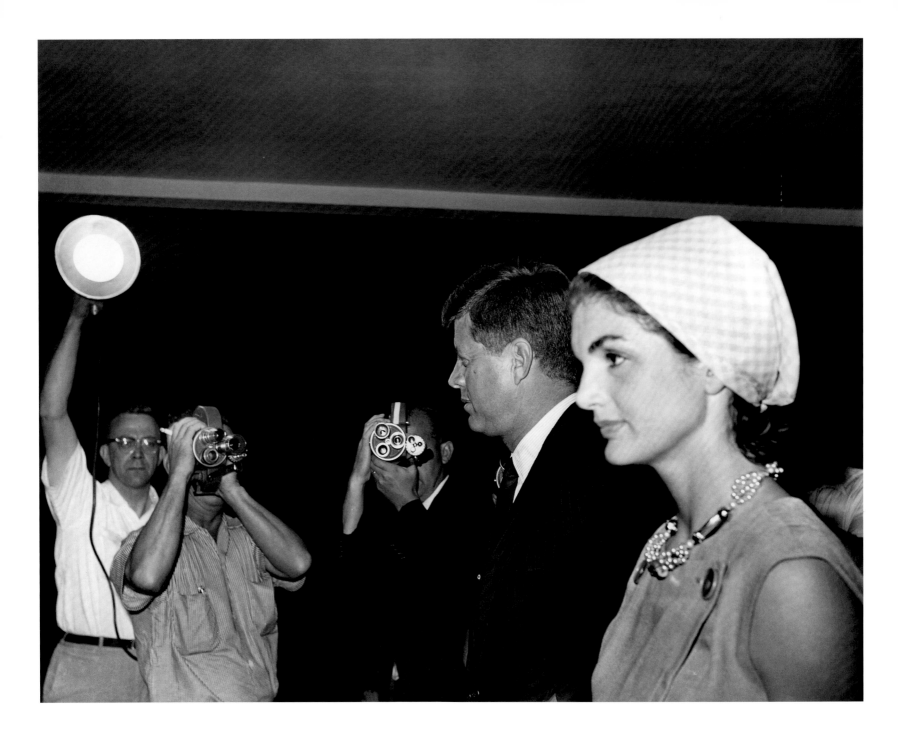

December 21, 1961 / Palm Beach, FL / President Kennedy and the First Lady pictured together on a late afternoon visit made to St. Mary's Hospital to see the president's father, Joseph P. Kennedy

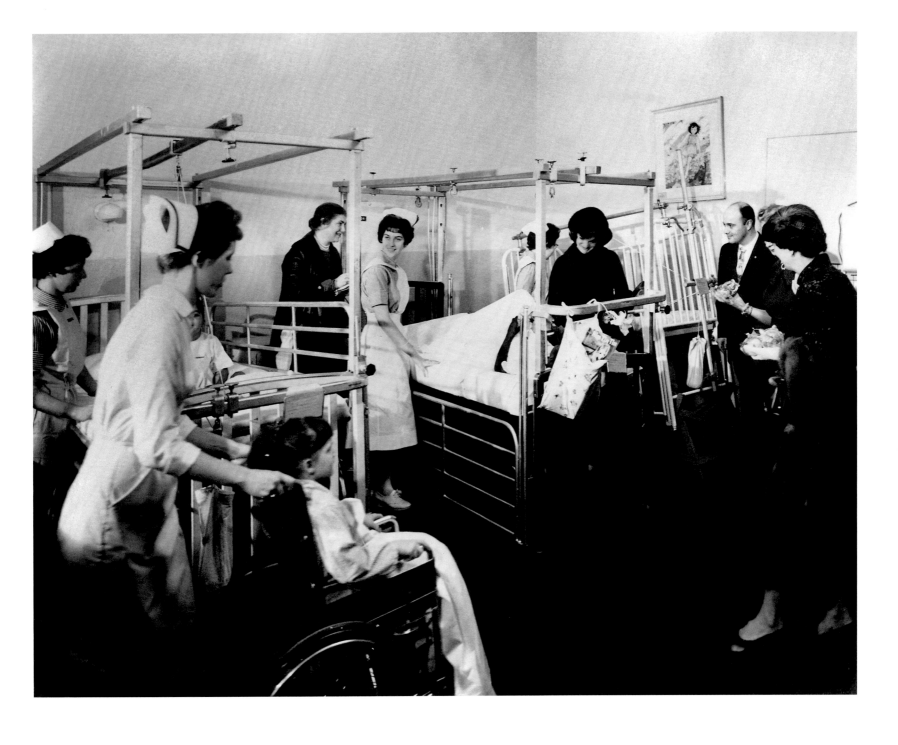

December 12, 1961 / Washington, DC / Jackie Kennedy at the Washington, DC Children's Hospital

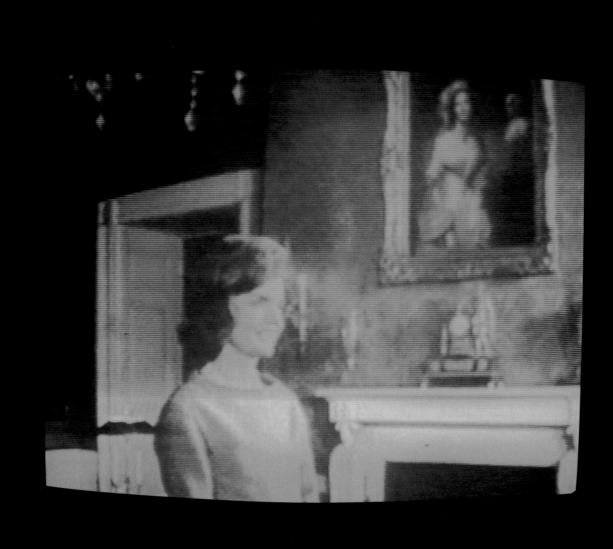

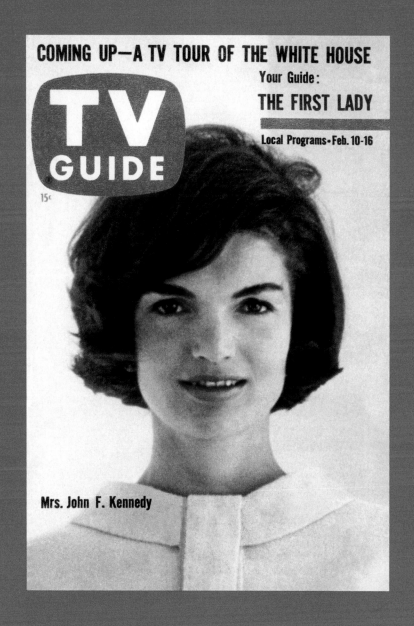

February 1962 / Jackie on the cover of *TV Guide*. On January 13, 1962, fifty-four members of a CBS television crew set up in the White House to produce and record a unique event: Jacqueline Bouvier Kennedy would conduct a personal tour of the presidential mansion for the benefit of nearly 80 million Americans who would be tuned in. The show was a great success and Mrs. Kennedy received over 10,000 letters from schoolchildren and other citizens about the program.

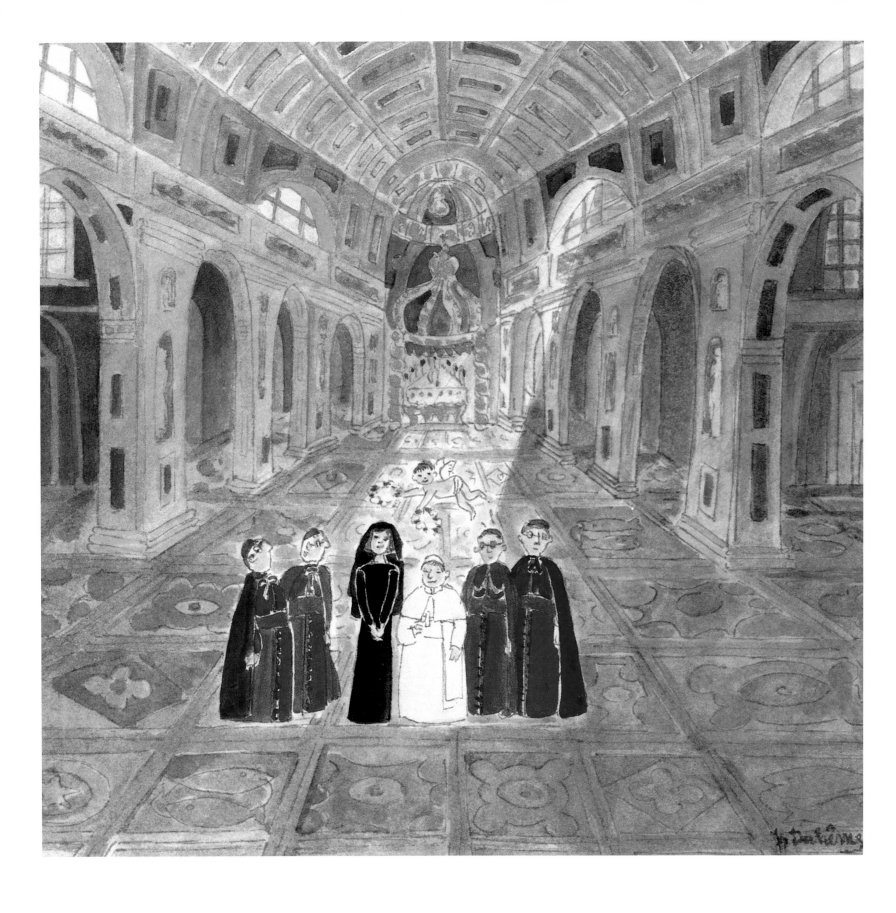

March 11, 1962 / Vatican City, Rome, Italy / Painting by Jacqueline Duhême of Jackie Kennedy at the Vatican with a shaft of light coming down upon Jackie and Pope John XXIII

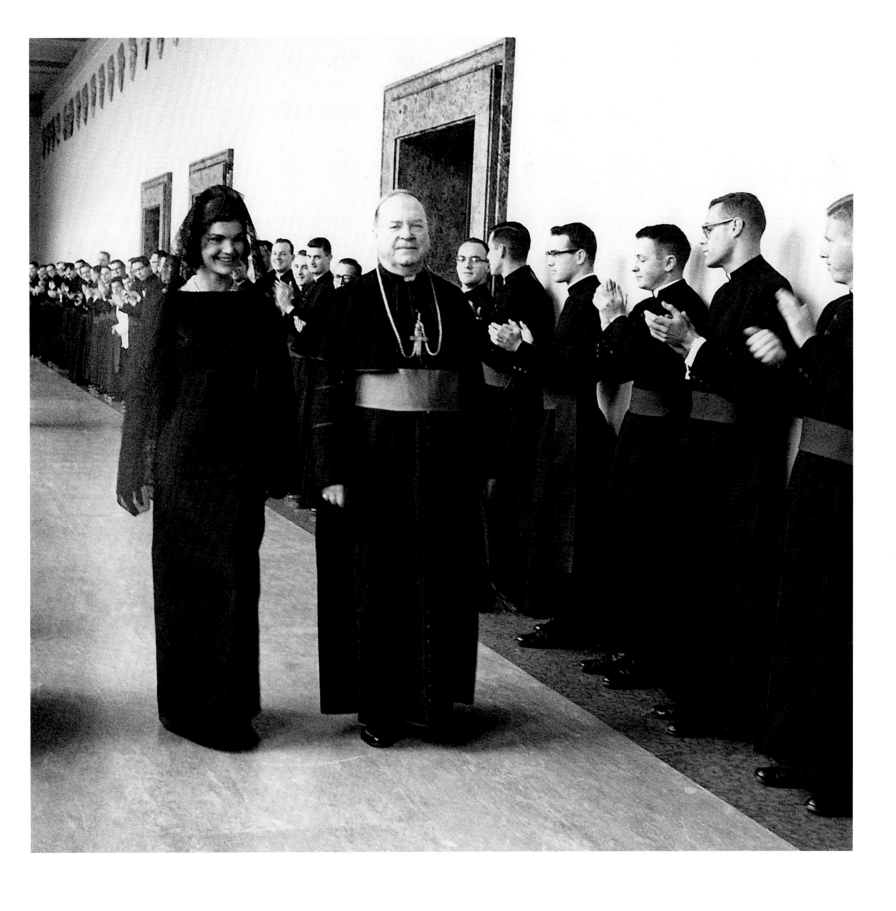

March 11, 1962 / Vatican City, Rome, Italy / Jackie Kennedy arriving in the papal apartment for an audience with Pope John XXIII. Escorting her is Msgr. Pius A. Benincasa of Buffalo. When the First Lady arrived to see him, he began nervously rehearsing the two methods of address he had been advised to use when she entered: "Mrs. Kennedy, Madame," or "Madame, Mrs. Kennedy." When the moment came to greet her, however, to the amusement of the press corps he abandoned both and rushed to her saying, "Jackie!"

March 12, 1962 / Palam Airport, New Delhi, India / The arrival of Jackie Kennedy in India. In 1962 Jacqueline Bouvier Kennedy accepted an invitation by Prime Minister Nehru to visit India. The coat and hat she wore for her arrival in New Delhi is an ensemble made famous when the American ambassador to India, John Kenneth Galbraith, described its color as "radioactive pink."

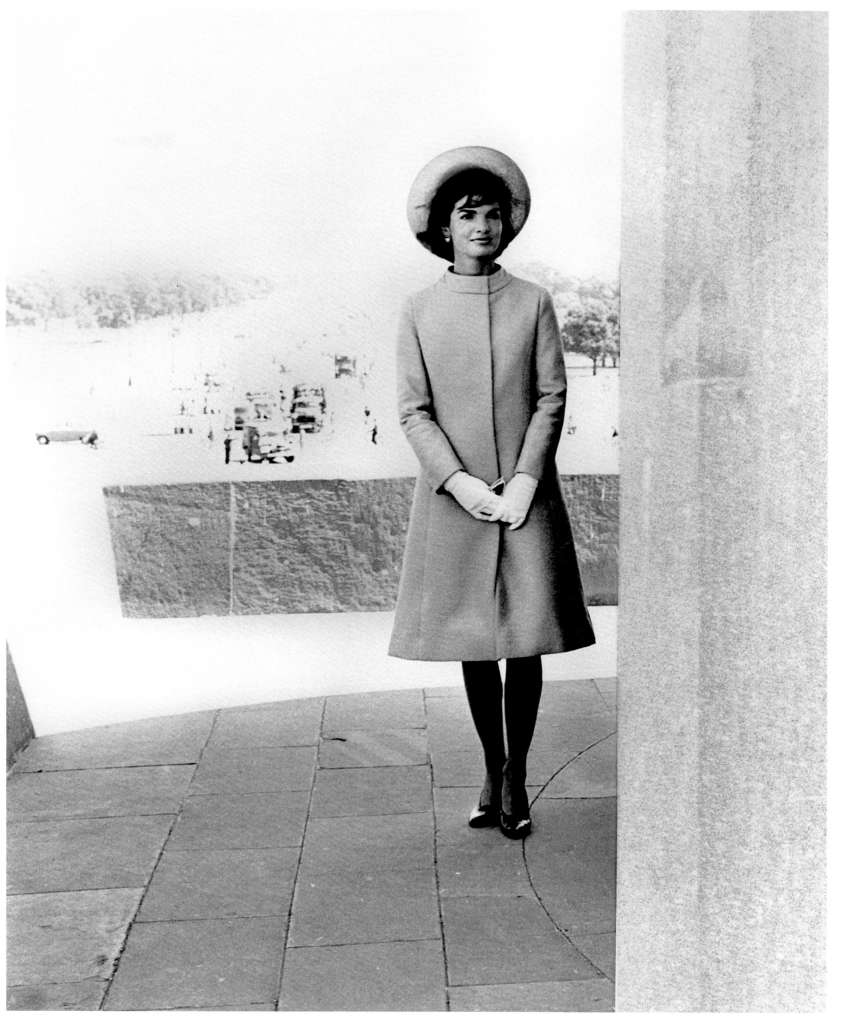

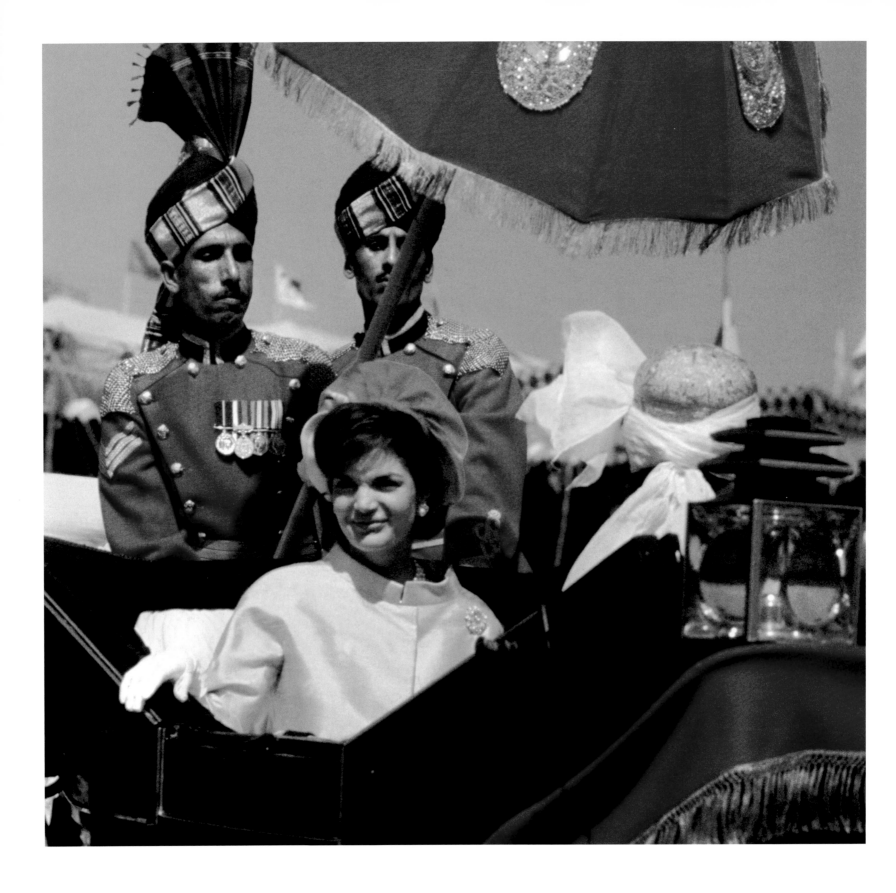

March 1962 / Pakistan / The First Lady during her official visit to Pakistan

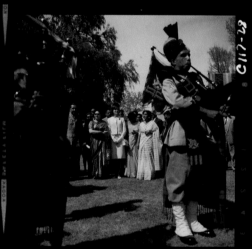

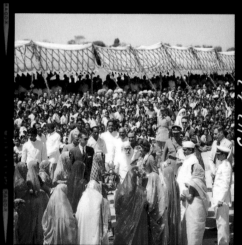

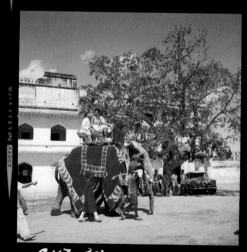

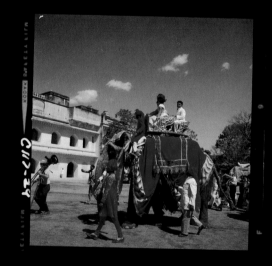

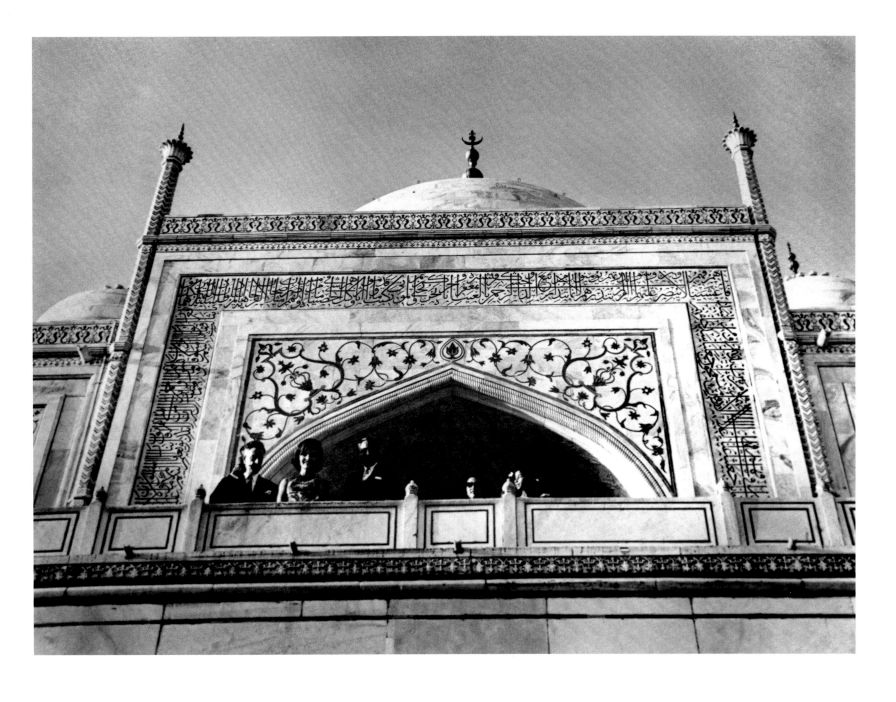

March 1962 / India / The First Lady during her trip to India

March 15, 1962 / Agra, India / Jackie visiting the Taj Mahal

"Jackie is poetic, whimsical, provocative, independent, and yet feminine. Jackie has always kept her own identity and been different. Jack knows she'll never greet him with, 'What's new in Laos?'" Robert Kennedy

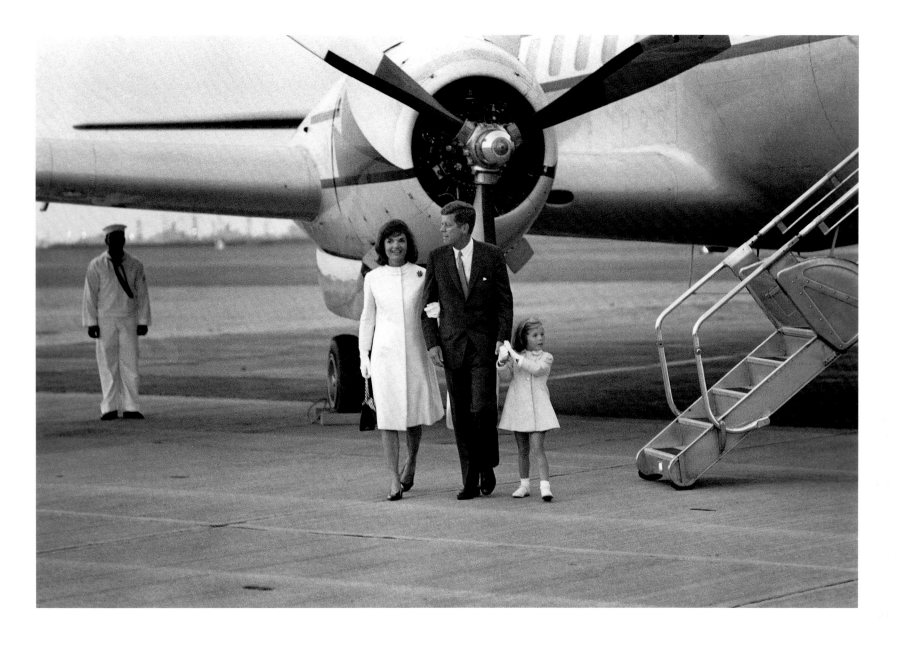

August 31, 1962 / Washington, DC / The arrival of the First Lady and Caroline, back from vacation in Italy

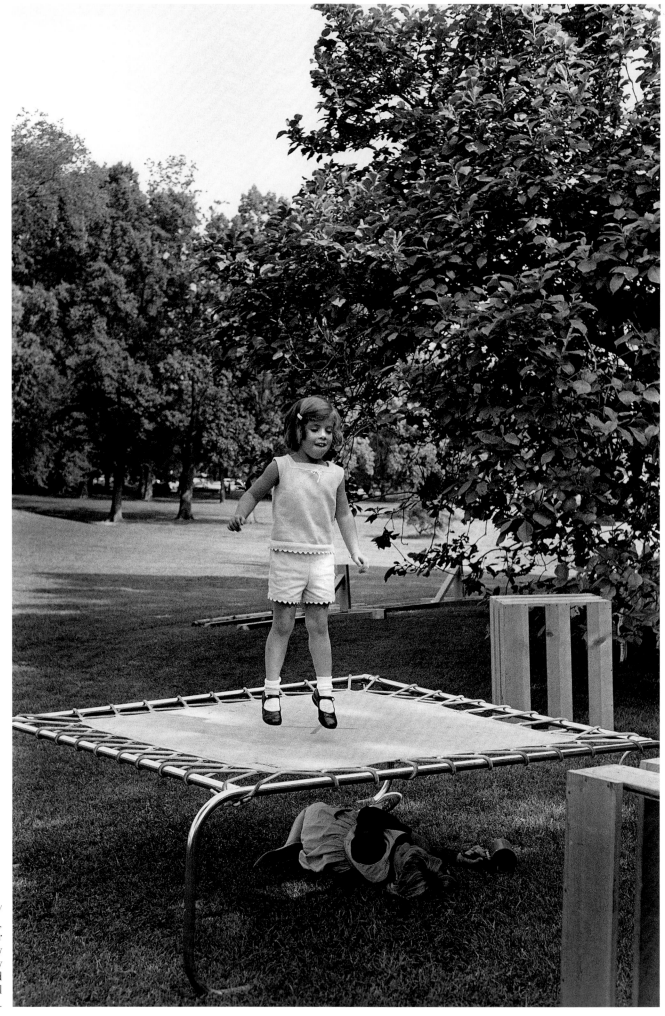

May 17, 1962 / Washington, DC /
While at the White House,
Jackie purchased a trampoline for
Caroline and John Jr. Afraid they may
fall off and get hurt, she ultimately
ordered the staff to dig a hole and
bury the trampoline at ground level
on the White House lawn.

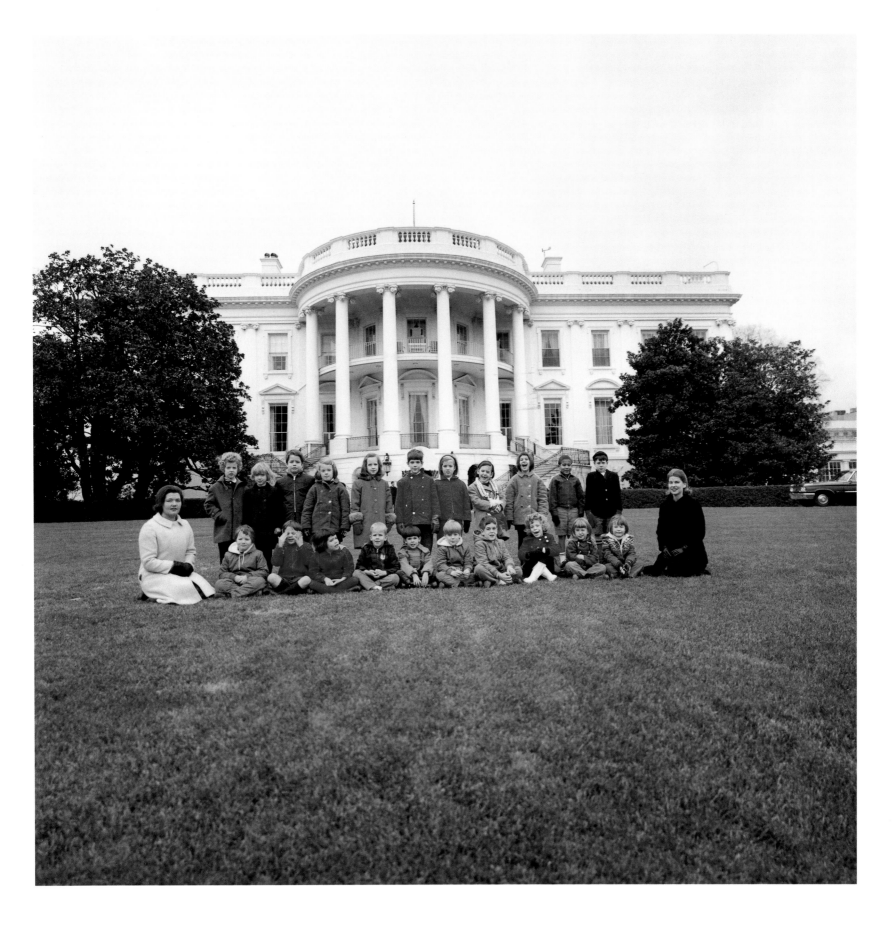

December 11, 1963 / Washington, DC / John F. Kennedy, Jr. among fellow classmates from the nursery that Jackie had installed in the White House

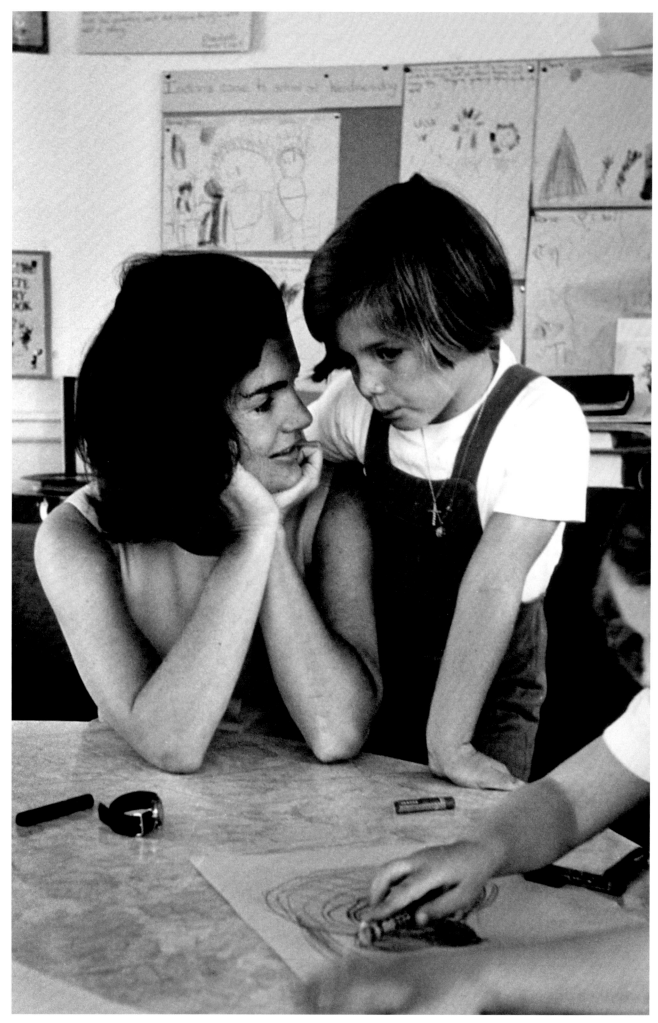

May 24, 1962 / Washington, DC /
Jackie sitting at a classroom table
during a visit to Caroline's school

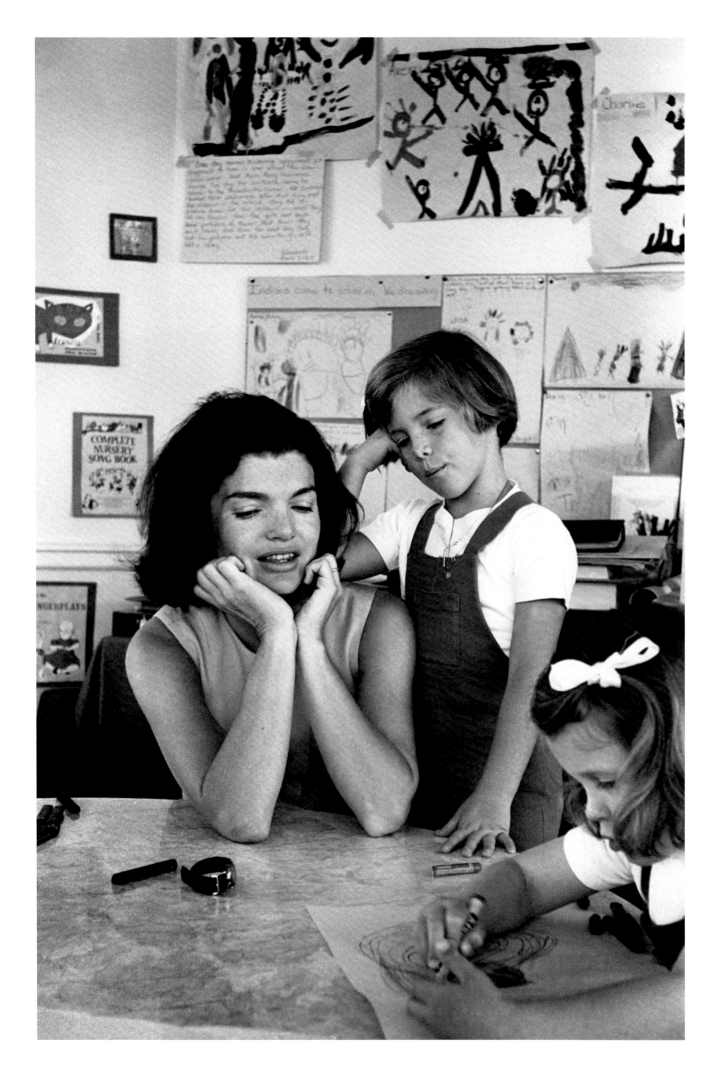

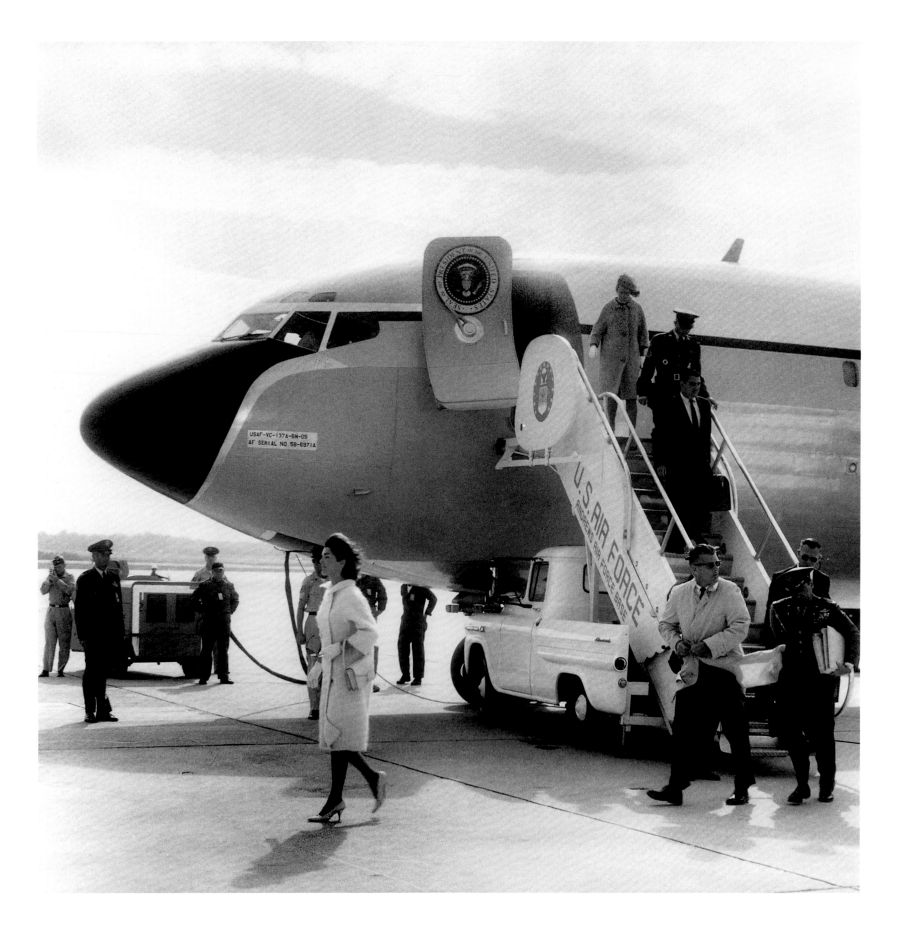

September 18, 1961 / Andrews Air Force Base, DC / Jackie Kennedy arriving at Andrews AFB, home of Air Force One, upon her return from Hyannis Port

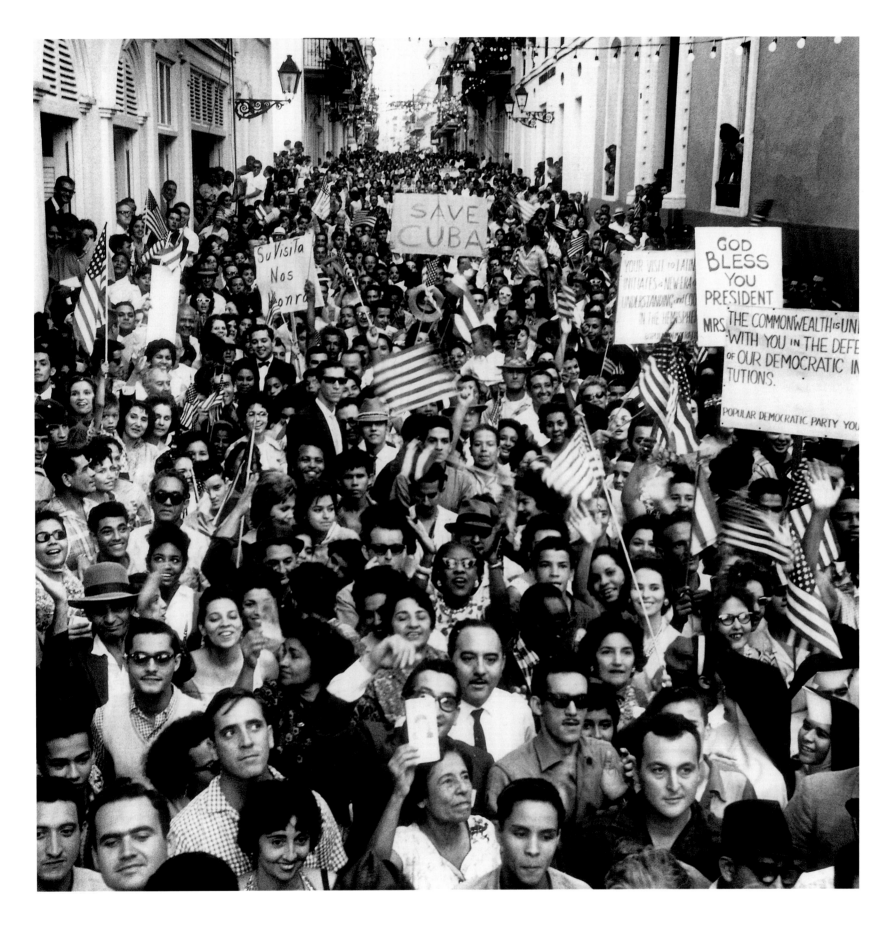

December 16, 1961 / San Juan, Puerto Rico / An enthusiastic crowd cheers President Kennedy and the First Lady at La Fortaleza, Governor Luis Muñoz Marín's mansion, just before their trip to South America. In 1949 Luis Muñoz Marín became Puerto Rico's first elected governor.

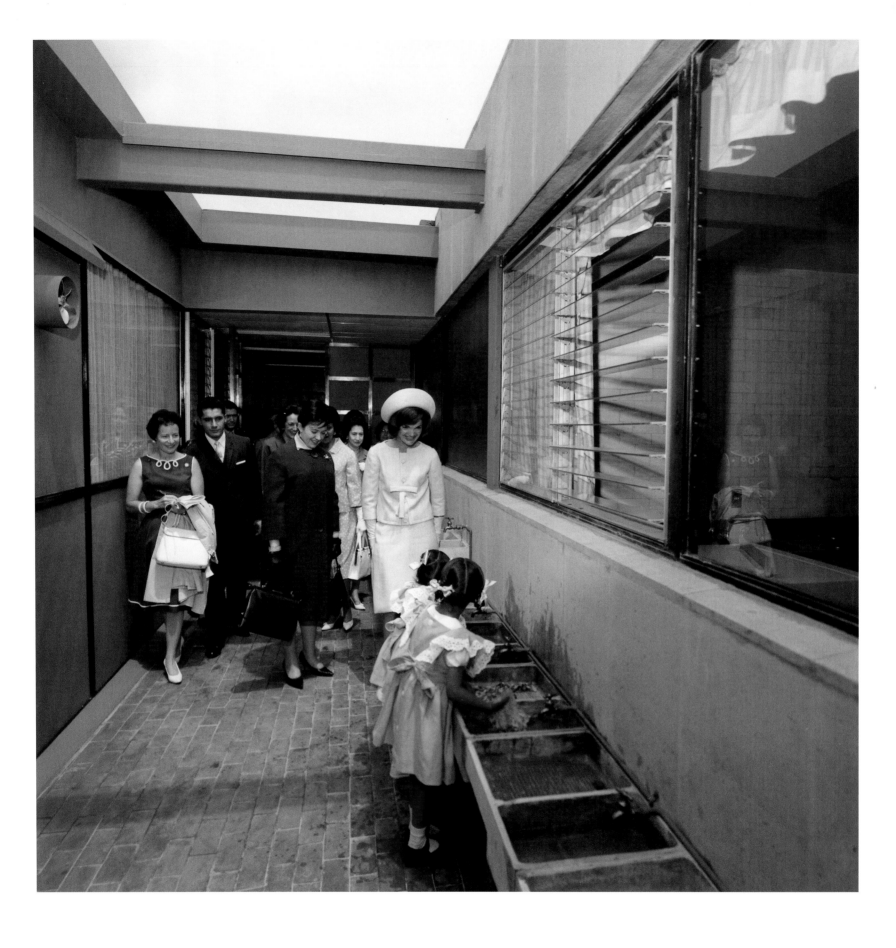

June 30, 1962 / Mexico City, Mexico / The First Lady at the Instituto Nacional de Protección a la Infancia

June 29, 1962 / Mexico City, Mexico / During a forty-eight hour visit to Mexico, Jackie addressed the journalists in Spanish, flanked by the Mexican president, Adolfo Mateos, and President Kennedy. The Mexicans were wild about Jackie. The *"vivas"* for her were as loud and as fervent as for her husband on their triumphal arrival in this ancient Aztec capital.

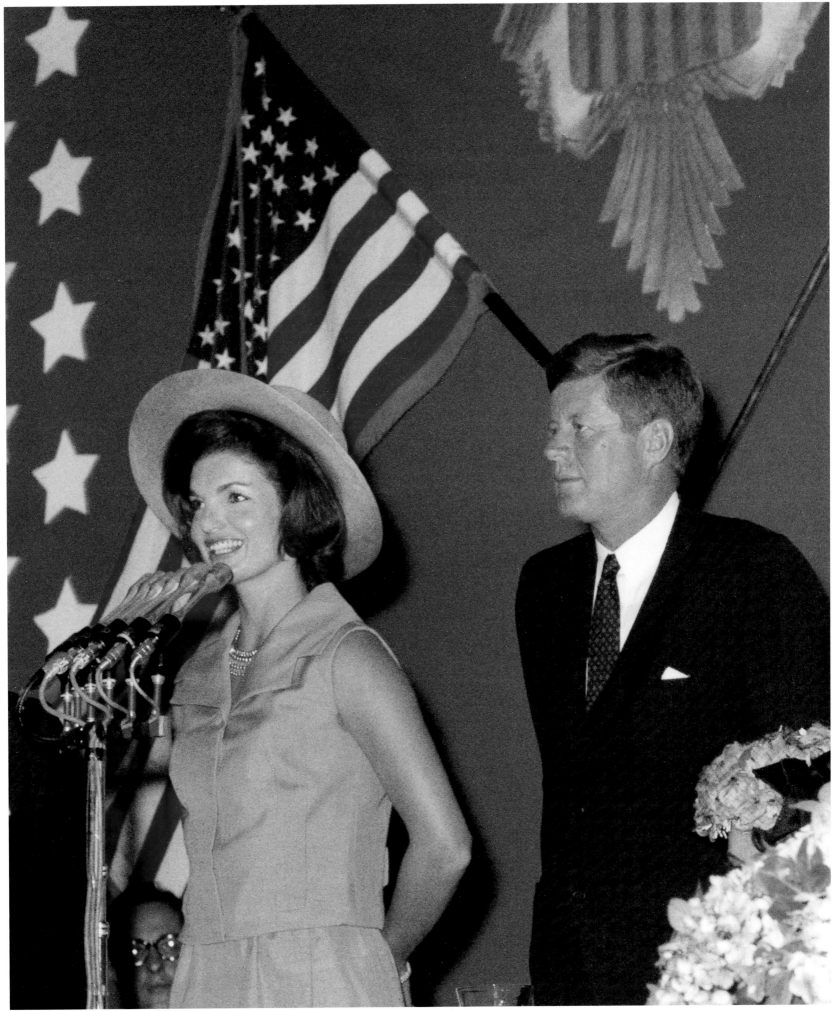

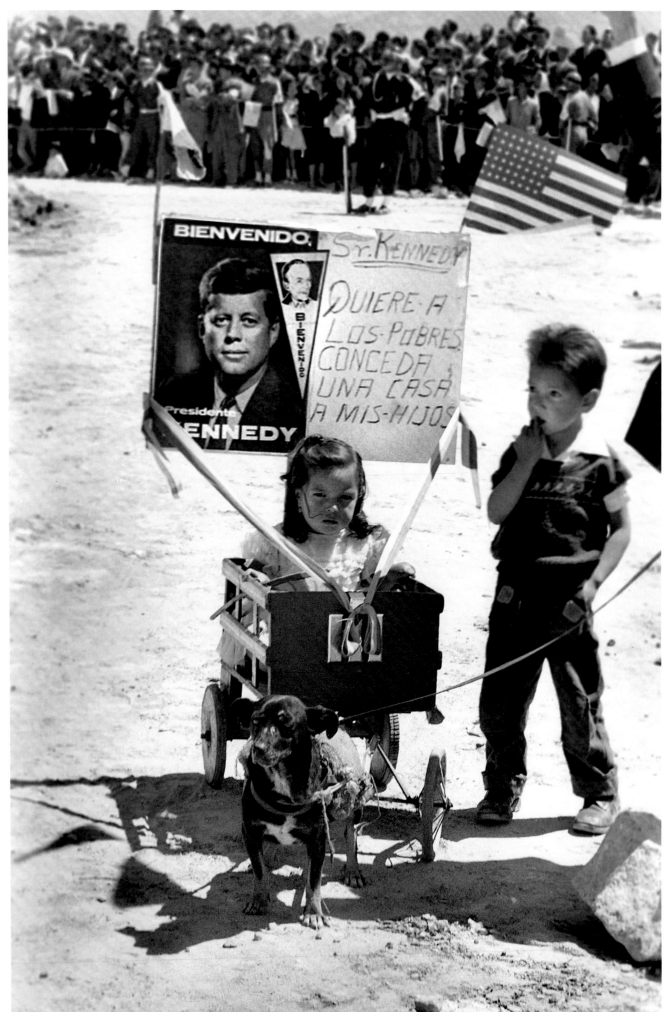

December 17, 1961 / Bogota, Colombia / The arrival of President Kennedy in Colombia. "Mr. Kennedy. Please support the poor. Bring a house to my children."

116

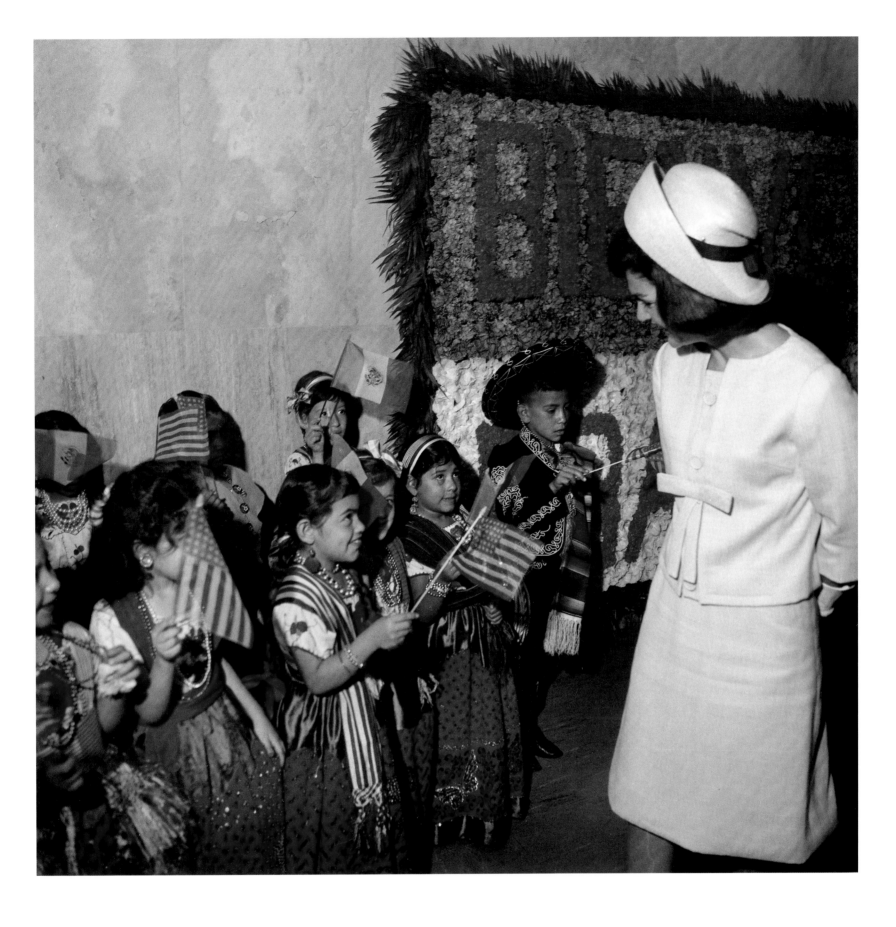

June 30, 1962 / Mexico City, Mexico / The First Lady visiting the Instituto Nacional de Protección a la Infancia

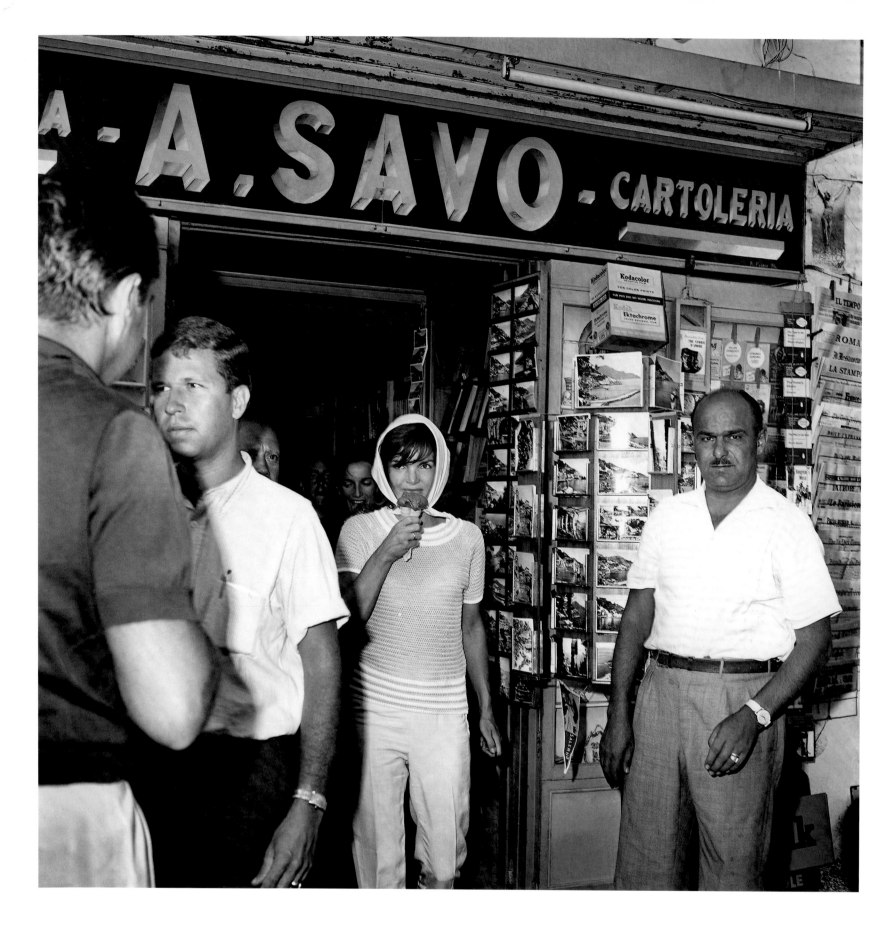

August 30, 1962 / Ravello, Italy / Jackie eating an ice cream cone after a visit at the beach at Amalfi

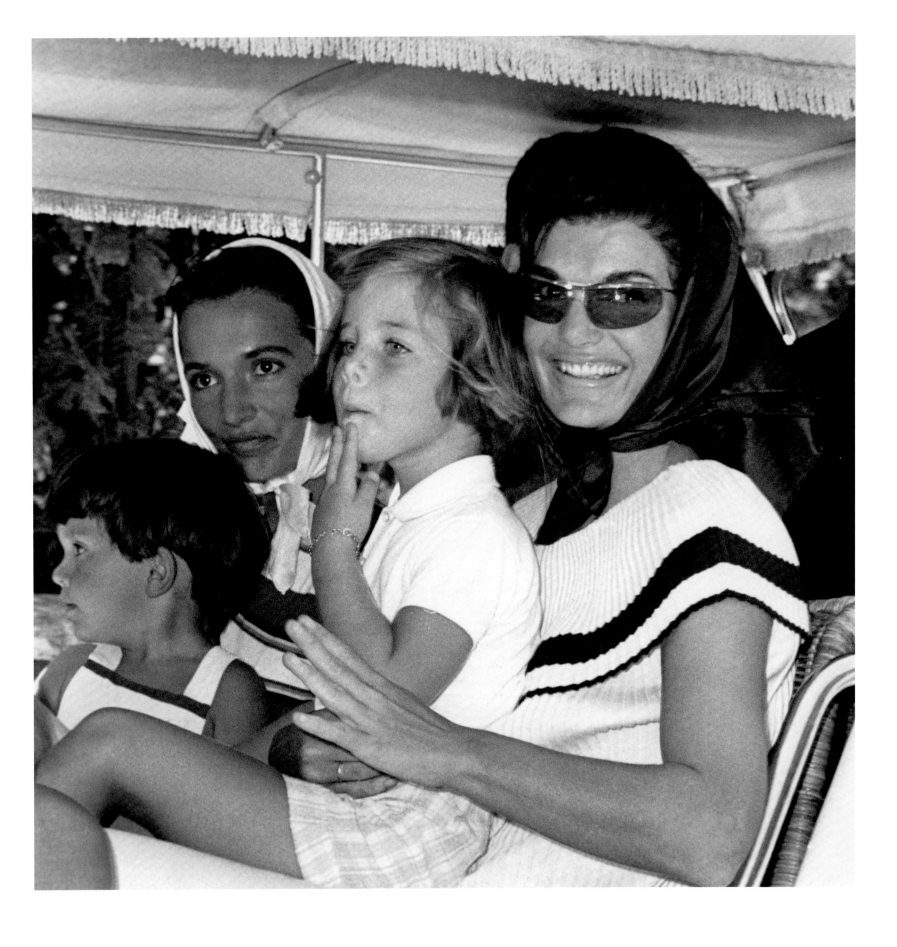

August 10, 1962 / Ravello, Italy / Caroline Kennedy riding on her mother's lap in a special umbrella-topped open beach car as they return from a swim.
That same afternoon, Jackie also gets in some waterskiing for the first time since their arrival.

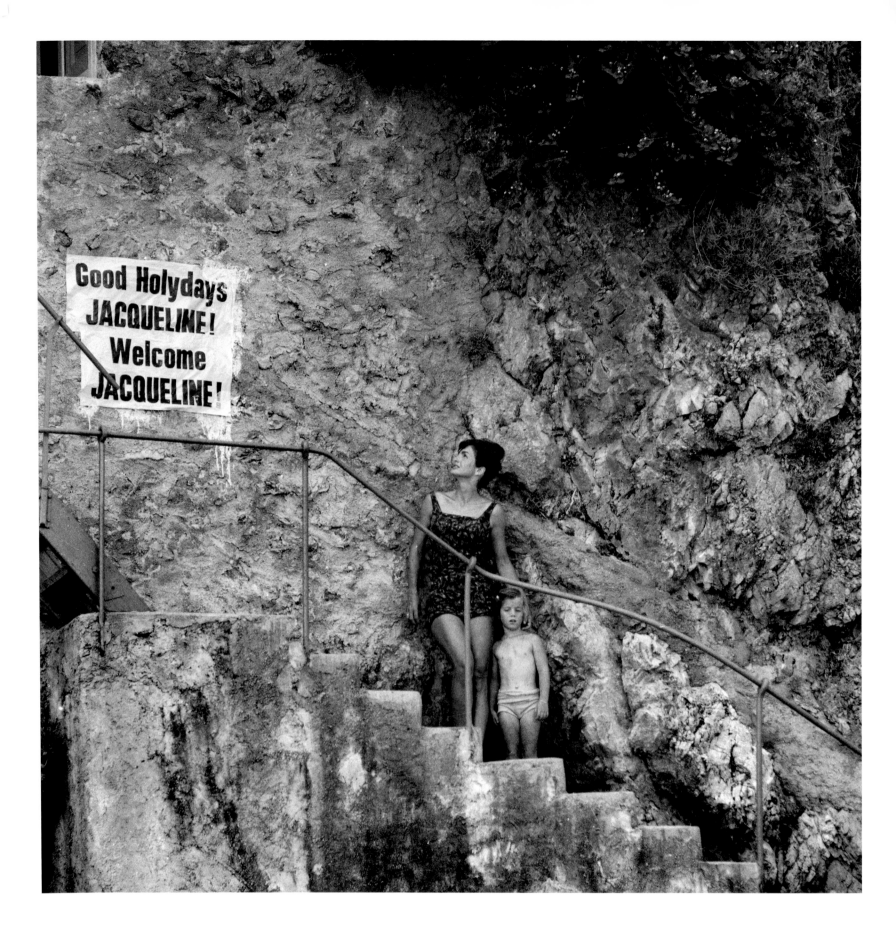

August 12, 1962 / Ravello, Italy / Vacationing at this seaside resort town, Jackie and Caroline are seen in bathing suits as they look at a welcome sign

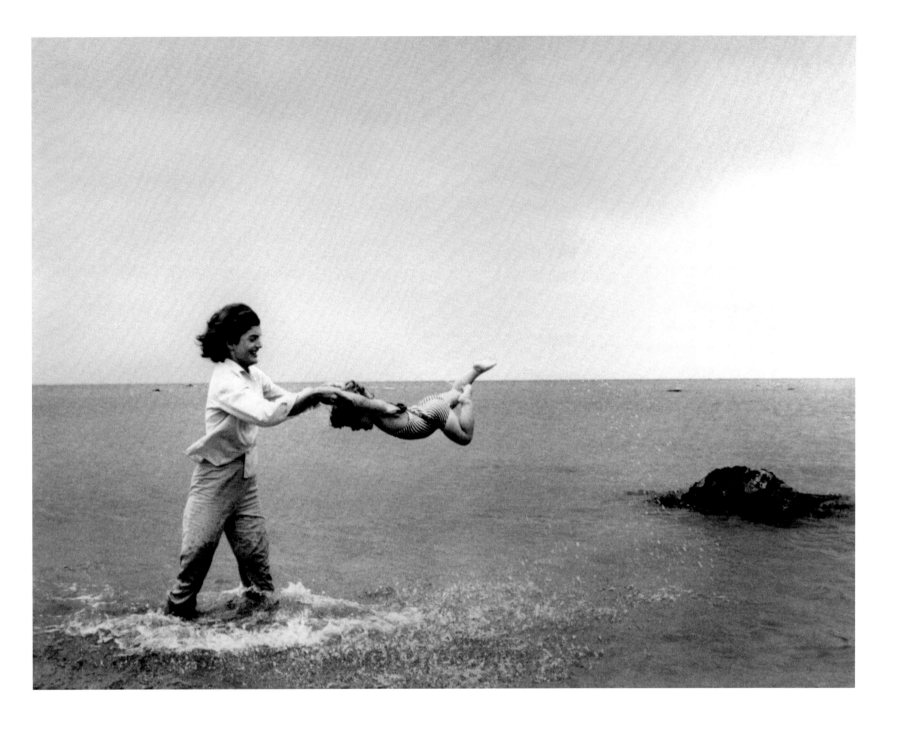

1959 / Hyannis Port, MA / Jackie and Caroline Kennedy

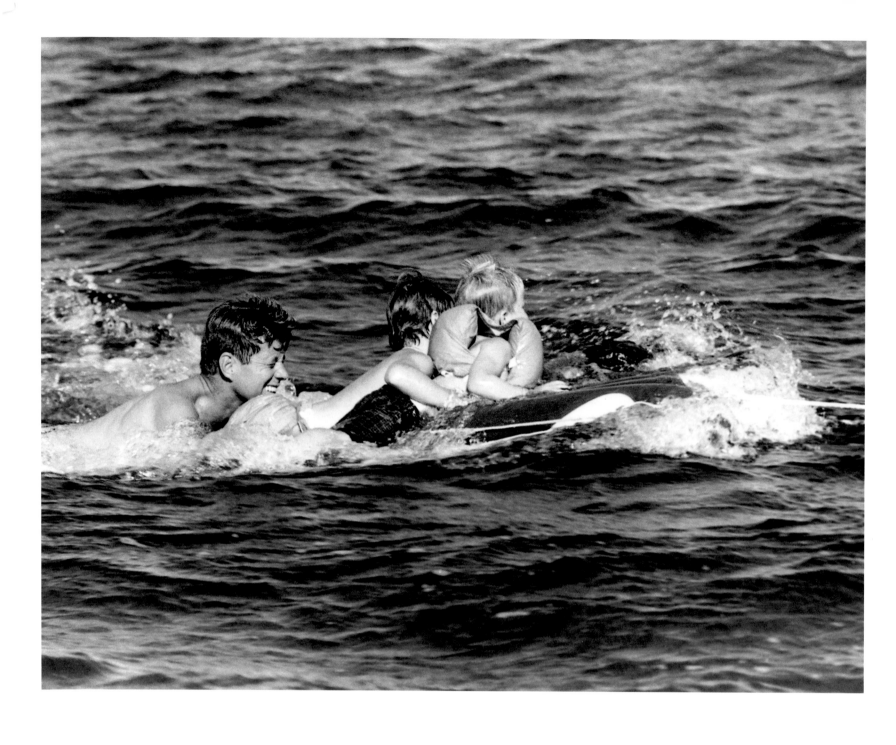

August 21, 1959 / Hyannis Port, MA / John F. Kennedy swimming with children

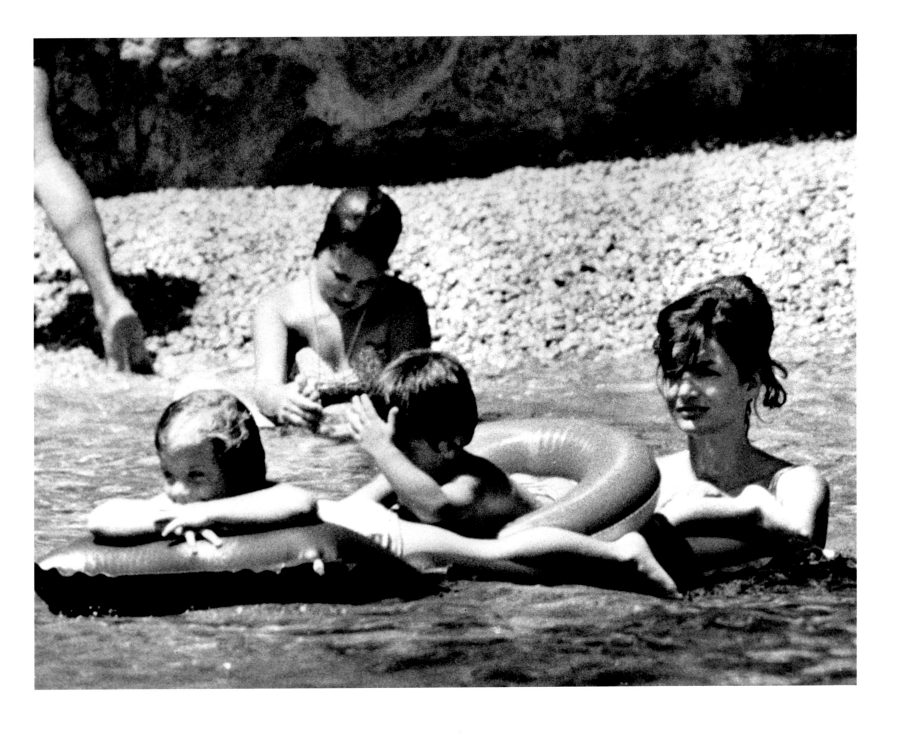

August 9, 1962 / Conca Del Marini, Italy / Jackie pushing two floats with Caroline and niece Anna Christina Radziwill while on vacation in Italy

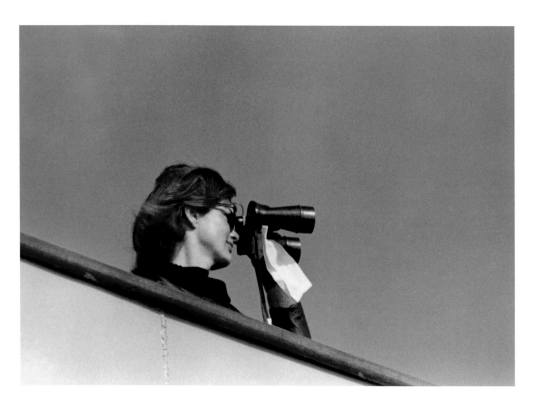

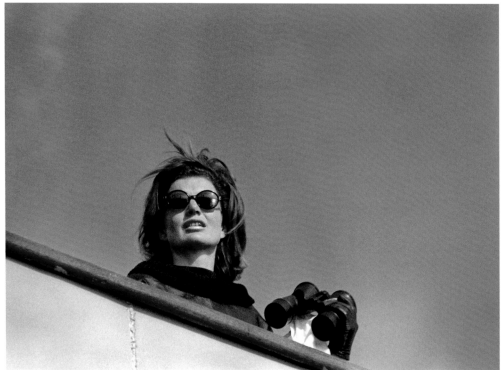

September 22, 1962 / Newport, RI / The First Lady watching the 4th America's Cup

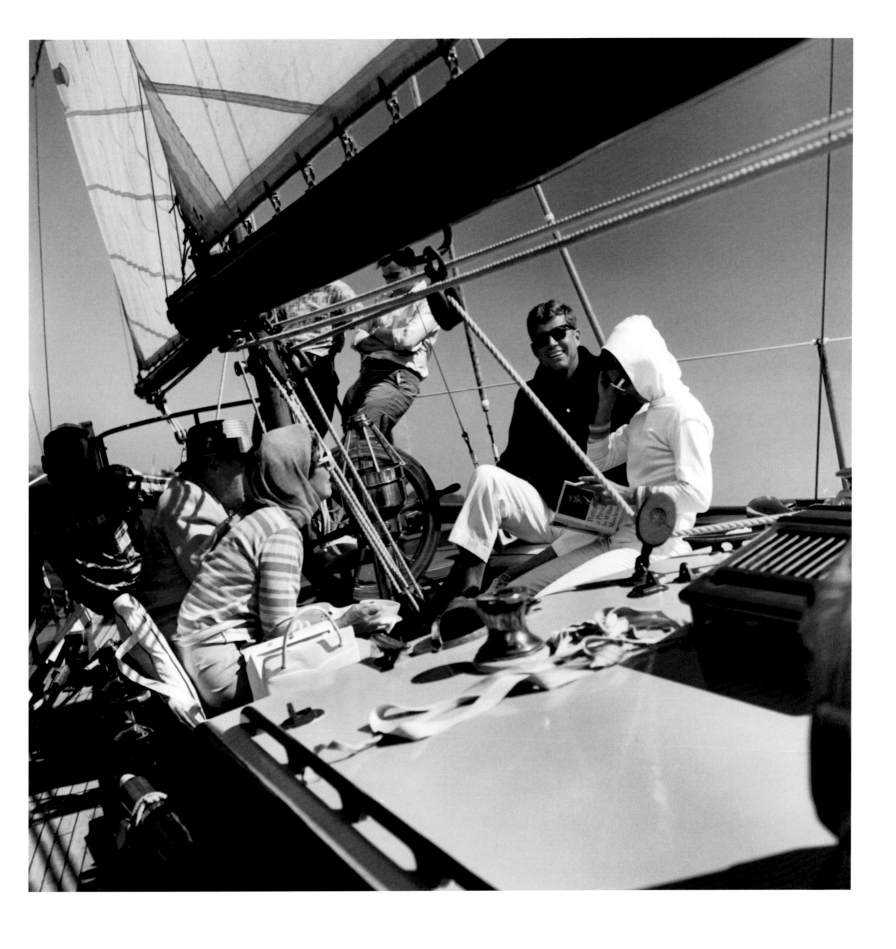

September 9, 1962 / Narragansett Bay, RI / Jackie and John F. Kennedy sailing aboard the U.S. Coast Guard yacht Manitou with Hugh D. Auchincloss, Mrs. Auchincloss, and others during their vacation at Hammersmith Farm

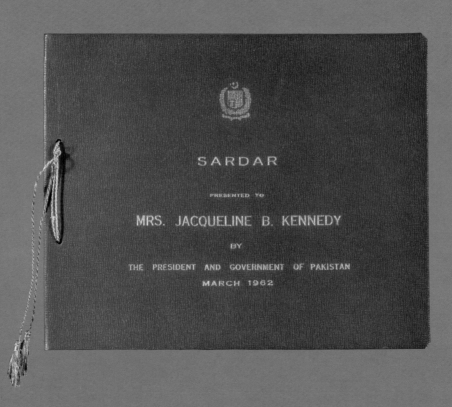

SARDAR

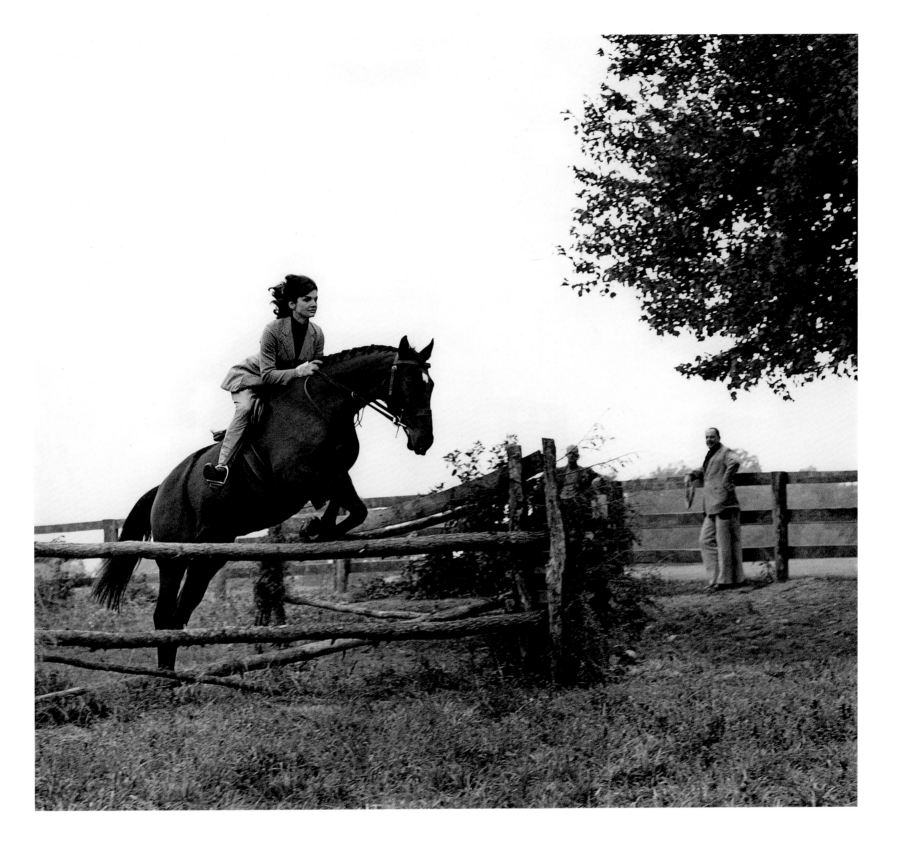

March 1962 / Pedigree of Arabian stallion, Sardar. Ever since Jackie was a child, she had a passion for horses and as First Lady she still loved to ride. She was so accomplished as a rider that President Khan of Pakistan offered her one of his own horses, Sardar, as a personal tribute to her skill.

September 25, 1962 / Glen Ora Farm, Middleburg, VA / Jackie riding the Arabian stallion during a visit of President Muhammad Ayub Khan

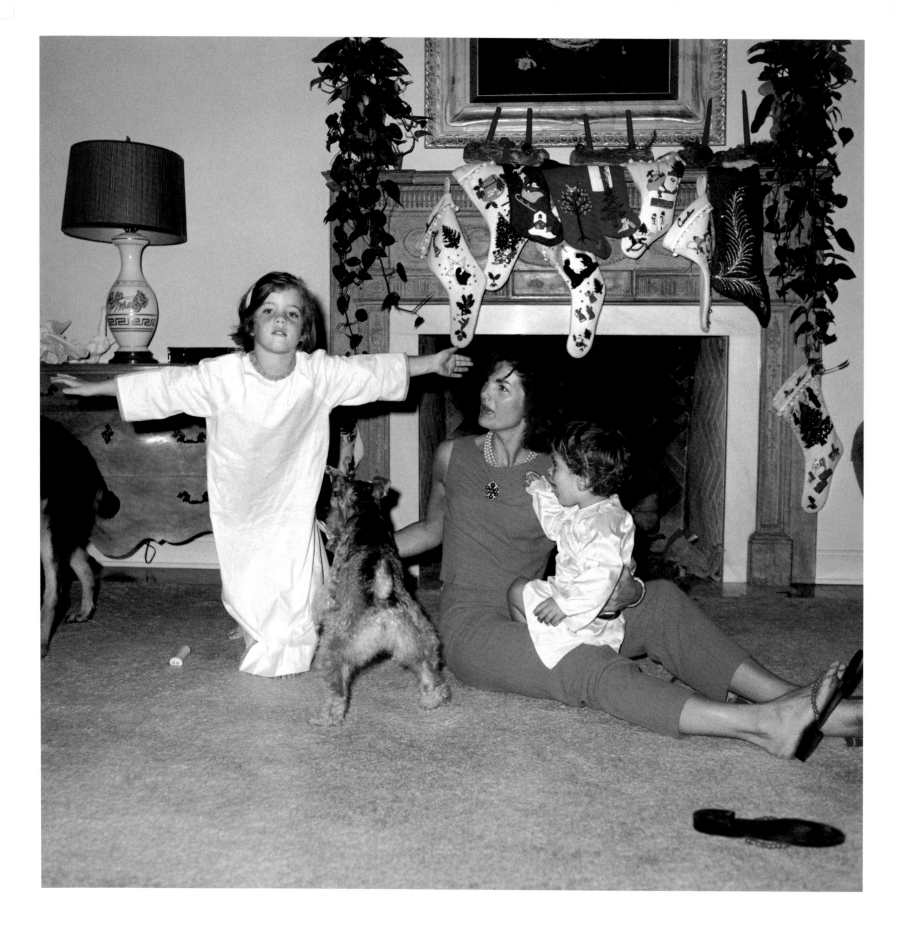

December 25, 1962 / Washington, DC / First Lady with Caroline and John Jr. during their Christmas celebration

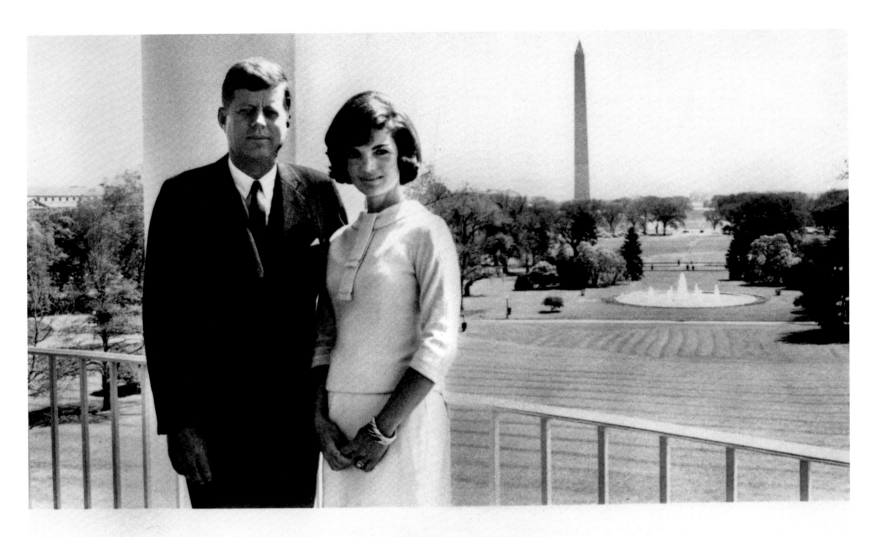

March 1961 / Washington, DC / A signed greeting card showing President and Mrs. Kennedy with the Washington Monument in the background

"I don't want my young children brought up by nurses and Secret Service men." Jackie

November 30, 1962 / White House, Washington, DC / Jackie and John Jr. watching from the door of the diplomatic reception room as the president lifts off from the South Lawn in his helicopter

130

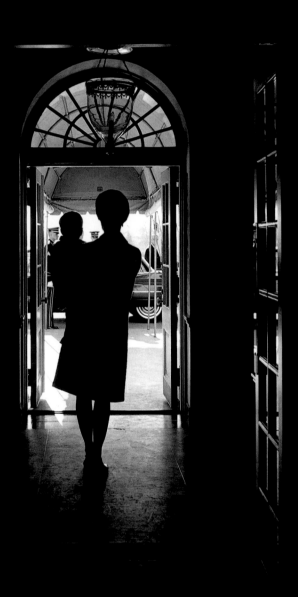

January 8, 1963 / Andrews Air Force Base, DC / Jackie and John F. Kennedy arriving at Andrews AFB from Palm Beach

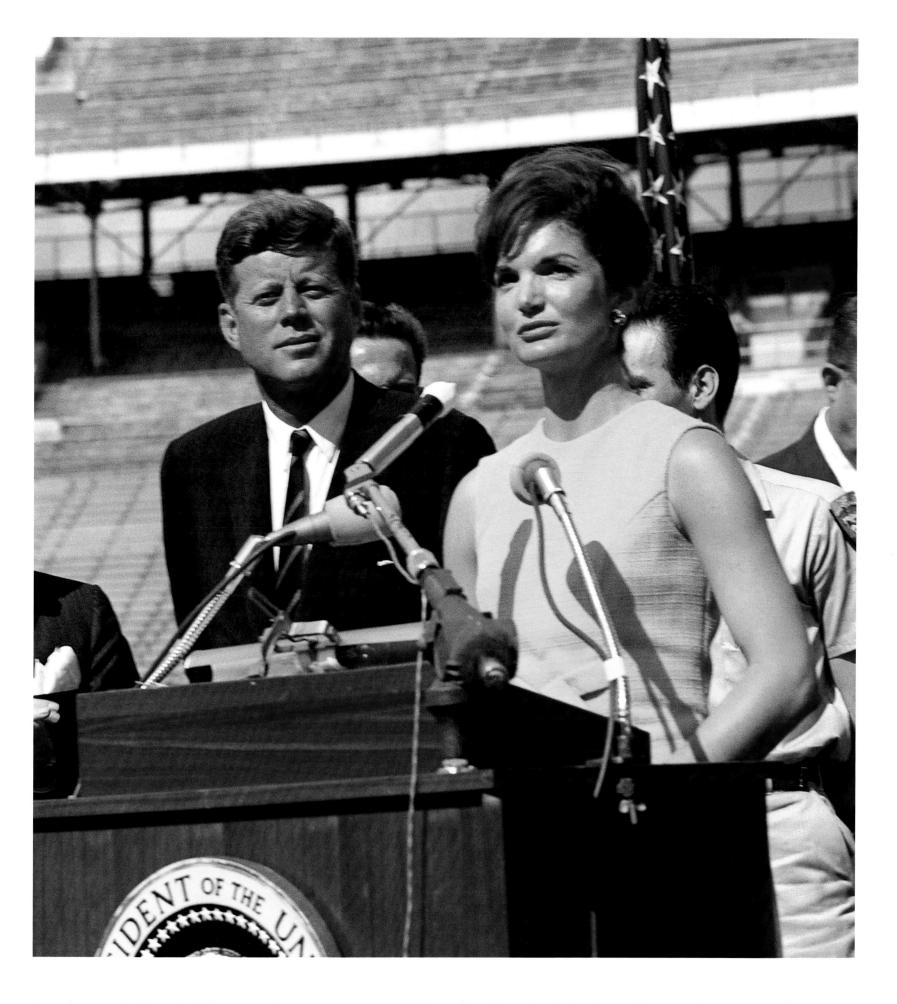

December 29, 1962 / Miami, FL / Addressing more than 40,000 men, women, and children in Miami's Orange Bowl Stadium, President Kennedy said that the proud battle flag of Brigade 2506, involved in the Bay of Pigs Invasion, will one day fly over a "free Havana." The First Lady, following her husband to the speaker's podium, received a tremendous ovation when she delivered a brief address in Spanish.

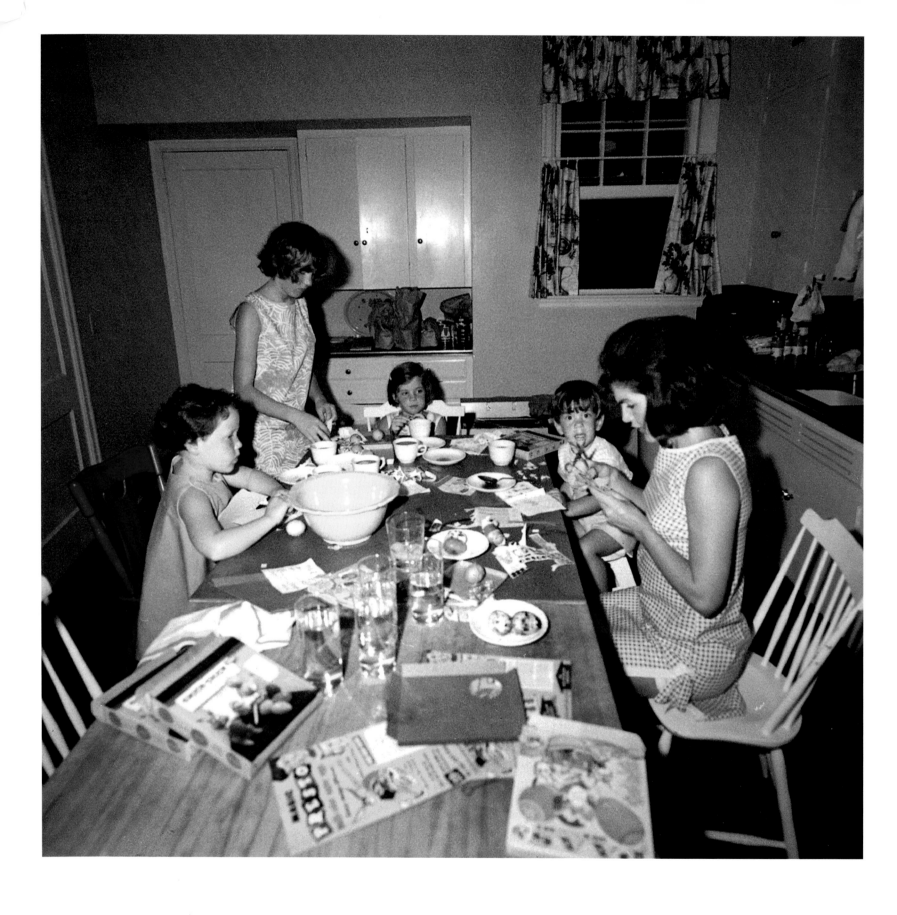

April 14, 1963 / Palm Beach, Miami, FL / Jackie decorating eggs with her kids, one of their friends, and Sally Fay for the next day's Easter Egg Roll

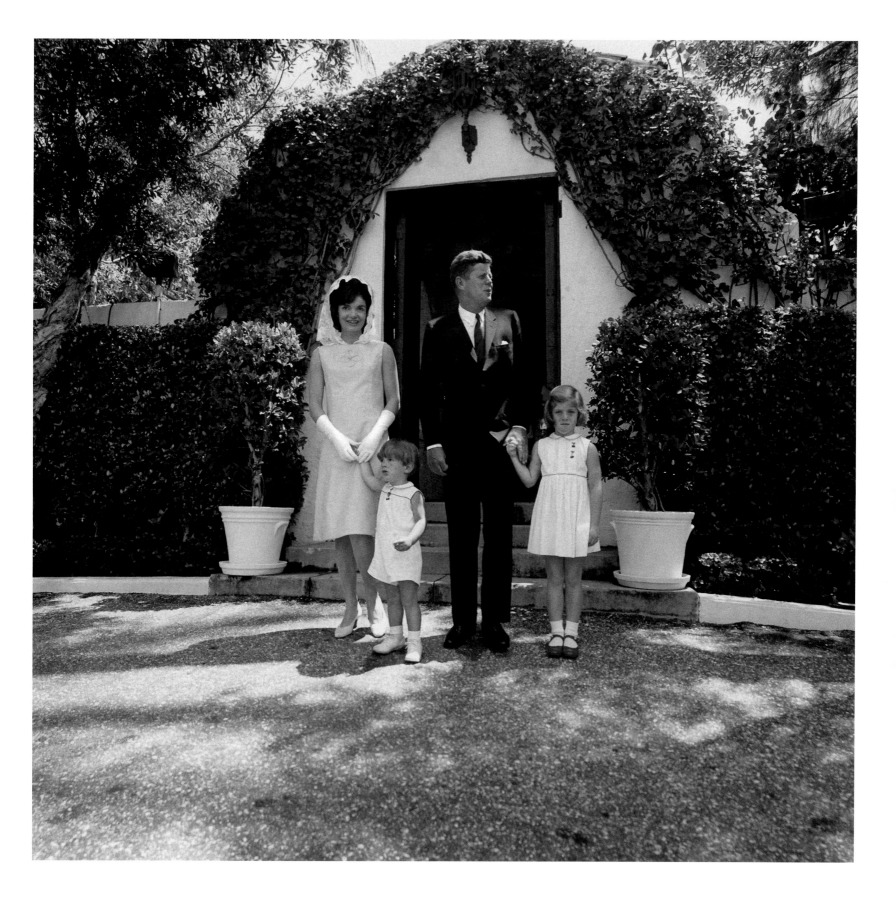

April 14, 1963 / Palm Beach, Miami, FL / Jackie and John F. Kennedy with their children Caroline and John Jr. on Easter Sunday

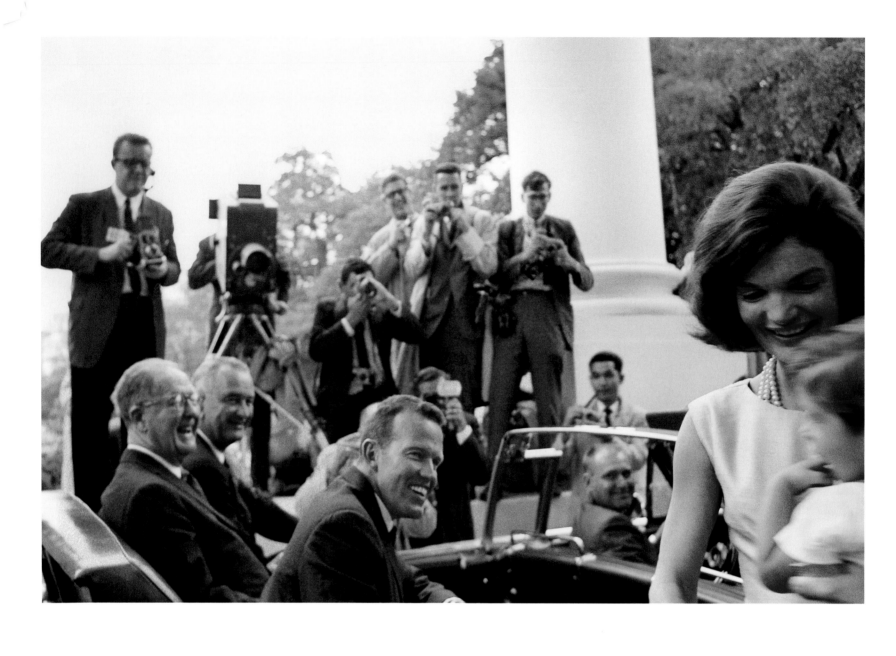

May 21, 1963 / Washington, DC / Jackie holding John Jr. in her arms during a presentation of the NASA Distinguished Service Medal to astronaut Gordon Cooper

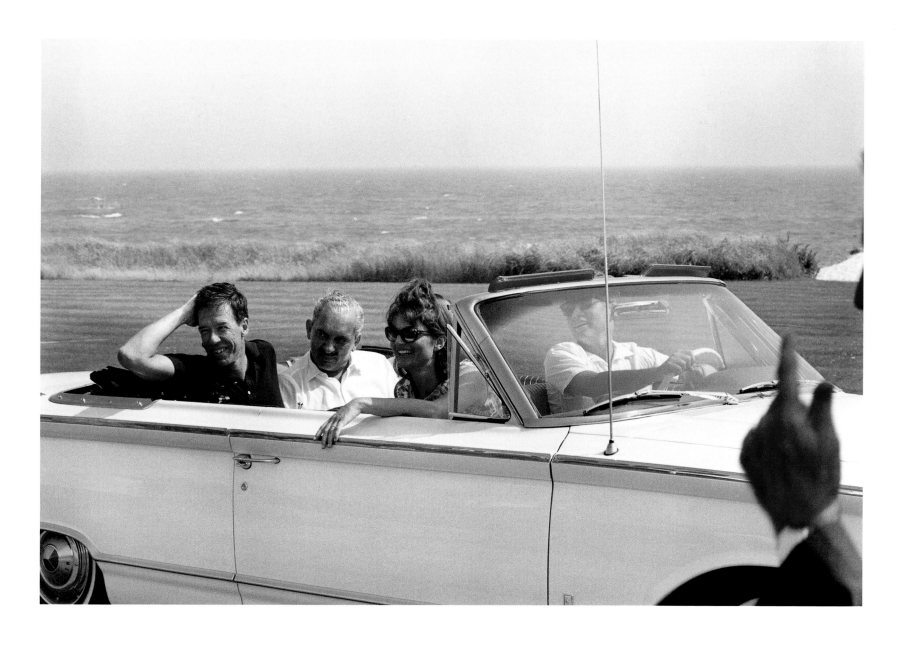

July 28, 1963 / Hyannis Port, MA / A weekend at Hyannis Port. In the back of the car are Jackie's brother-in-law, Prince Stanislas Radziwill, and Charles Spaulding, a longtime friend of John F. Kennedy.

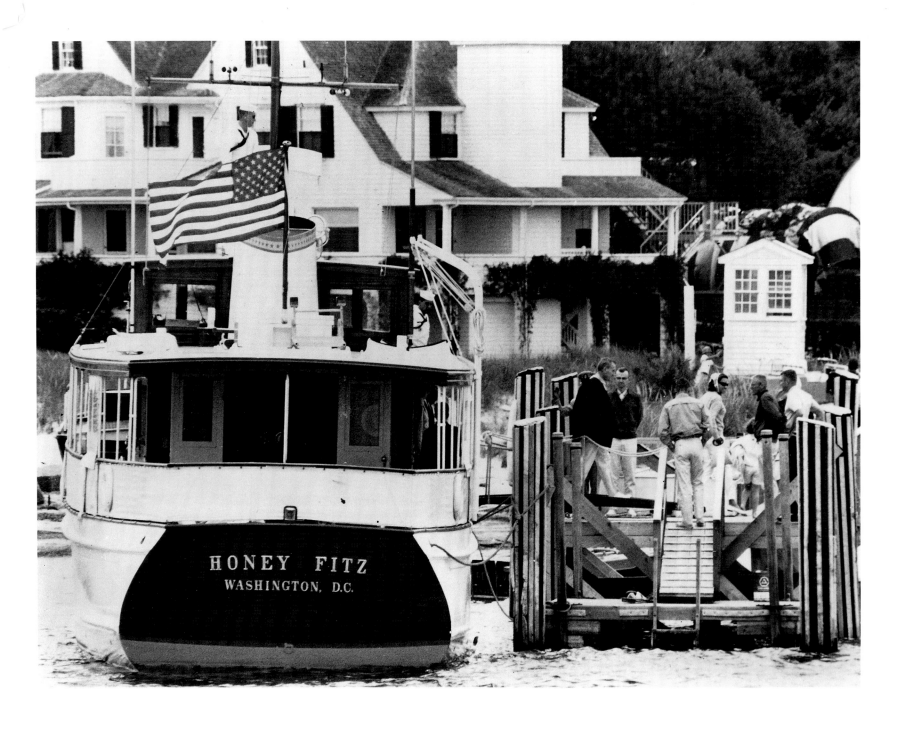

August 3, 1963 / Hyannis Port, MA / The president's yacht, Honey Fitz, awaiting departure

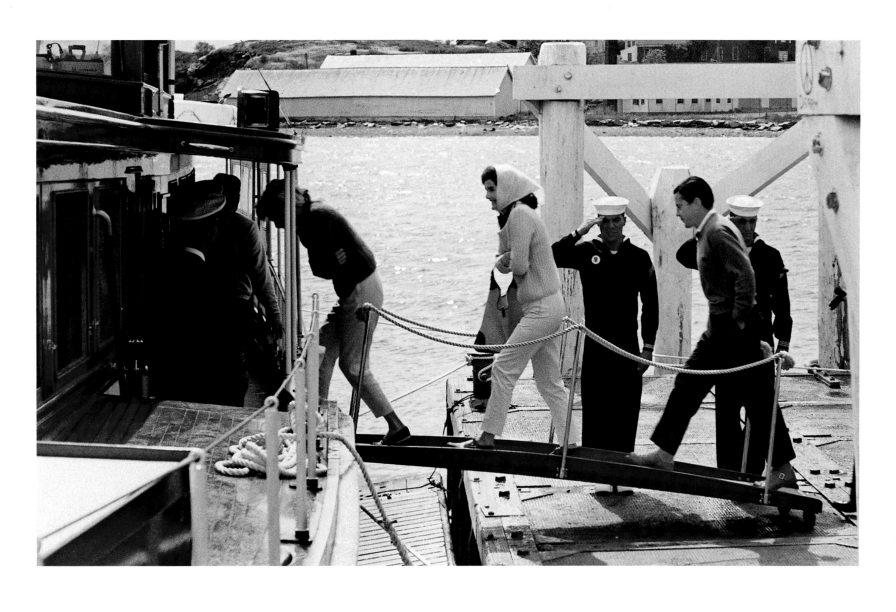

September 13, 1963 / Newport, RI / John and Jackie Kennedy with friends boarding the Honey Fitz

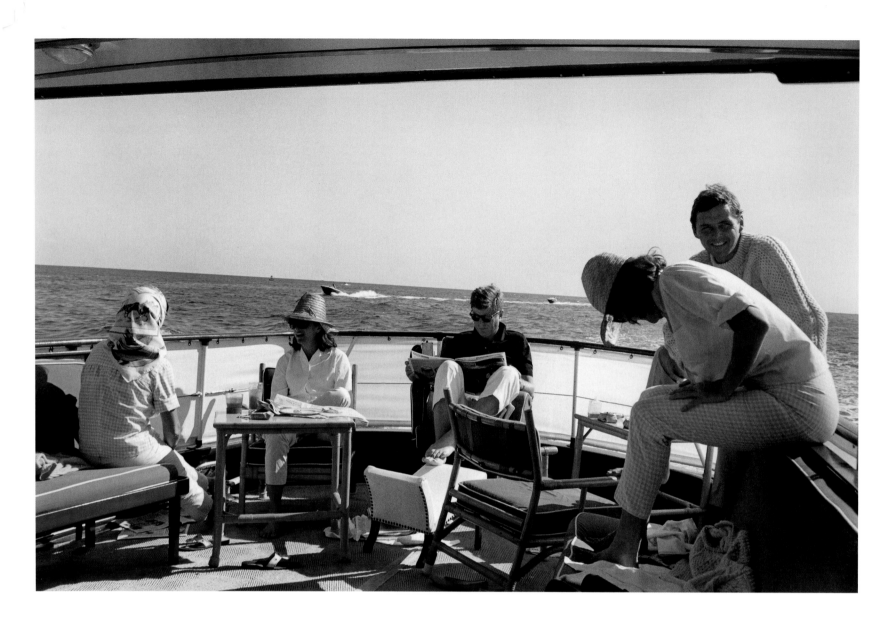

August 31, 1963 / Hyannis Port, MA / John and Jackie Kennedy with friends Steve Smith and Jean Smith during Labor Day weekend

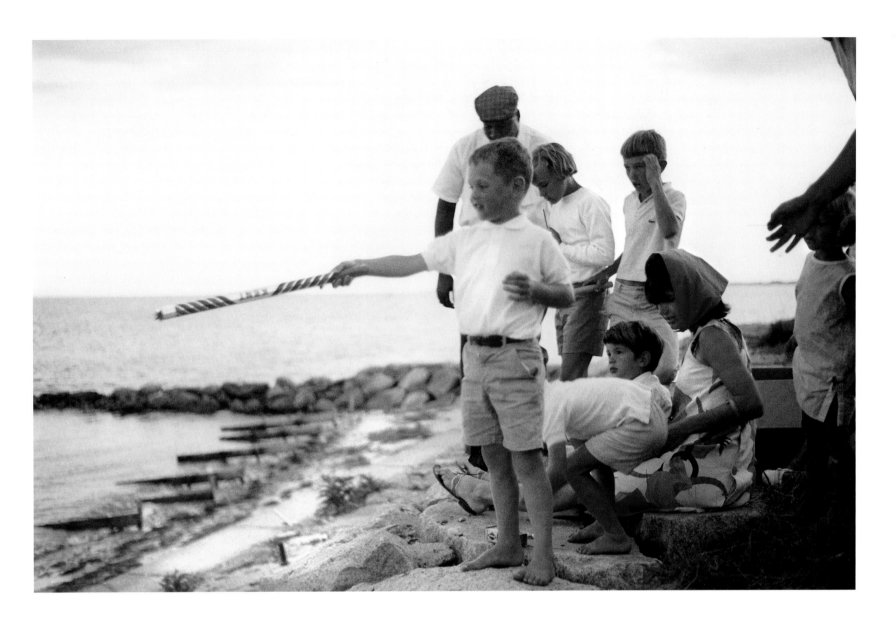

July 4, 1963 / Hyannis Port, MA / The First Lady with Caroline, John Jr., and other children during Independence Day weekend

August 4, 1963 / Hyannis
Port, MA / Caroline Kennedy
with her dog onboard Honey Fitz

September 14, 1963 / Newport, RI / John F.
Kennedy, Jr. with Secret Service Agent Foster,
in charge of his protection

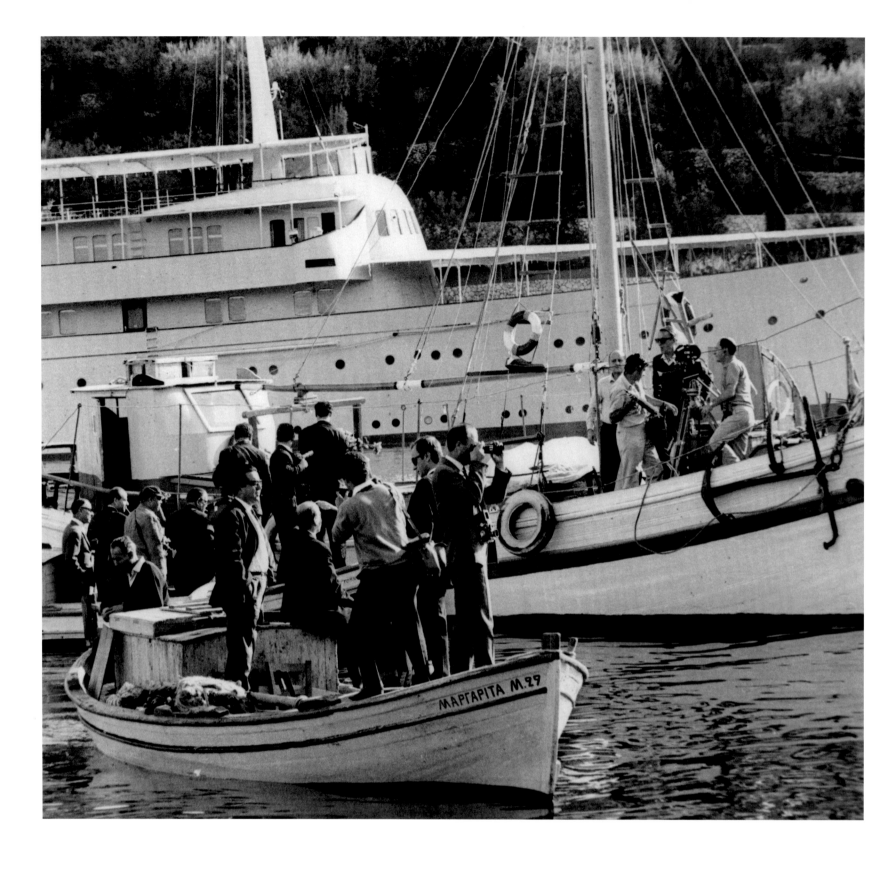

October 19, 1968 / Skorpios, Greece / Newsmen sitting in small boats off the shore of Skorpios, Aristotle Onassis' Ionian island, waiting for permission to land for pictures and stories about the impending marriage of Aristotle Onassis to Jacqueline Kennedy

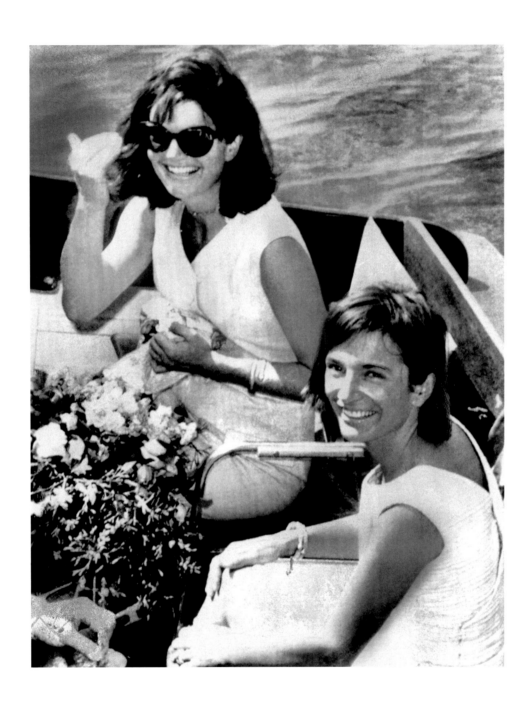

October 5, 1963 / Skorpios, Greece / Jackie Kennedy with Princess Lee Radziwill during her first cruise with Aristotle Onassis. Just for Jackie, the *Christina's* crew of sixty people had been increased by two hairdressers, a masseuse, and an orchestra for dancing in the evening. The *Christina* had been stocked with eight varieties of caviar, fresh fruits flown in from Paris, rare vintage wines, and buckets of mullet packed in ice.

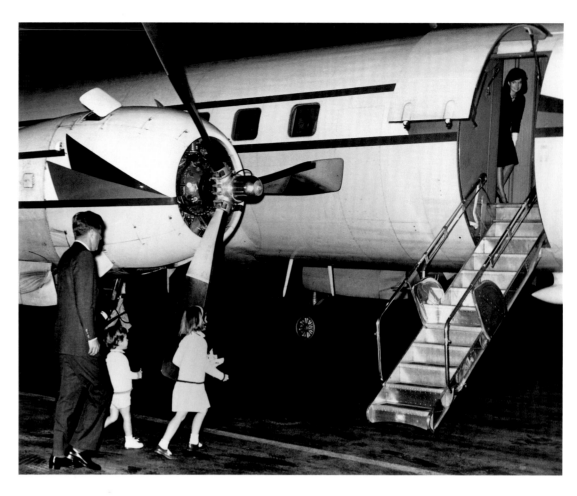

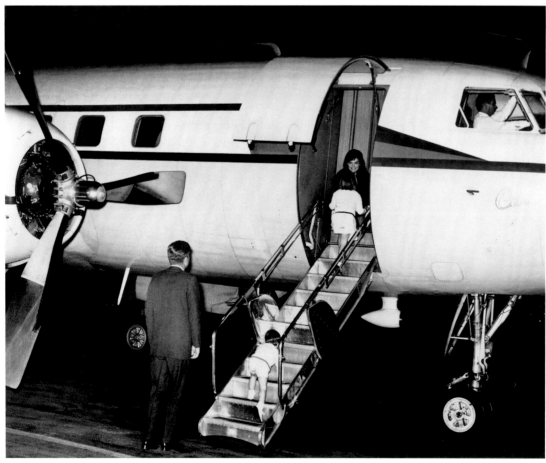

October 17, 1963 / Washington, DC / The return of the First Lady from her European vacation

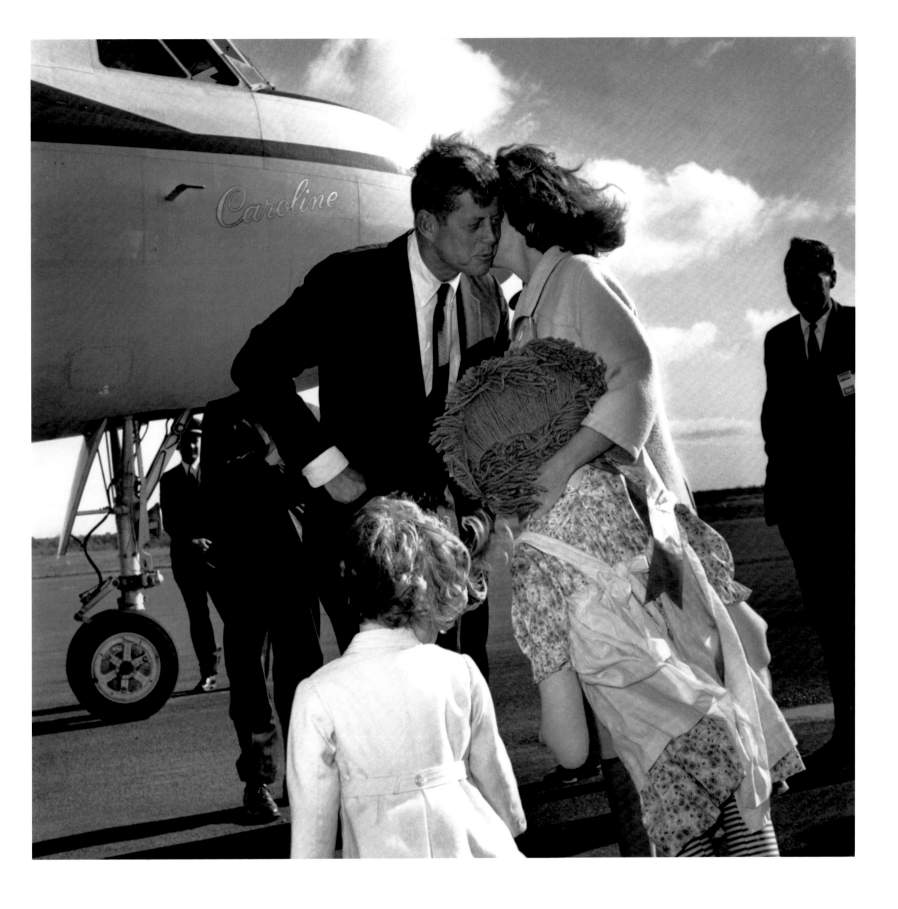

October 1, 1960 / Hyannis Port, MA / Mrs. Jacqueline Kennedy clutching her daughter's rag doll as she says goodbye to her husband John, the U.S. presidential candidate

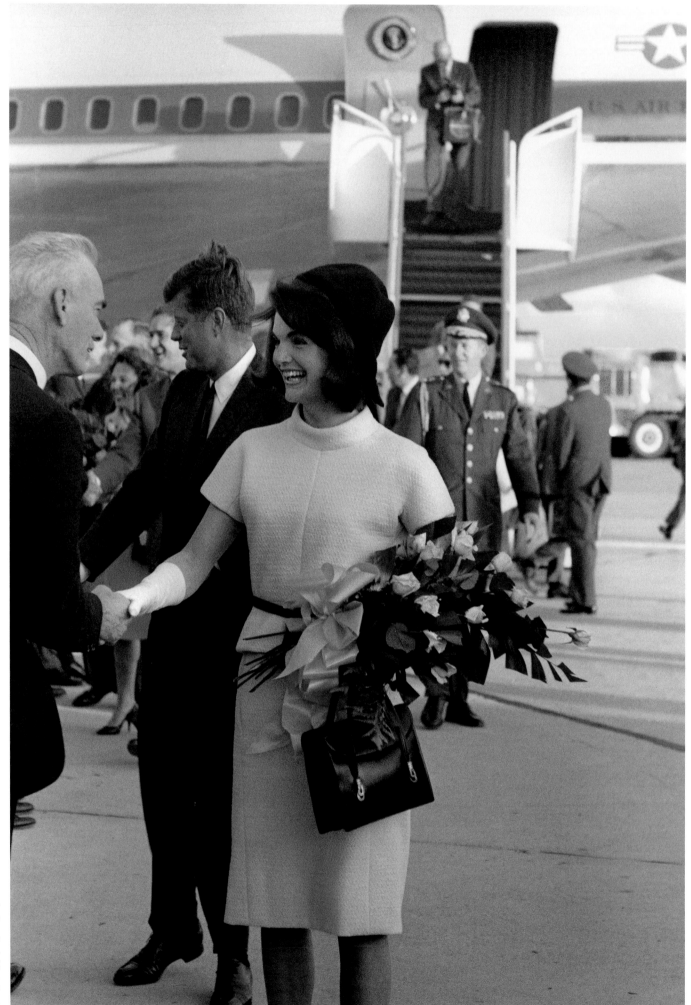

November 21, 1963 /
San Antonio, TX /
President Kennedy and
the First Lady arriving in
San Antonio during
their trip to Texas.
The following day, they
flew to Dallas.

November 22, 1963—Dallas

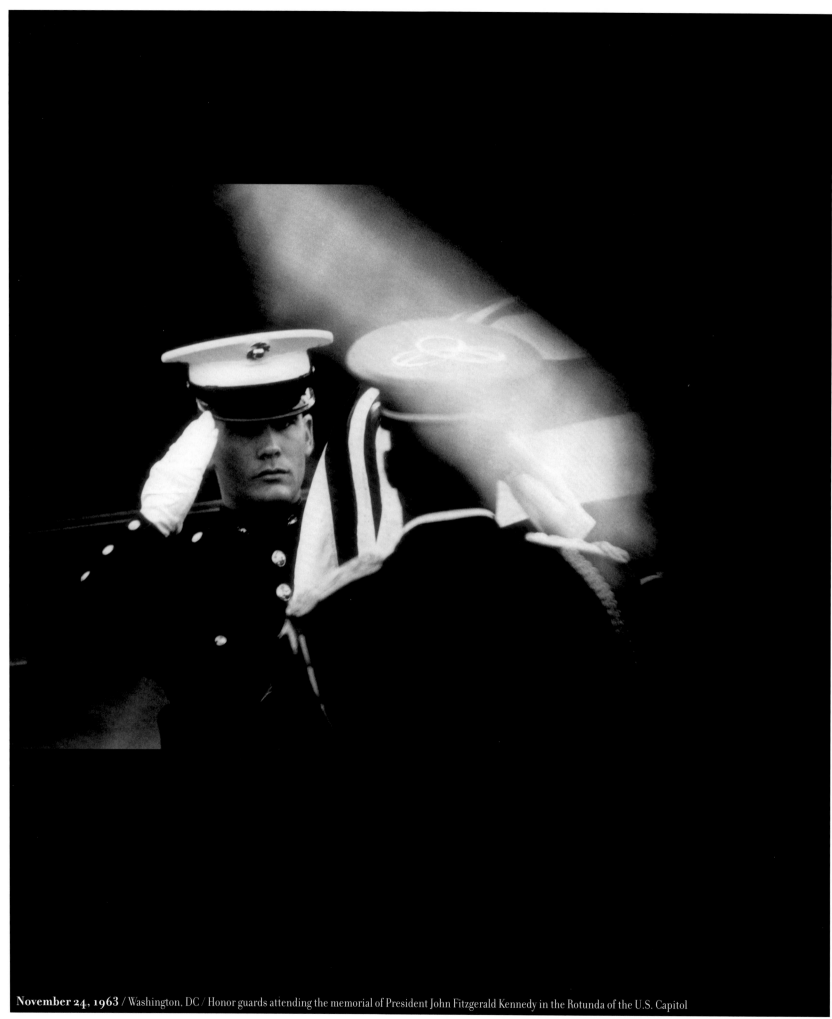

November 24, 1963 / Washington, DC / Honor guards attending the memorial of President John Fitzgerald Kennedy in the Rotunda of the U.S. Capitol

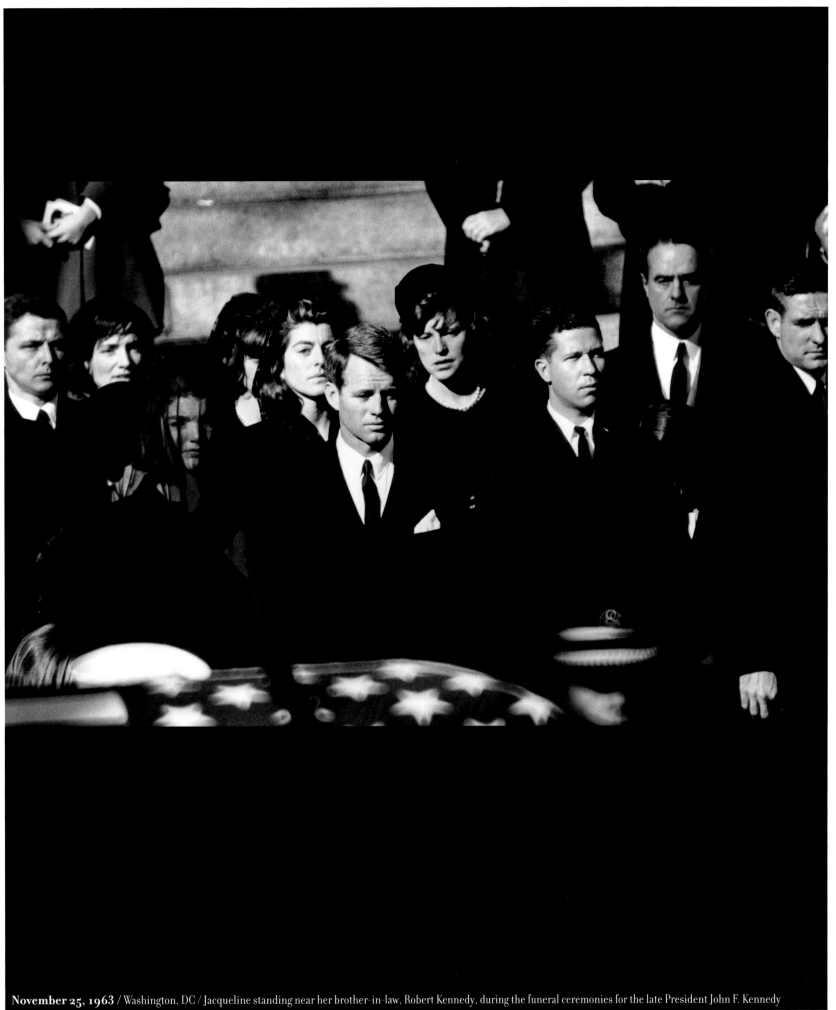

November 25, 1963 / Washington, DC / Jacqueline standing near her brother-in-law, Robert Kennedy, during the funeral ceremonies for the late President John F. Kennedy

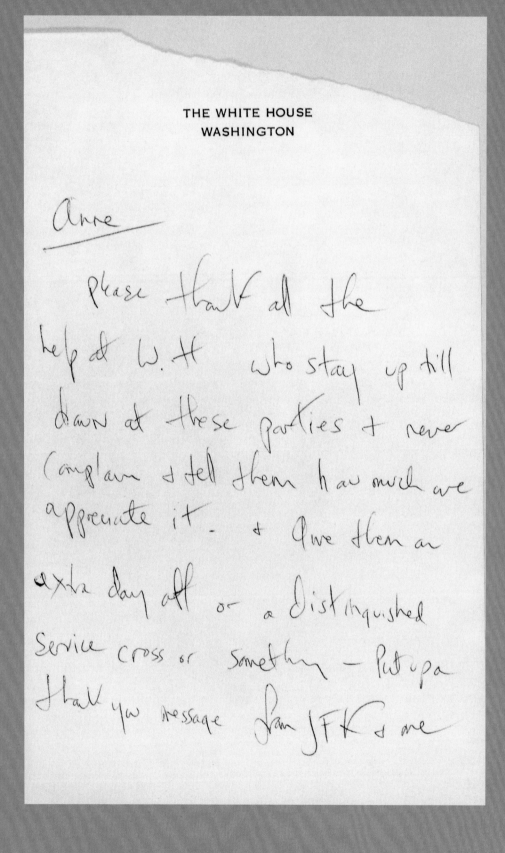

THE WHITE HOUSE
WASHINGTON

Anne

Please thank all the help at W.H who stay up till dawn at these parties & never complain & tell them how much we appreciate it. & Que them an extra day off or a Distinguished Service cross or something — Put up a thank you message from JFK & me

January 1964 / Washington, DC / "Anne, please thank all the help at W.H. who stay up till dawn at these parties and never complain and tell them how much we appreciate it. And give them an extra day off or a distinguished service cross or something. Put up a thank you message from JFK and me." Anne is Anne H. Lincoln, Assistant Social Secretary for the First Lady and chief of household staff.

May 30, 1963 / Washington, DC / Nancy Tuckerman, one of Jackie's social secretaries. Nancy worked at the White House as Staff Coordinator to Mrs. Kennedy, arranging all aspects of state dinners, state entertainment, ordering state gifts, and coordinating President Kennedy's receptions on his state visits abroad.

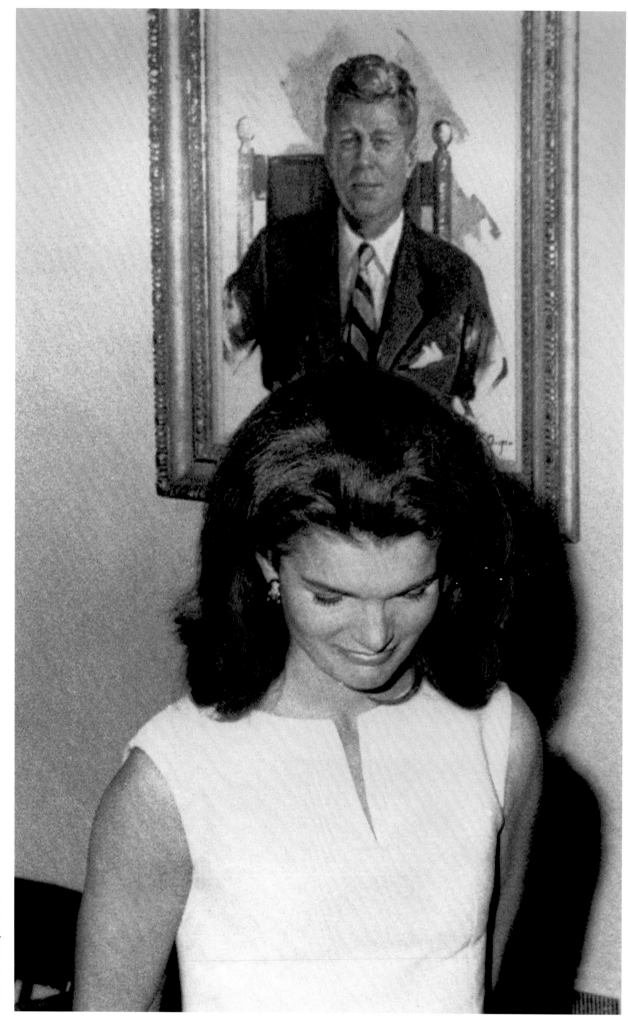

October 17, 1966 / Cambridge, MA / Jackie standing beneath a portrait of her late husband after the first meeting of the Advisory Committee for the Institute of Politics at Harvard University. Harvard renamed its Graduate School of Public Administration the John F. Kennedy School of Government and created within the school the Institute of Politics.

"All the changes in the world, for good or for evil, were first brought about by words." Jackie

December 29, 1966 / Antigua, British West Indies / Wearing a shirt to protect him from sunburn, John F. Kennedy, Jr. runs from the surf on the beach, where the family is spending a two-week vacation. During the family outing, Jackie took him swimming about fifty yards off shore.

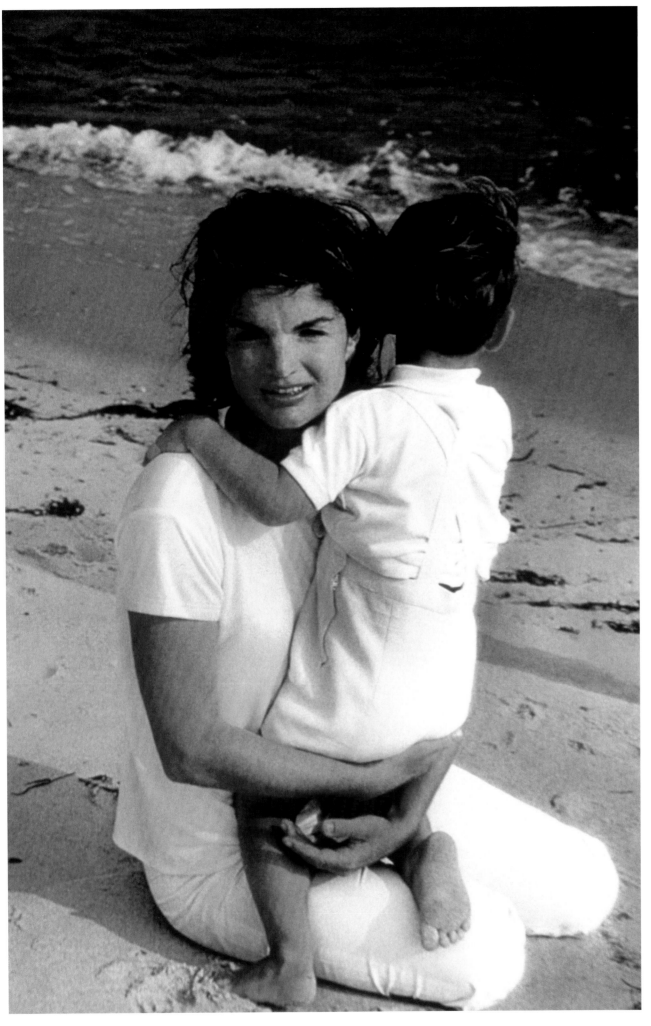

January 1, 1964 / Hyannis Port, MA / Jackie and John Jr. on the beach

157

January 15, 1966 / Gstaad, Switzerland / Jackie Kennedy spending a winter holiday with her children

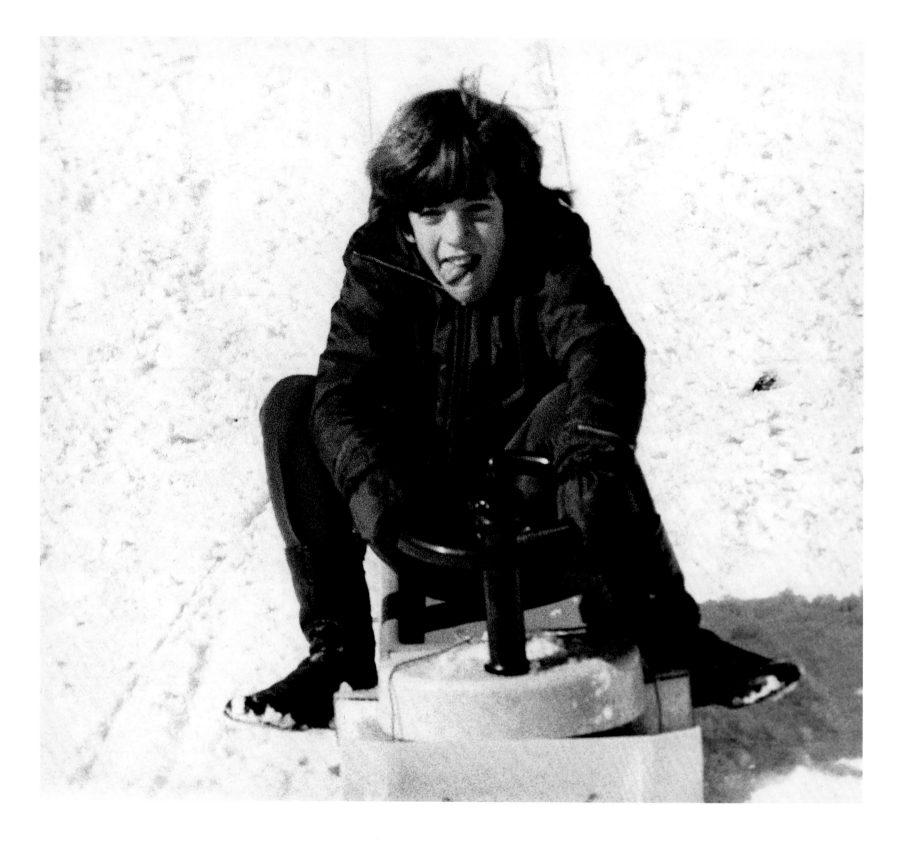

January 3, 1971 / New York, NY / John Kennedy, Jr. sleigh riding in Central Park

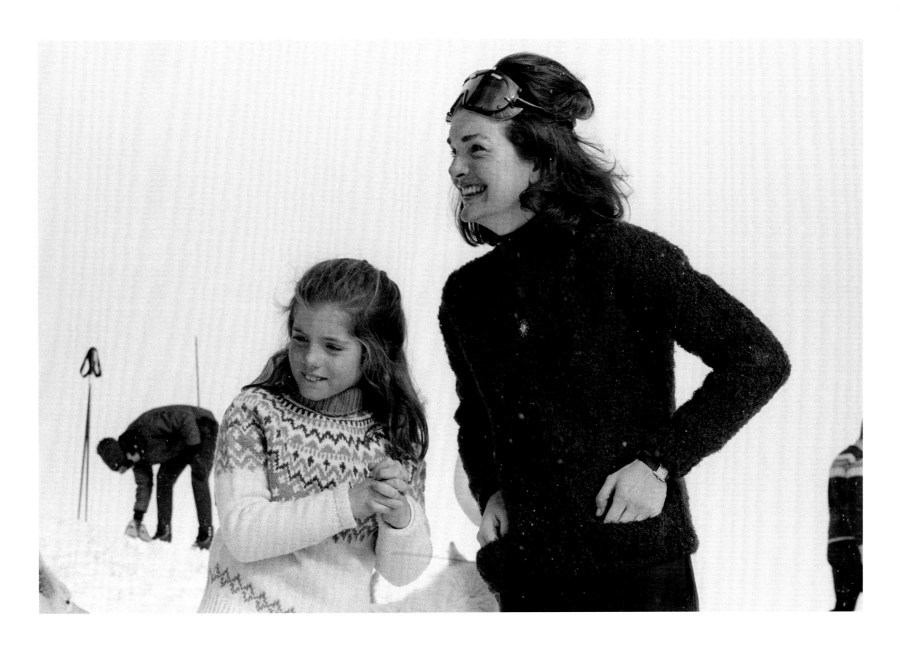

January 4, 1966 / Sun Valley, ID / Jackie and Caroline enjoying a joke during a family vacation at Sun Valley visiting with the family of Robert F. Kennedy

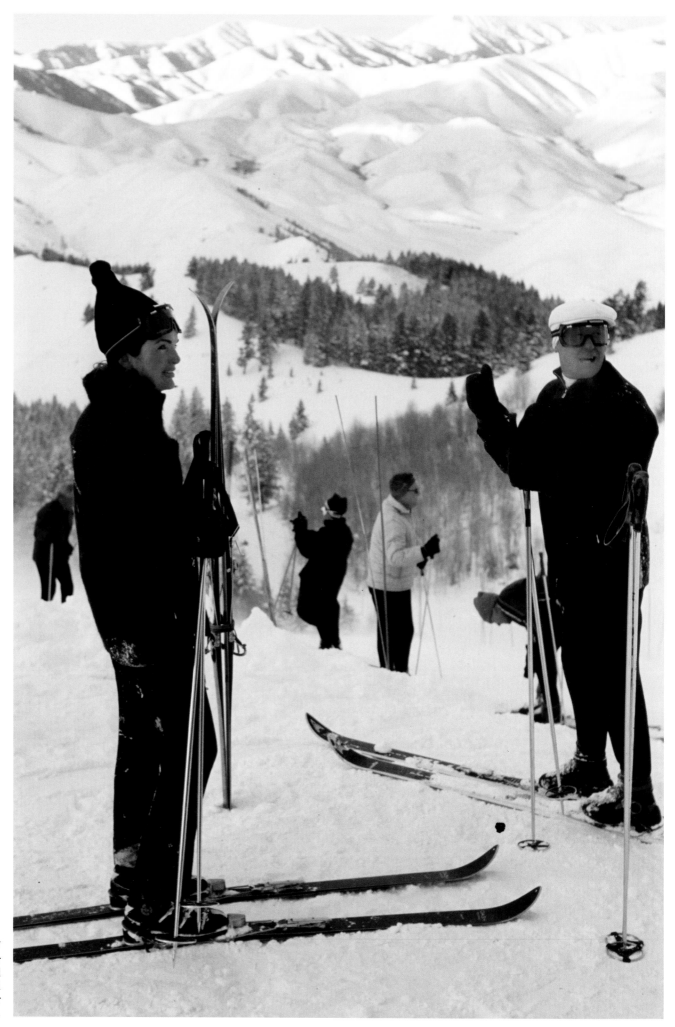

January 1, 1966 / Sun Valley, ID / Jackie Kennedy and ski instructor Sigi Engle on the slopes of Bald Mountain. Sigi Engle was also a ski instructor for Gary Cooper and Clark Gable.

January 15, 1966 / Gstaad, Switzerland / Jackie Kennedy spending a winter holiday with her children

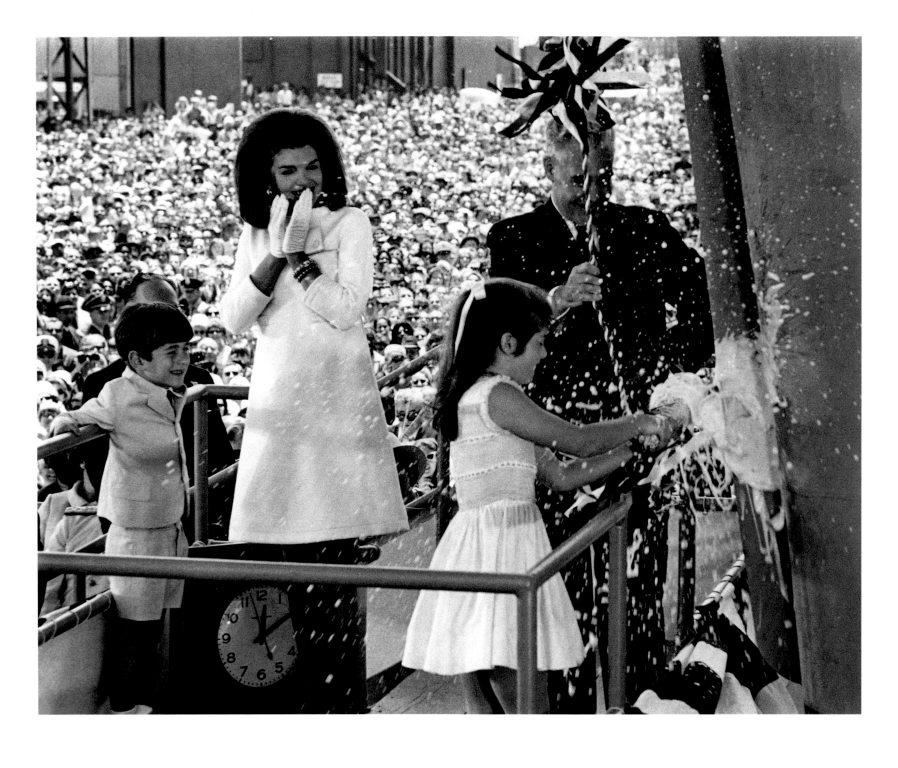

May 27, 1967 / Newport News, VA / Caroline Kennedy, nine years old, christening the USS John F. Kennedy. Assisting Caroline is Donald A. Holden, president of the shipyard company that built the aircraft carrier, which subsequently entered naval service September 7, 1968.

1966 / New York, NY / An elegant Jackie Kennedy attending a charity event at the Lincoln Center for the Performing Arts for the Committee to Rescue Italian Art. Jackie assumed the honorary presidency of this organization, which was created when the Arno River overflowed, threatening the artistic treasures of Florence.

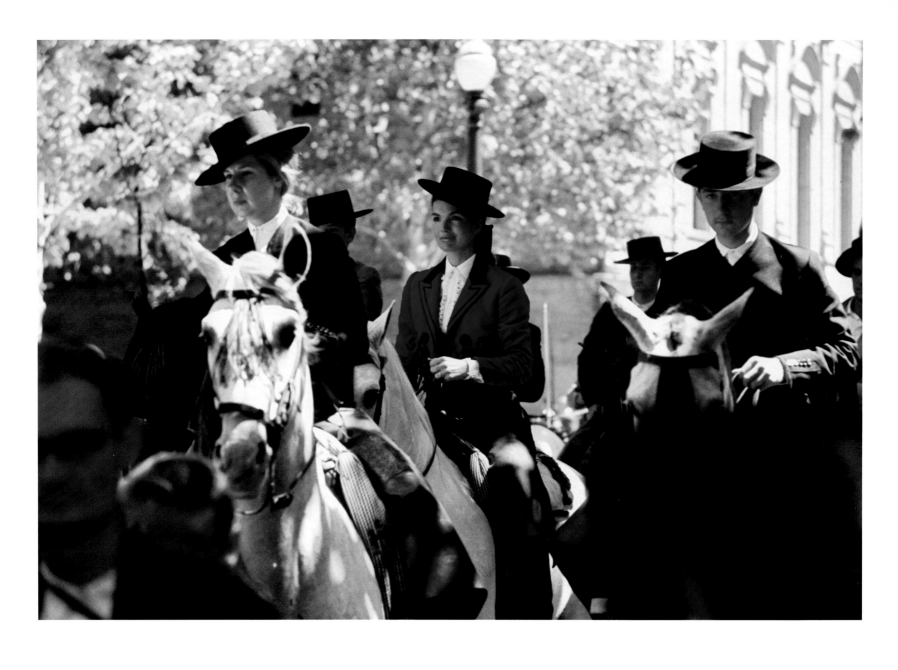

April 22, 1966 / Seville, Spain / Jackie and her hostess, the Duchess of Alba, wearing typical Andalusian riding outfits as they ride through Seville's Spring Fair

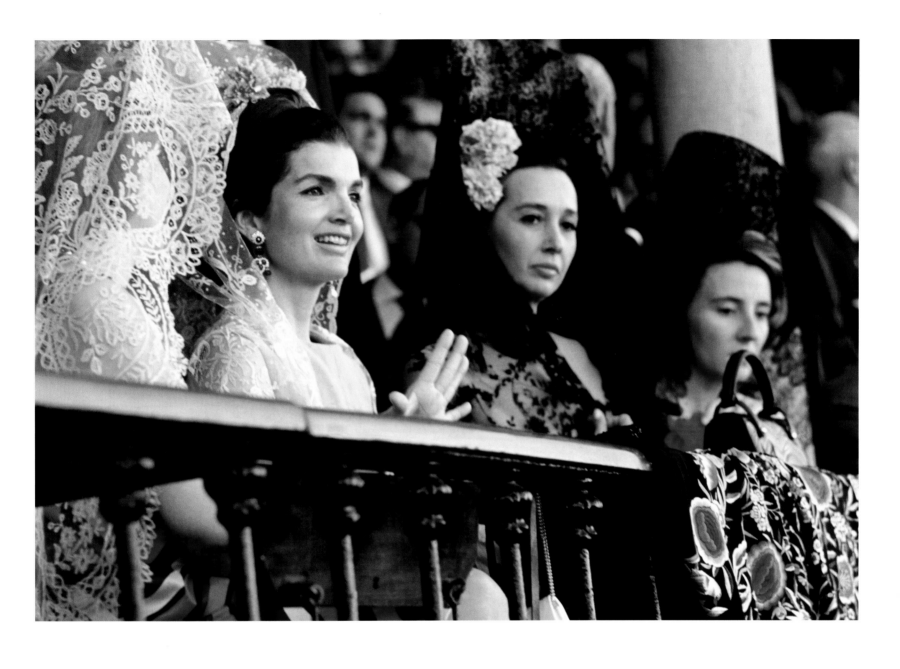

April 21, 1966 / Seville, Spain / Jackie Kennedy and her hostess, the Duchess of Alba, wearing mantillas of white lace, attending the Seville bullfights

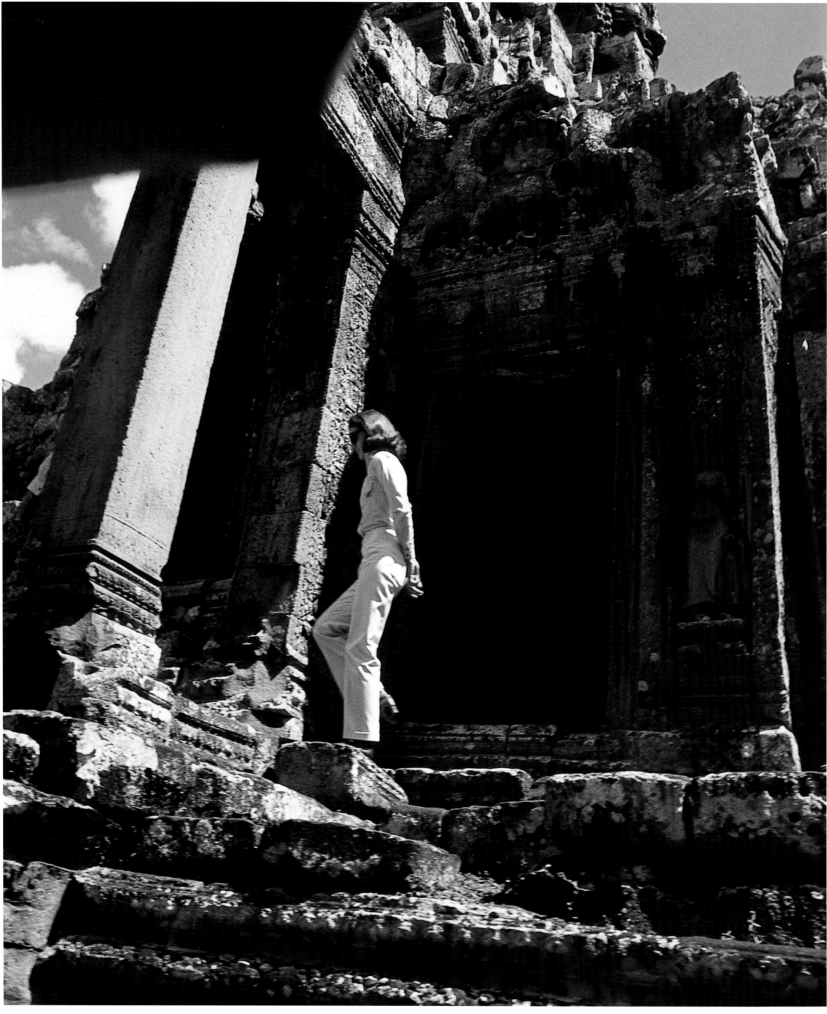

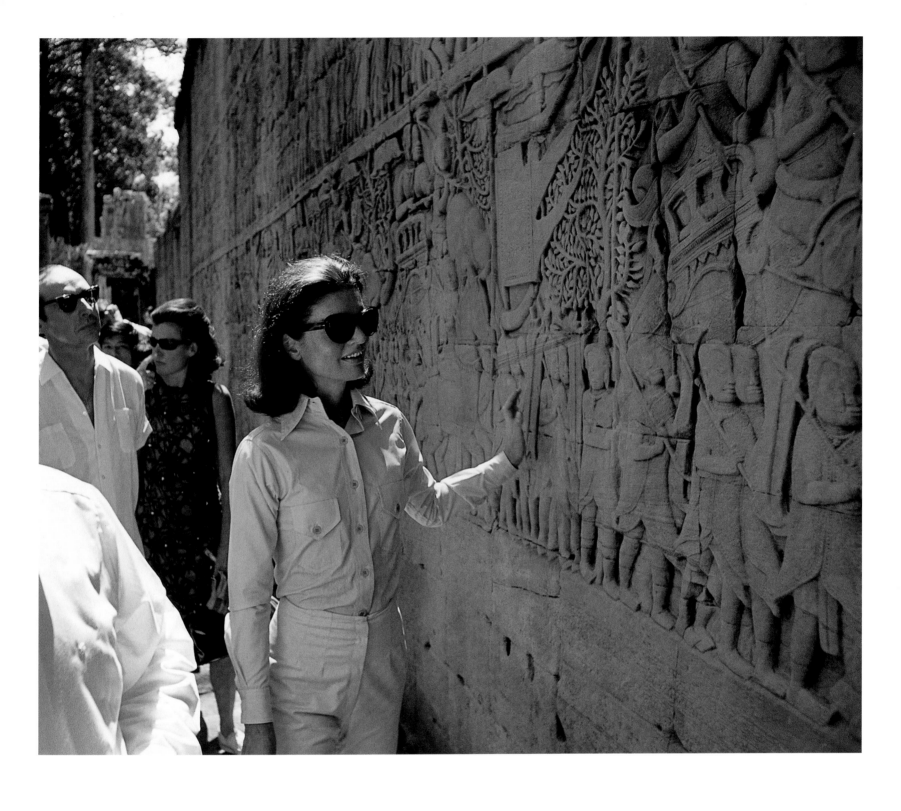

November 6, 1967 / Angkor, Cambodia / Jackie Kennedy at Banteay Srei ("Citadel of the Woman")

November 6, 1967 / Angkor, Cambodia / Jackie Kennedy, Mrs. Charles Bartlett, and Lord Harlech, a former British ambassador to the United States and longtime friend, at Banteay Srei

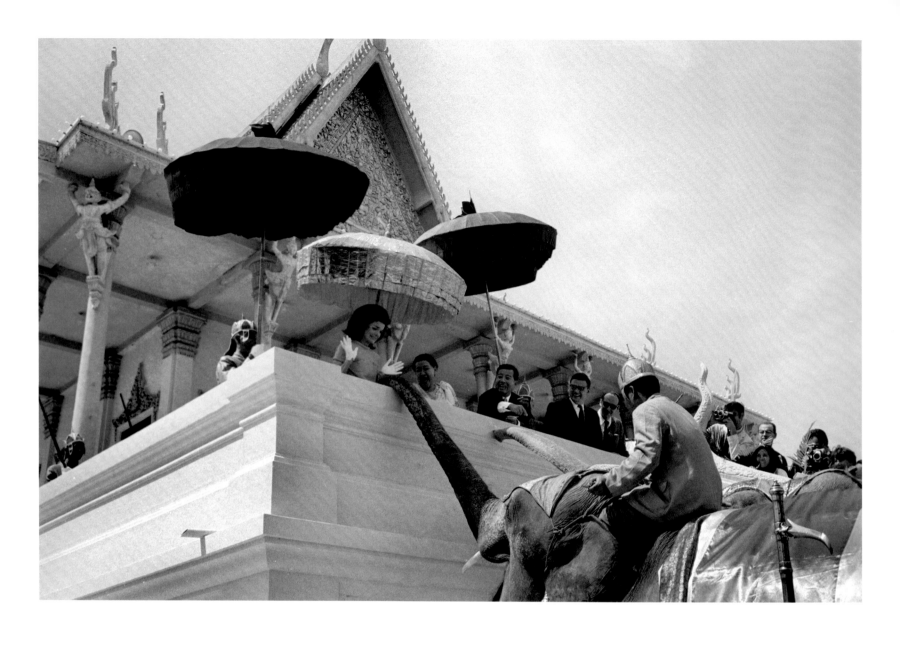

November 9, 1967 / Khemarin Palace, Phnom Penh, Cambodia / With members of Cambodia's royal family watching in great amusement, Jackie seems very surprised as a royal elephant she was feeding places his trunk a little too close for her comfort. Next to Mrs. Kennedy is Queen Kossamak Nearireath and her son, Cambodia's chief of state, Prince Norodom Sihanouk. Concerned with the Vietnamese Communist buildup in sanctuaries and fearing a large-scale U.S. attack across his borders, Prince Norodom Sihanouk invited Jackie Kennedy for a visit, allowing her to fulfill a "lifelong dream of seeing Angkor Wat." In March 1969, Sihanouk invited Jackie Kennedy for another visit and re-established relations with the U.S. But it was too late to avoid a U.S. invasion. At the end of April 1970, the U.S. invaded Cambodia.

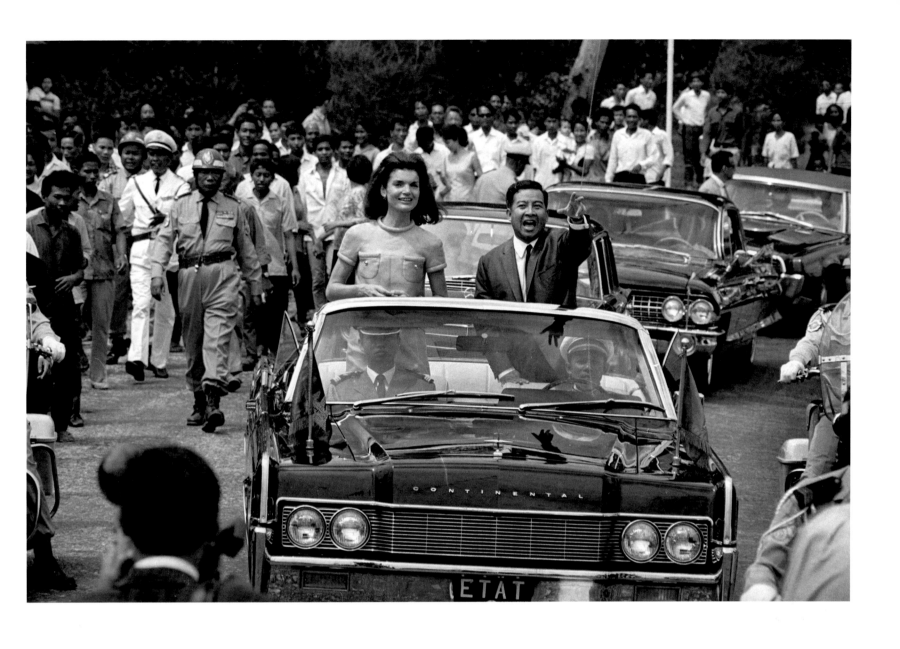

November 6, 1967 / Sihanoukville, Cambodia / Jackie Kennedy and Chief of State Norodom Sihanouk during a motorcade.
Jackie earlier dedicated a boulevard to her late husband as thousands of Cambodians cheered.

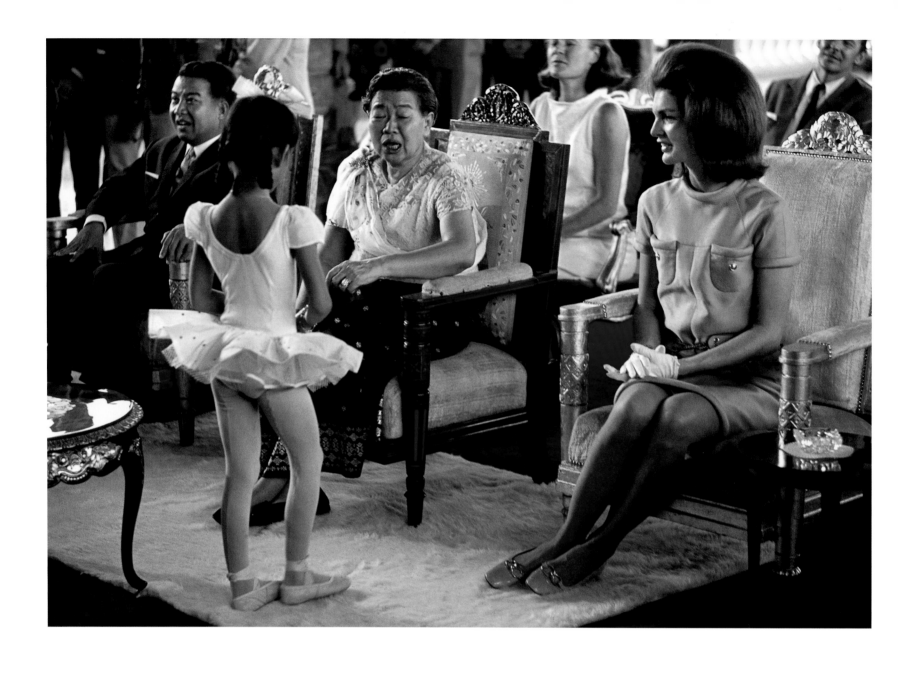

November 6, 1967 / Phnom Penh, Cambodia / A young Cambodian ballerina in front of her distinguished audience in the throne room of Khemarin Palace.
From right to left: Jackie Kennedy, Queen Kossamak Nearireath, and Chief of State Prince Norodom Sihanouk

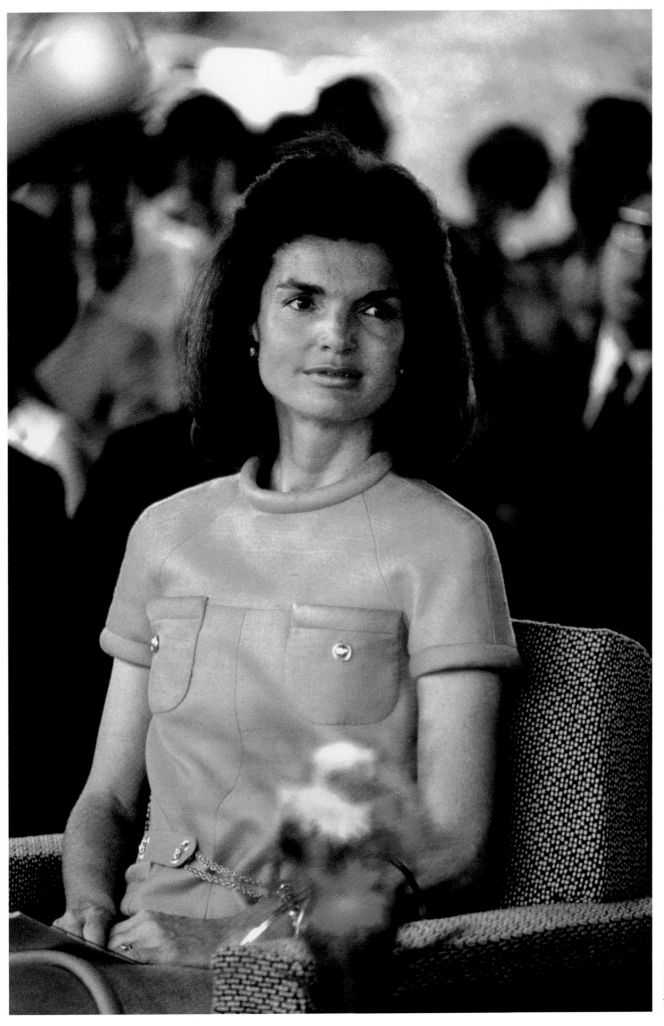

November 6, 1967 /
Phnom Penh, Cambodia /
Jackie Kennedy on a six-day
trip to Cambodia

173

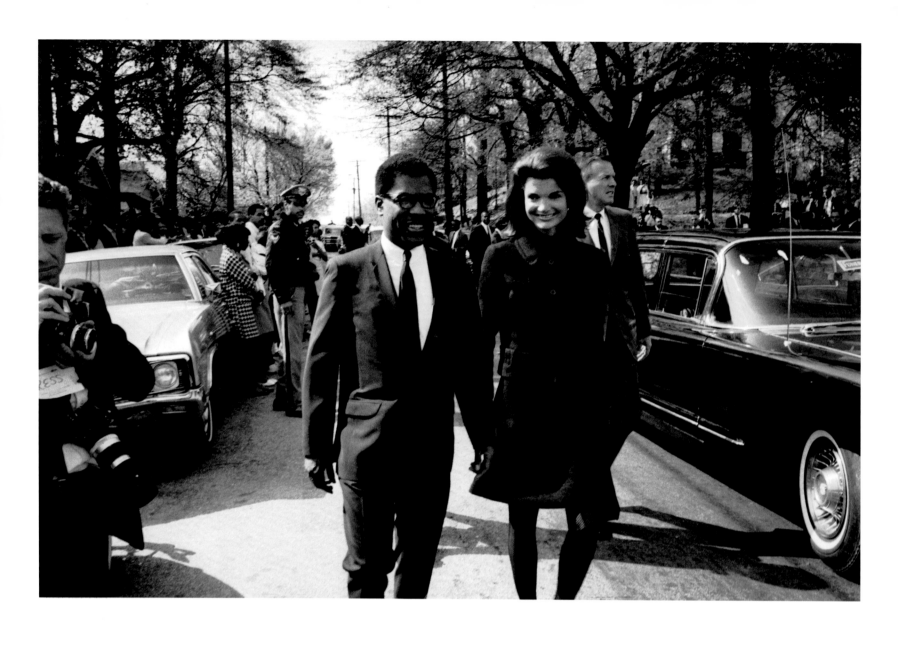

April 9, 1968 / Atlanta, GA / Jackie departing from the home of Coretta Scott King, Mrs. Martin Luther King, Jr., where she paid her respects to the widow of the slain Civil Rights leader following King's funeral

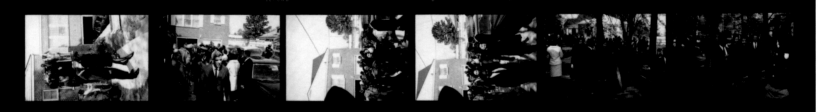

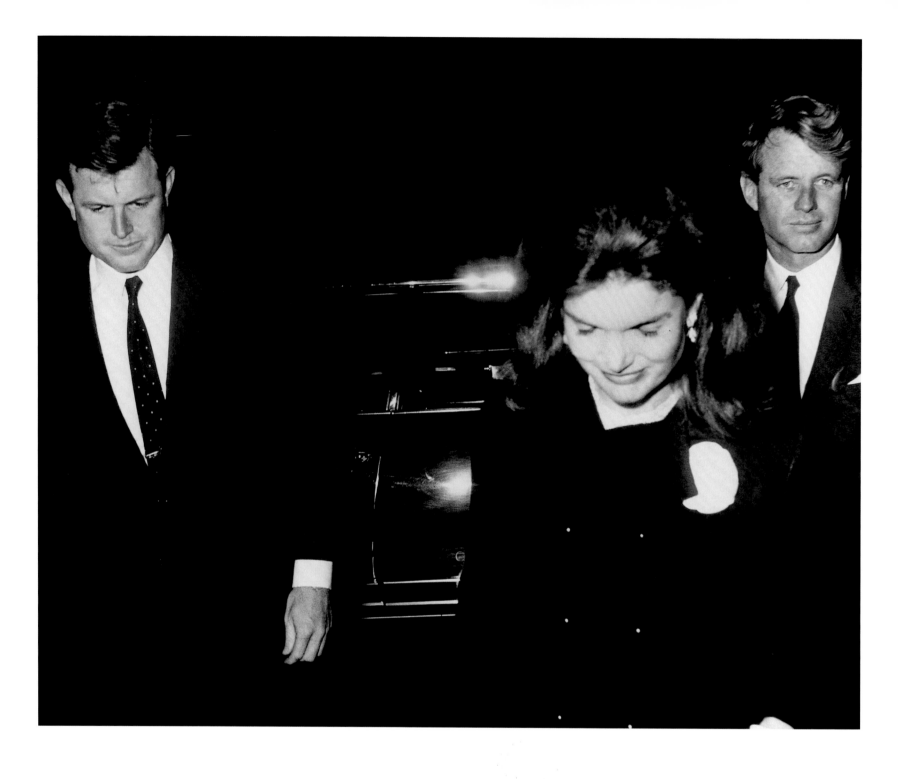

September 1966 / Jackie Kennedy accompanied by the brothers of her late husband, John F. Kennedy

September 25, 1965 / Boston, MA / Jackie Kennedy with her brother-in-law Edward Kennedy during a benefit ball. It is her first social appearance since the assassination of her husband.

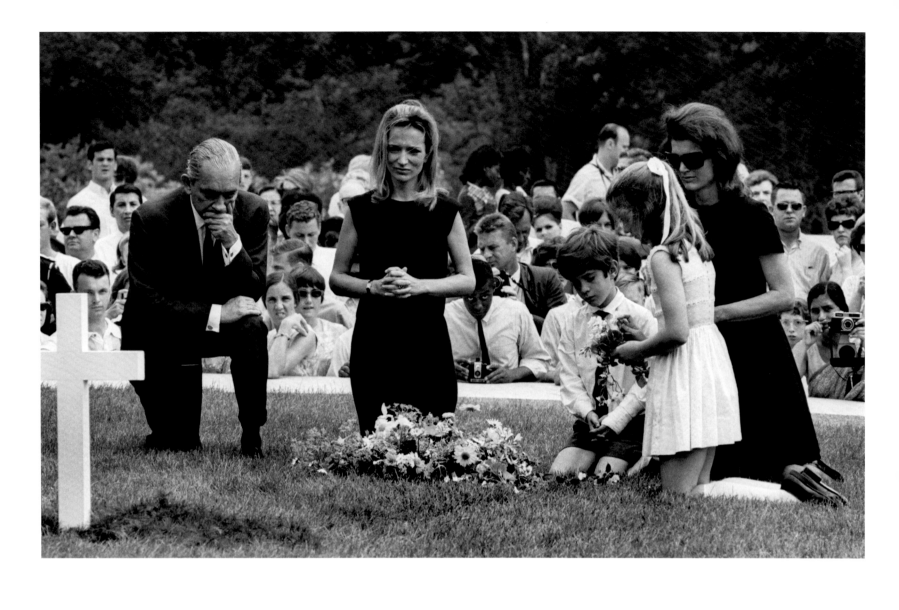

April 9, 1968 / Atlanta, GA / Jackie Kennedy leaving the home of Coretta Scott King, Mrs. Martin Luther King, Jr., after paying the widow her respects

June 9, 1968 / Arlington, VA / Lee Radziwill, Jackie Kennedy, and her children kneeling at the grave of Robert F. Kennedy. The Senator, who took care of Jackie and her children after John F. Kennedy's assassination, was assassinated while running for president in 1968.

"The only routine with me is no routine at all." Jackie

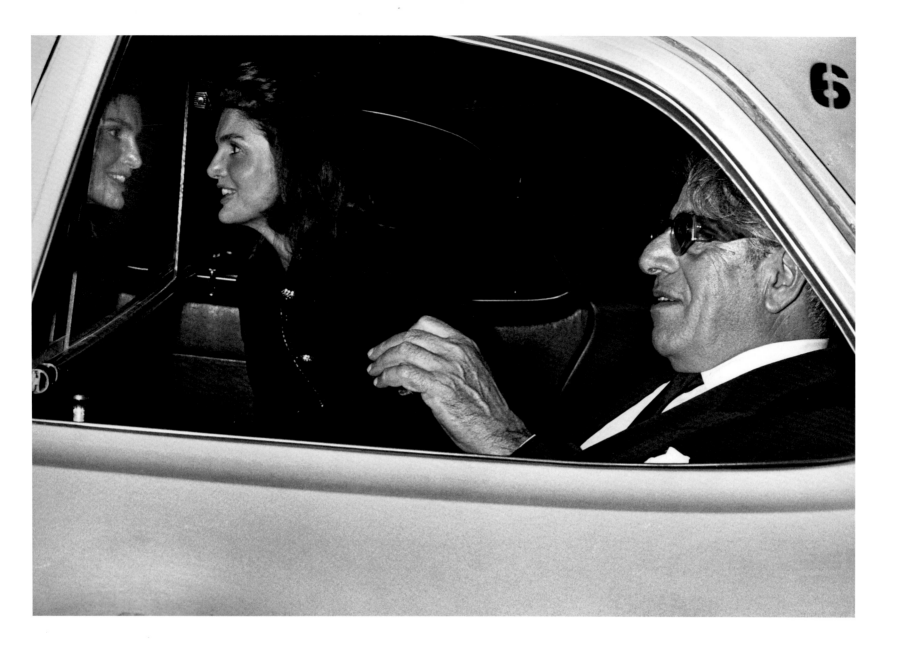

September 21, 1969 / New York, NY / Jackie and Aristotle Onassis at John F. Kennedy International Airport

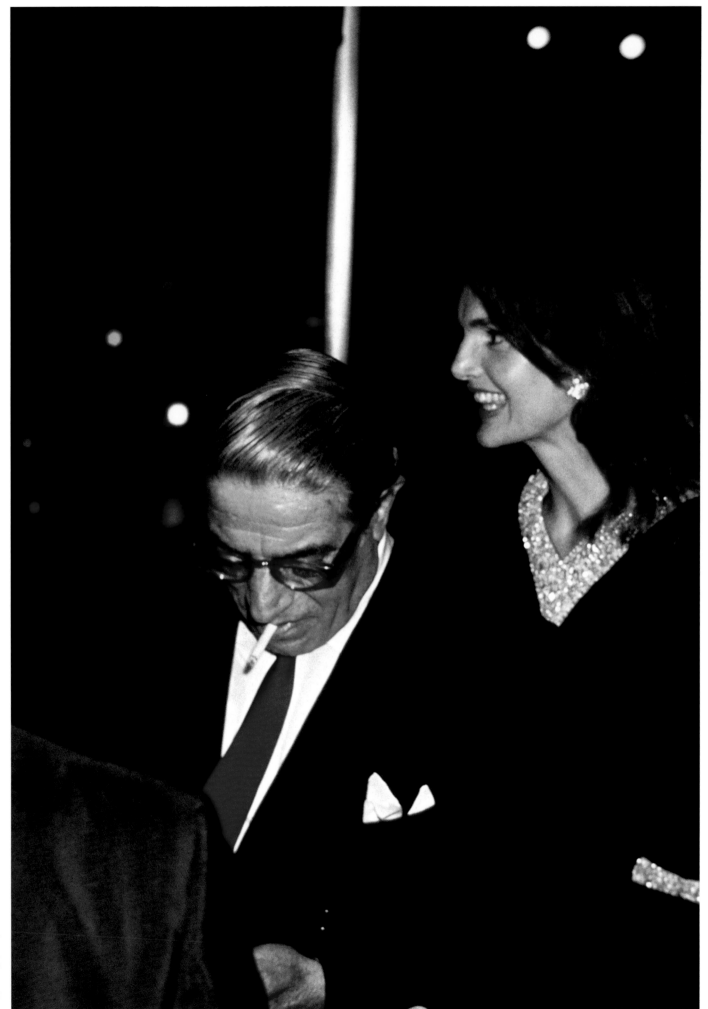

October 15, 1969 /
New York, NY / Jackie and
Aristotle Onassis after
dinner at La Côte Basque,
their favorite restaurant
in Manhattan

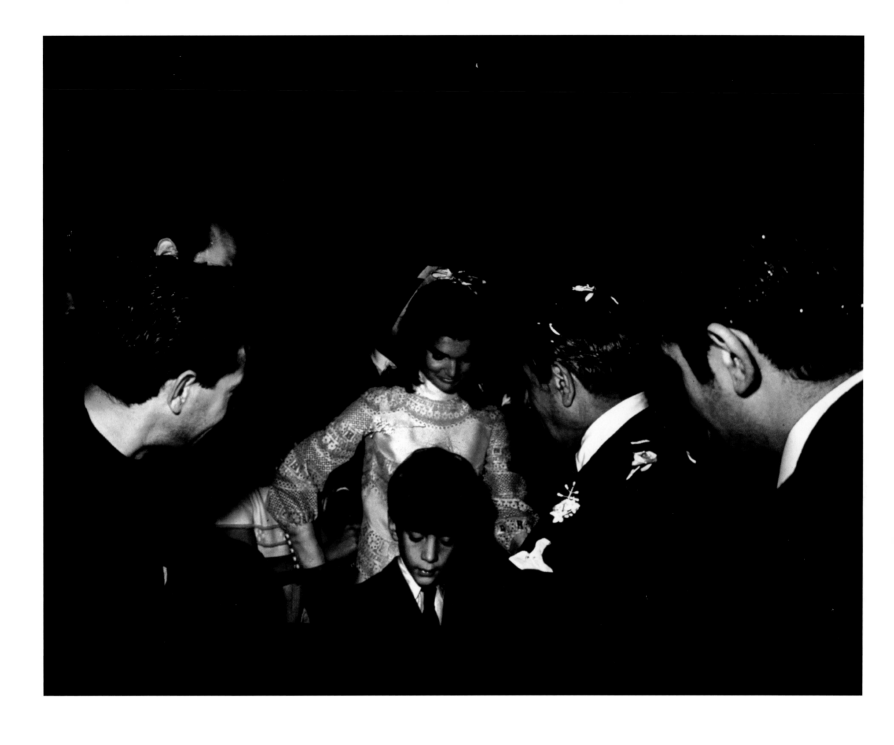

October 20, 1968 / Skorpios, Greece / John F. Kennedy, Jr., seven years old, standing in front of his mother and new stepfather, Aristotle Onassis, during their wedding on Onassis' private island of Skorpios

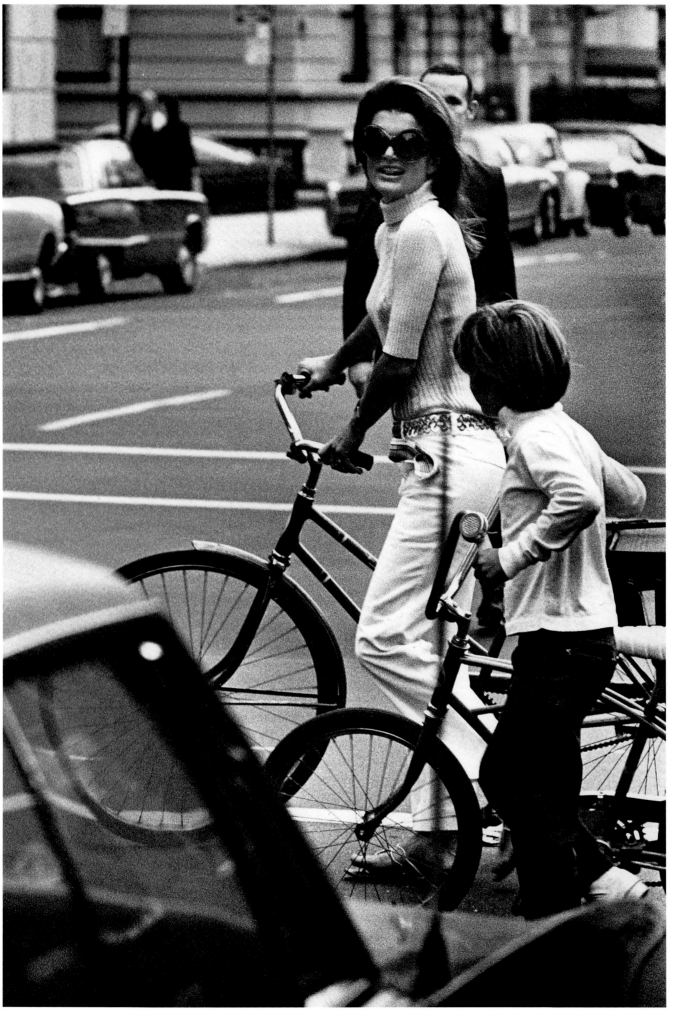

May 6, 1969 /
Peapack, NJ / Jackie and
children at a candy store

September 24, 1969 /
New York, NY / Jackie and John
Jr. riding bikes in Manhattan

June 9, 1969 / New York, NY / Through the revolving door of La Côte Basque, Jackie casually smoking a cigarette with Aristotle Onassis and friends

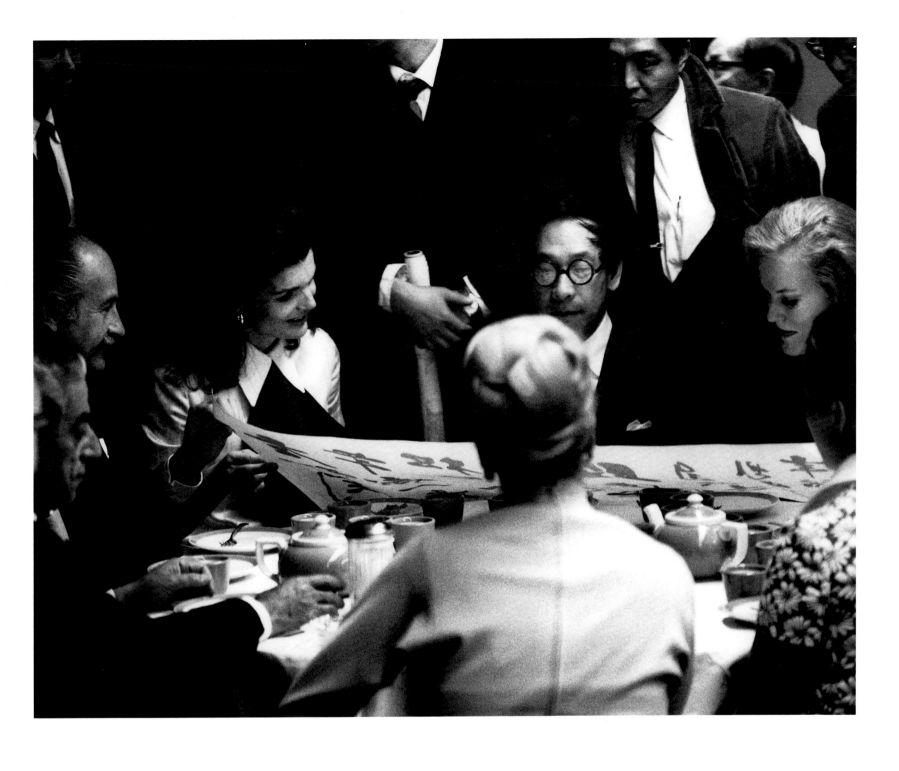

February 1969 / New York, NY / Jackie and Aristotle Onassis at a Chinese restaurant, having dinner with the famous architect, I.M. Pei, who designed the JFK Library in Boston and the Pyramide du Louvre in Paris

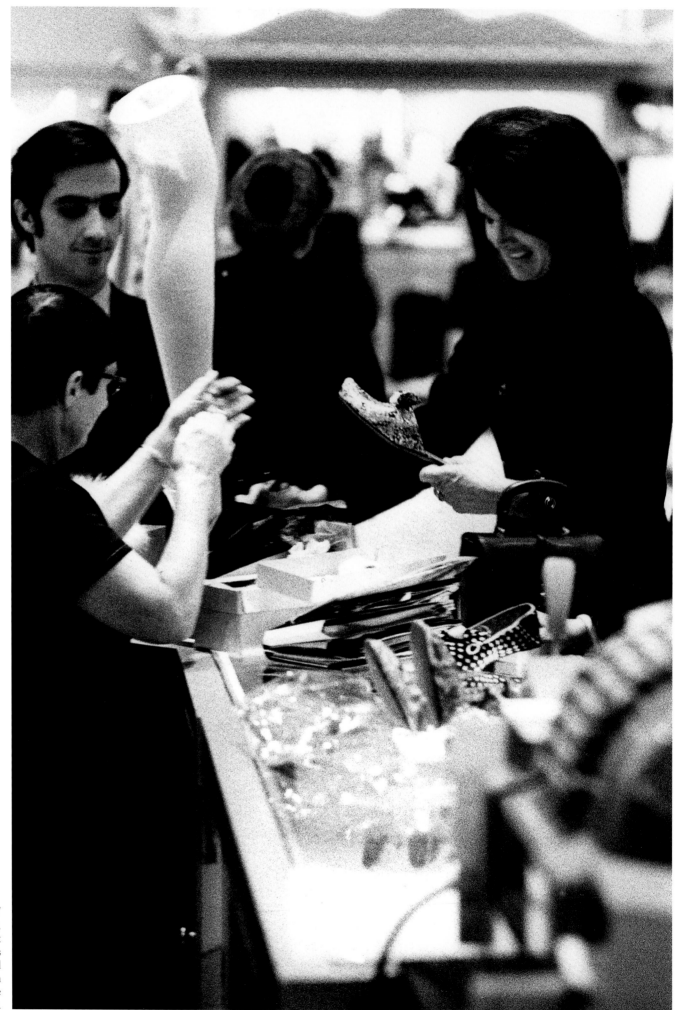

May 6, 1970 / New York, NY / Jackie shopping in Bonwit Teller, a department store that specialized in high-end women's apparel. In May 1990 Donald Trump demolished the Fifth Avenue store in order to make room for the Trump Tower.

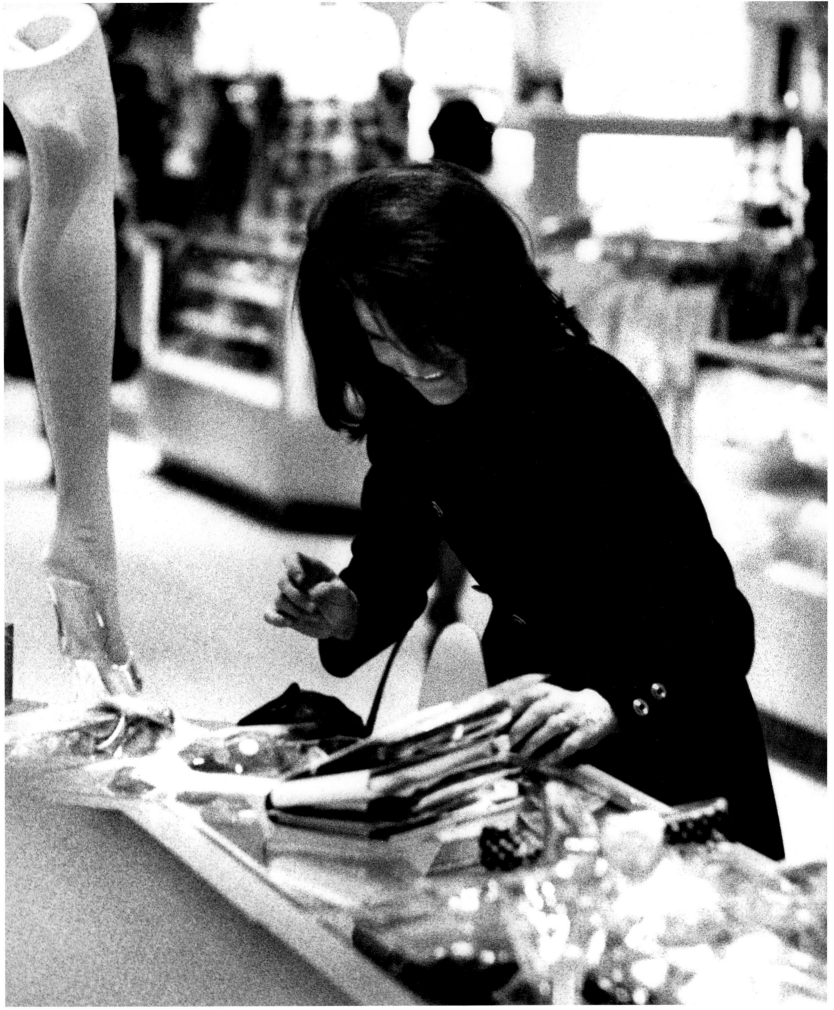

May 10, 1970 / Peapack, NJ / Jackie Kennedy on the day John Jr. won a blue ribbon at the Peapack Annual Horse Show

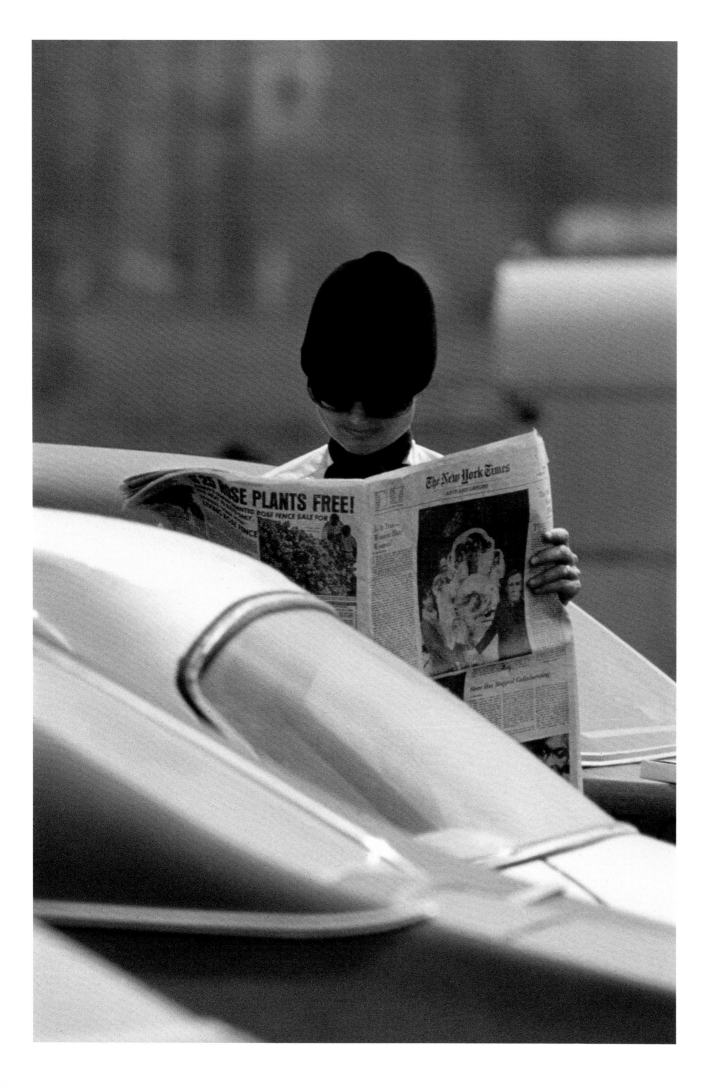

August 1970 / Skorpios, Greece / Jackie and Lee Radziwill at the beach house of Aristotle Onassis

July 1970 / Skorpios, Greece / Caroline, John Jr, and their governess starting the engine of their motorboat

August 1970 / Skorpios, Greece / John Jr. in his boat off the isle of Skorpios

August 1970 / Ischia, Italy / Jackie and Aristotle Onassis in their boat

August 24, 1970 /
Capri, Italy / Jackie with
her sister, Lee

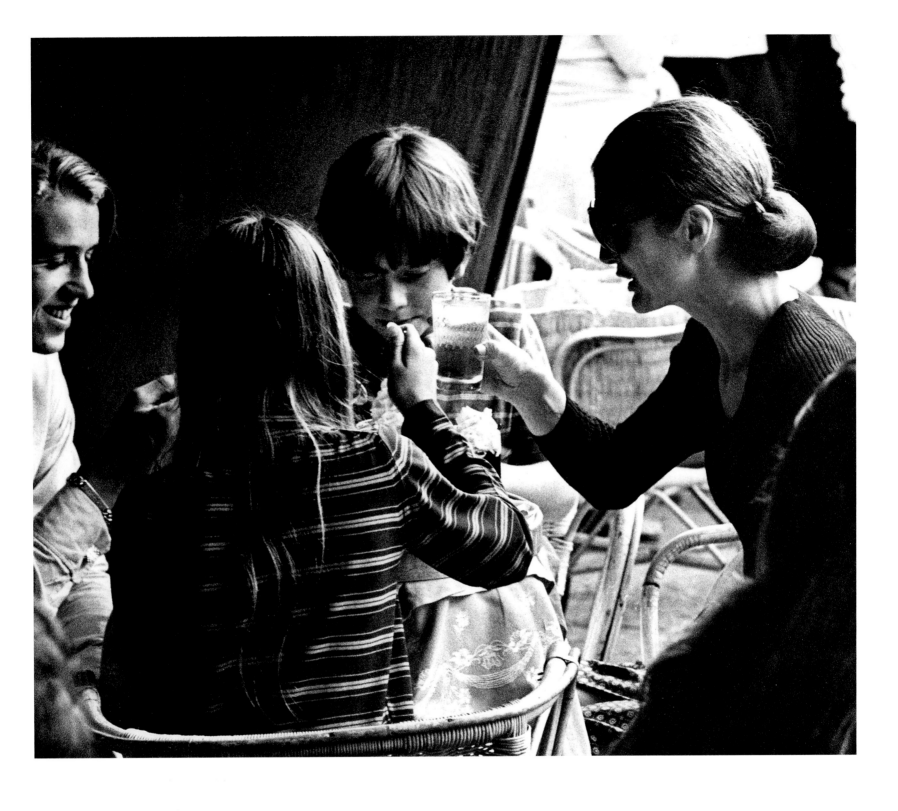

August 24, 1970 / Capri, Italy / Jackie with her niece and nephew, Christina and Anthony Radziwill, in a café

"Jackie may have been an angel many times, but she was not a saint."

Yusha Auchincloss

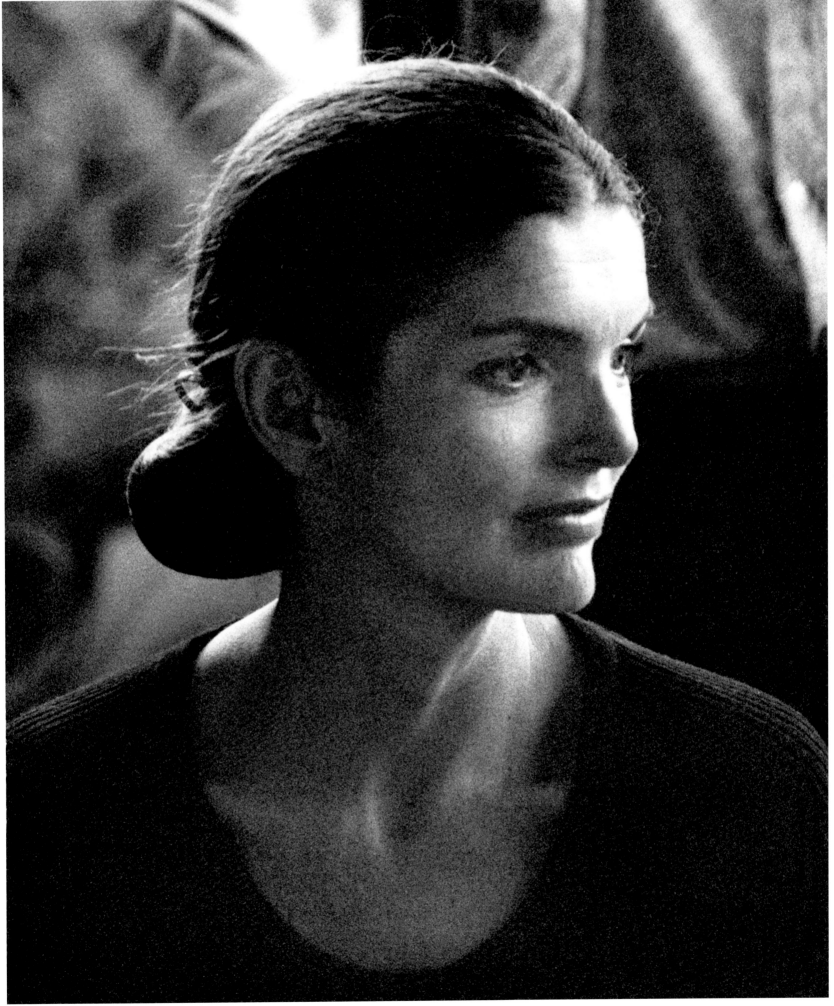

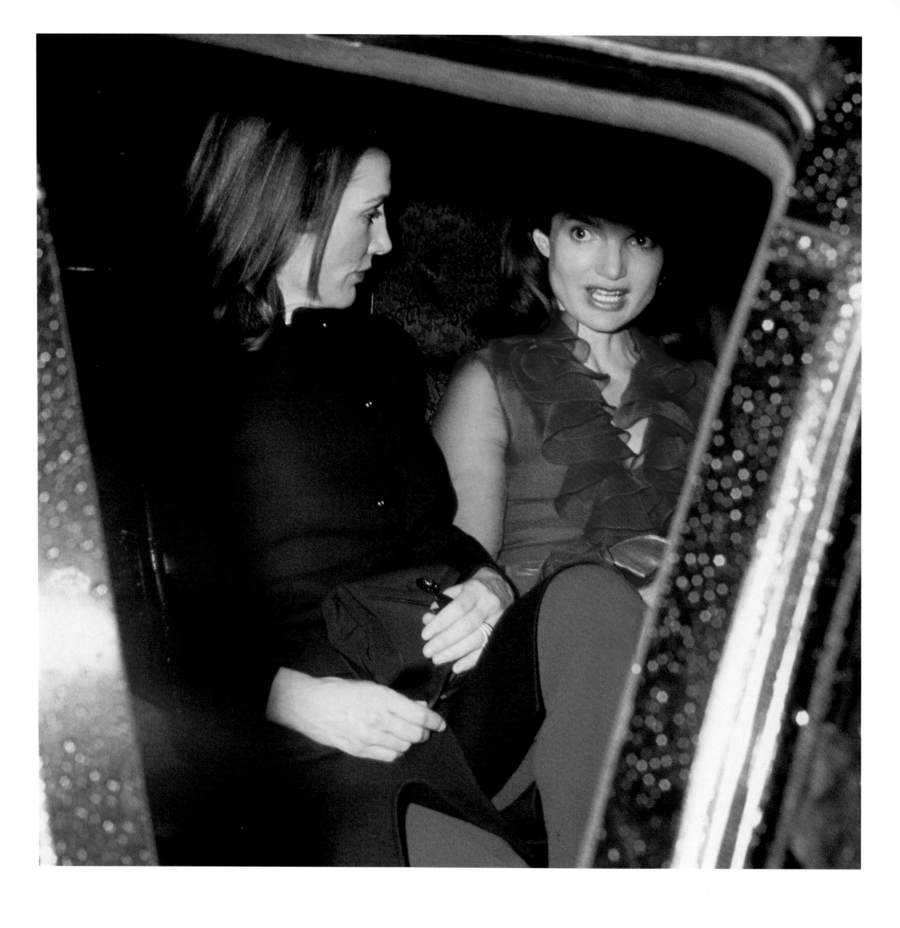

November 14, 1970 / New York, NY / Jackie wearing a red Valentino dress for a dinner at La Côte Basque with Aristotle Onassis, Prince Stanislas and Lee Radziwill, and Pierre Salinger

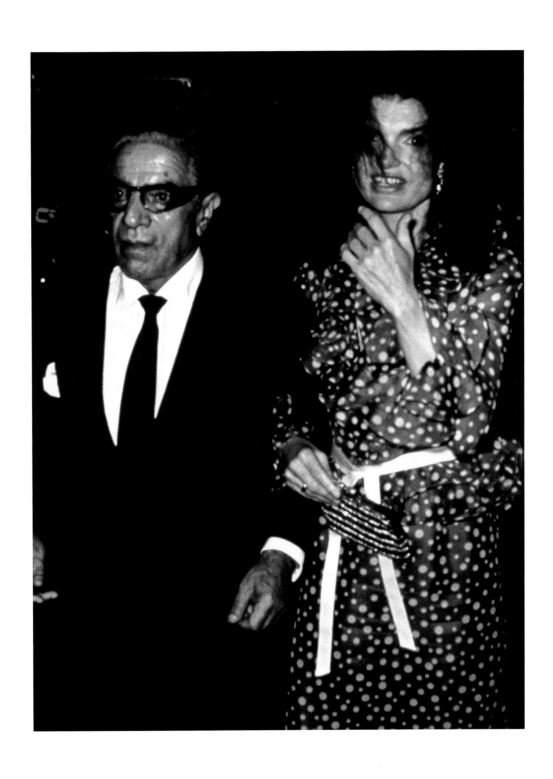

1970 / New York, NY / Jackie and Aristotle Onassis walking up Fifth Avenue to Jackie's apartment after dinner at La Côte Basque

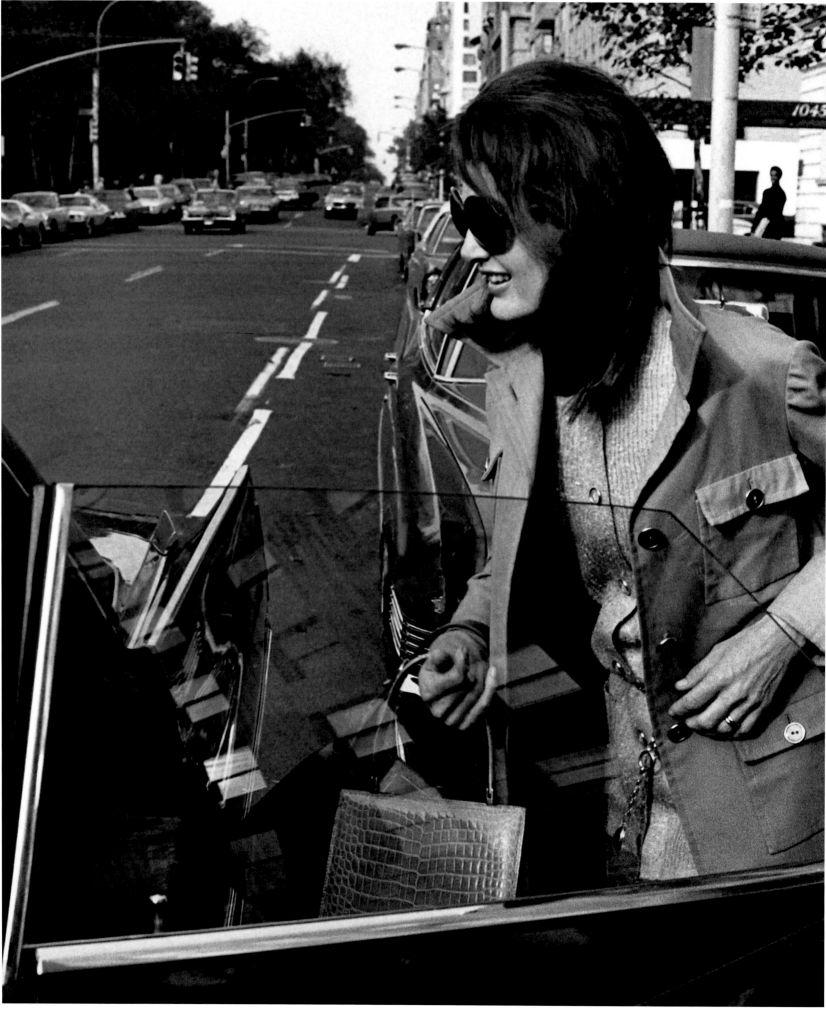

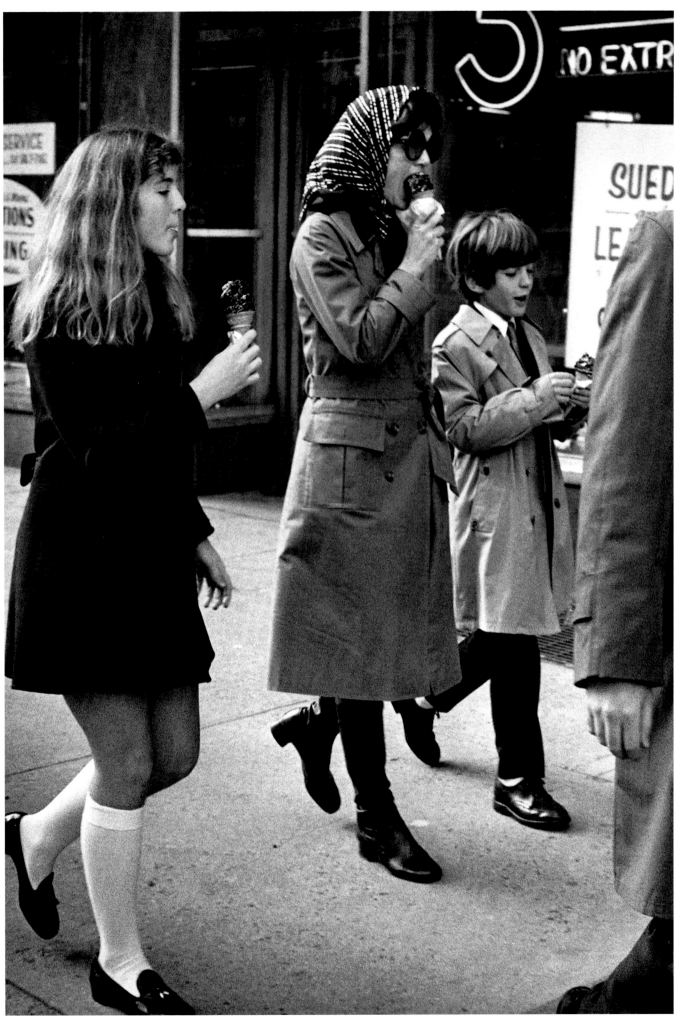

October 15, 1970 /
New York, NY / Jackie
shopping at the Bonwit Teller
department store

December 18, 1970 /
New York, NY / Jackie, Caroline,
and John Kennedy, Jr. enjoying
ice cream while walking on
Broadway after picking John Jr.
up at school

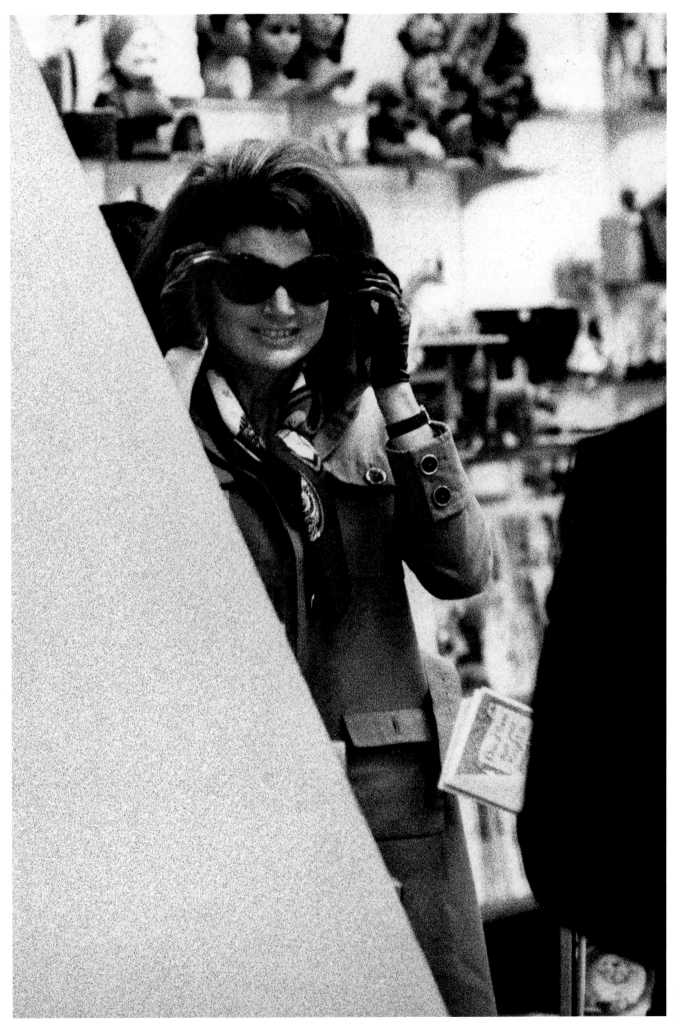

October 15, 1970 /
New York, NY / Jackie buying
magazines at JFK Airport

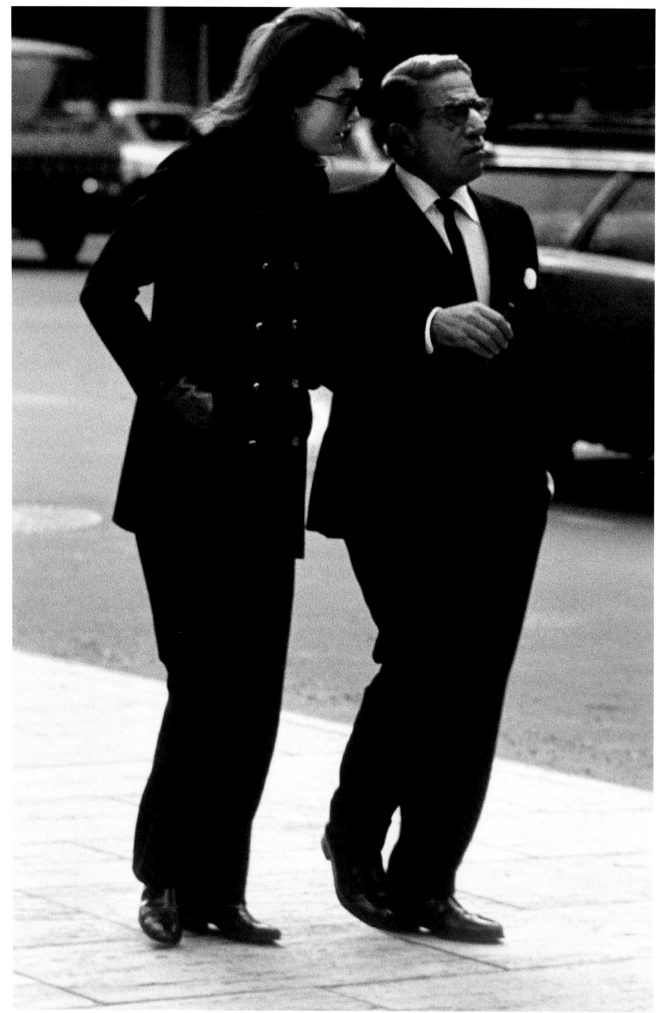

January 17, 1971 /
New York, NY / Jackie and Aristotle
Onassis departing P.J. Clarke's
restaurant. This eatery, noted for its
hamburgers, was a favorite weekend
lunch spot for the duo. Following
lunch this Saturday afternoon, they
stopped in the King Carol Record
Store and then hopped a cab to
Bloomingdale's for some
"real shopping."

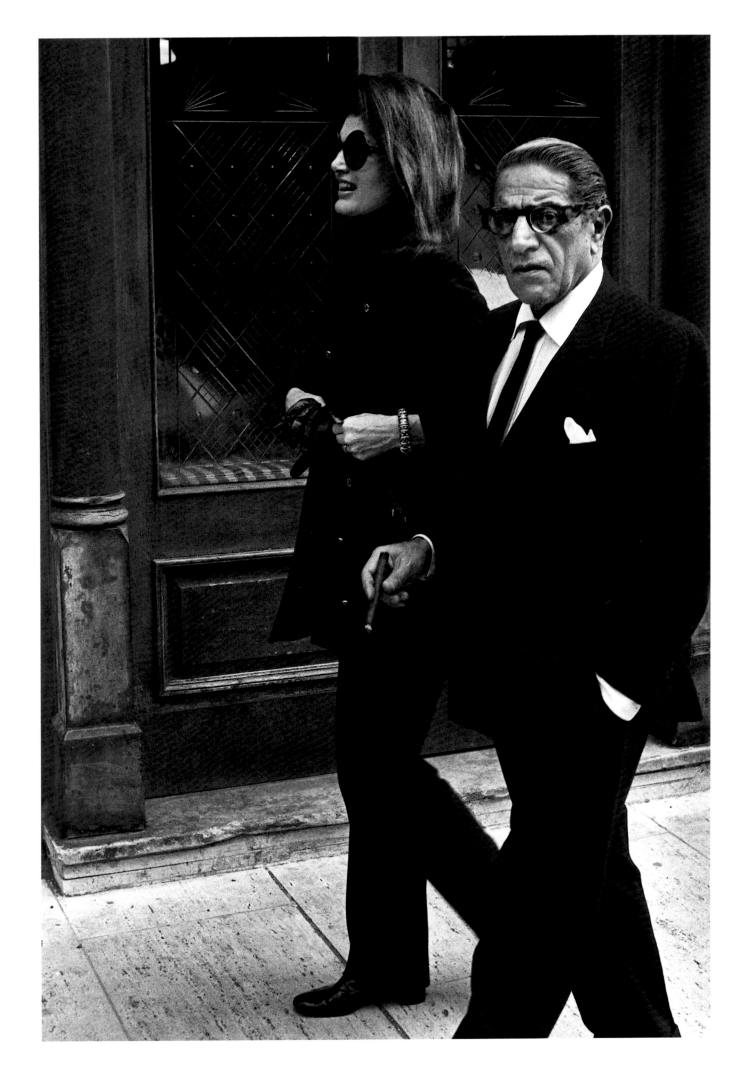

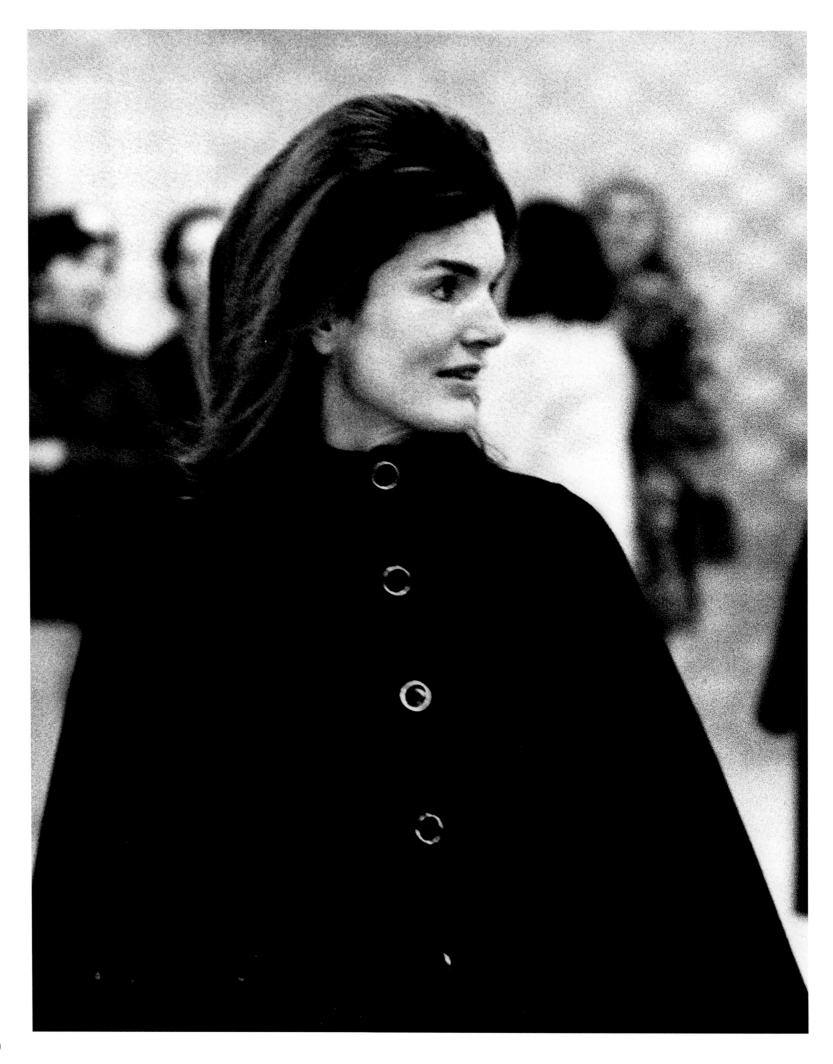

"No one else looked like her, spoke like her, wrote like her, or was so original in the way she did things." Senator Edward Kennedy

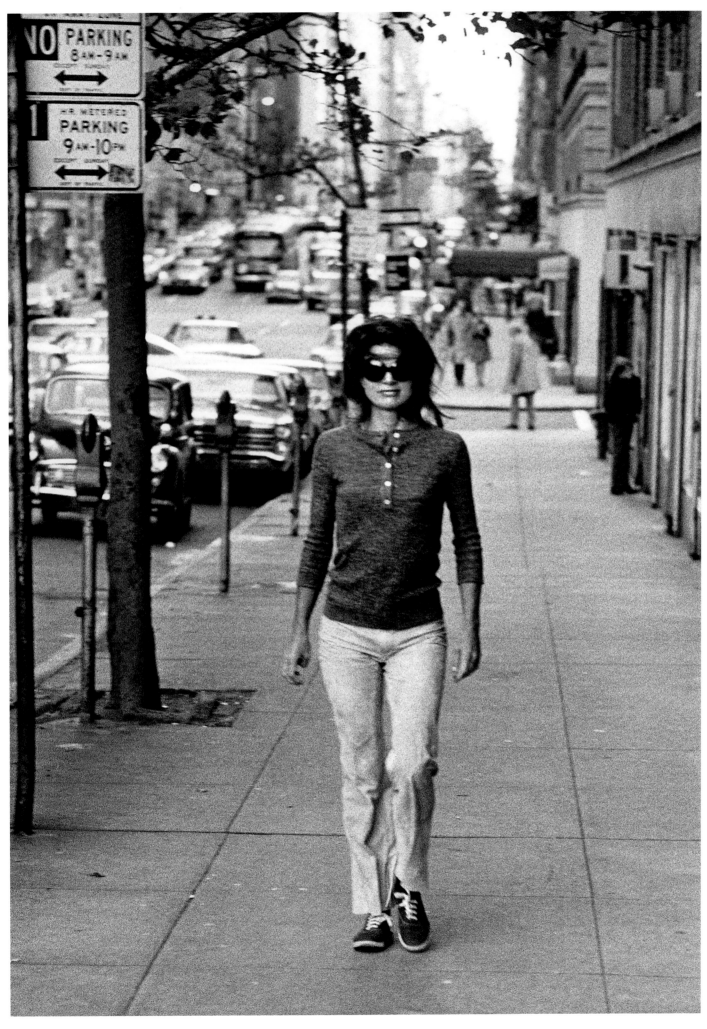

October 4, 1971 /
New York, NY / Jackie
watching a tennis match in
Central Park

October 7, 1971 /
New York, NY / Jackie
walking on Madison
Avenue

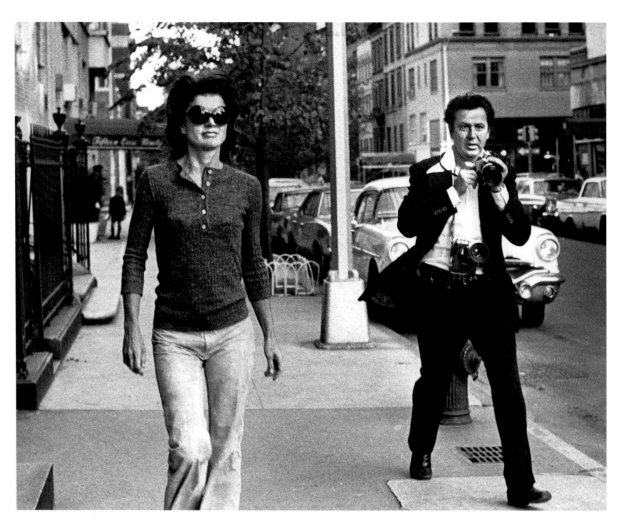

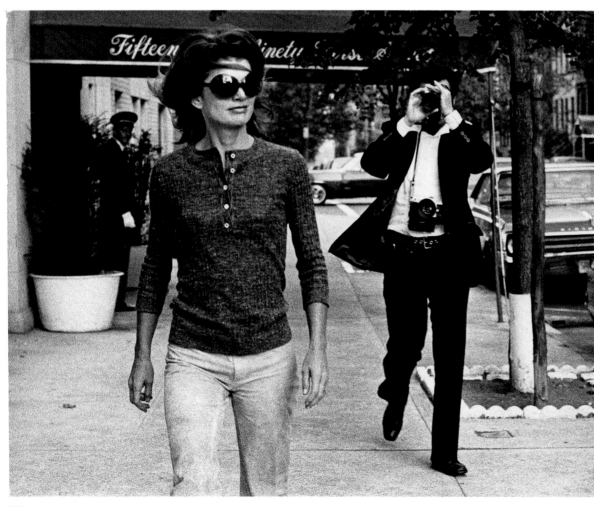

October 7, 1971 / New York, NY /
Jackie walking on Madison Avenue while
photographer Ron Galella takes several
shots of her

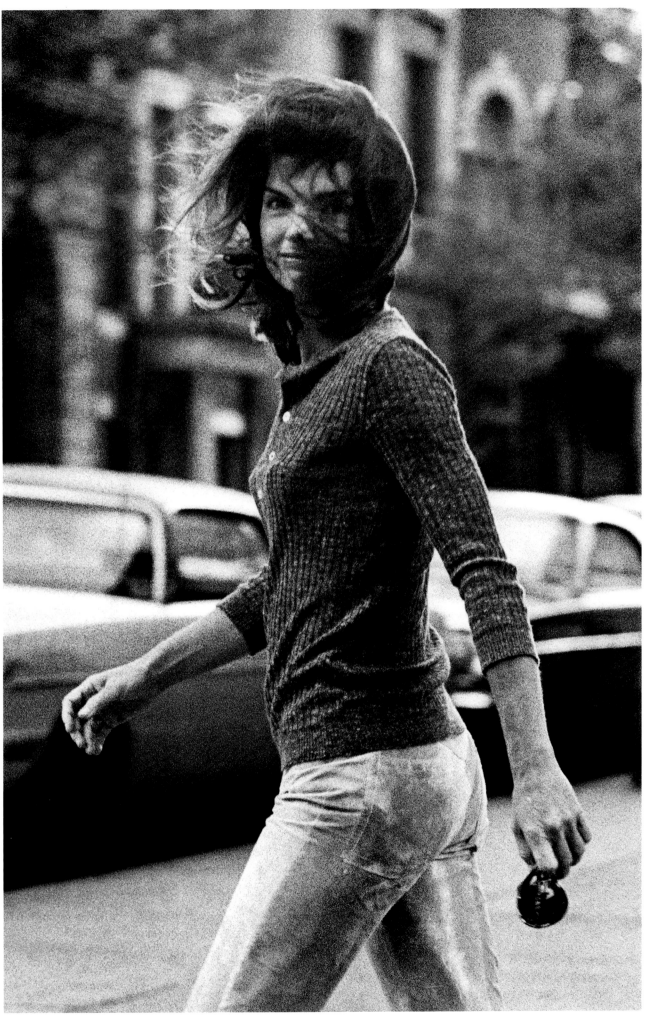

October 7, 1971 / New York, NY /
Jackie on Madison Avenue

December 1, 1971 / New York, NY / Jackie walking the dog in a bizarre outfit. Later that evening she attended the Shakespeare play *The Two Gentlemen of Verona*.

December 1, 1971 / New York, NY / Jackie leaving the Russian Tea Room to see Shakespeare's *The Two Gentlemen of Verona*

October 4, 1973 / Paris, France /
Jackie Onassis during a visit to Paris

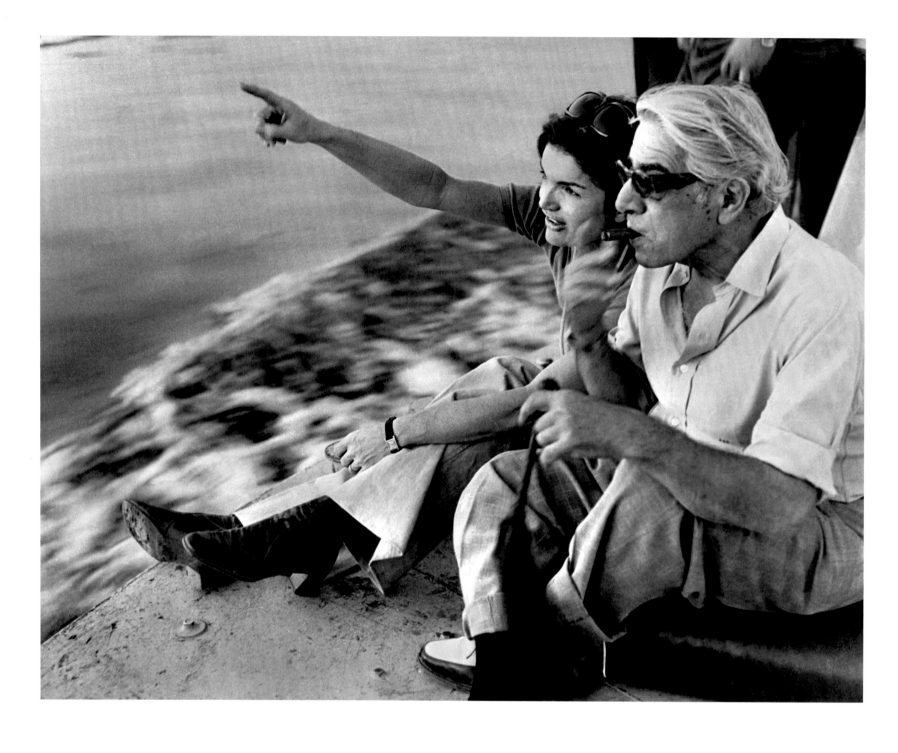

March 28, 1974 / Assouan, Egypt / Jackie Onassis and a cigar-smoking Aristotle Onassis watching the scenery from a boat during a ten-day tour of Egypt

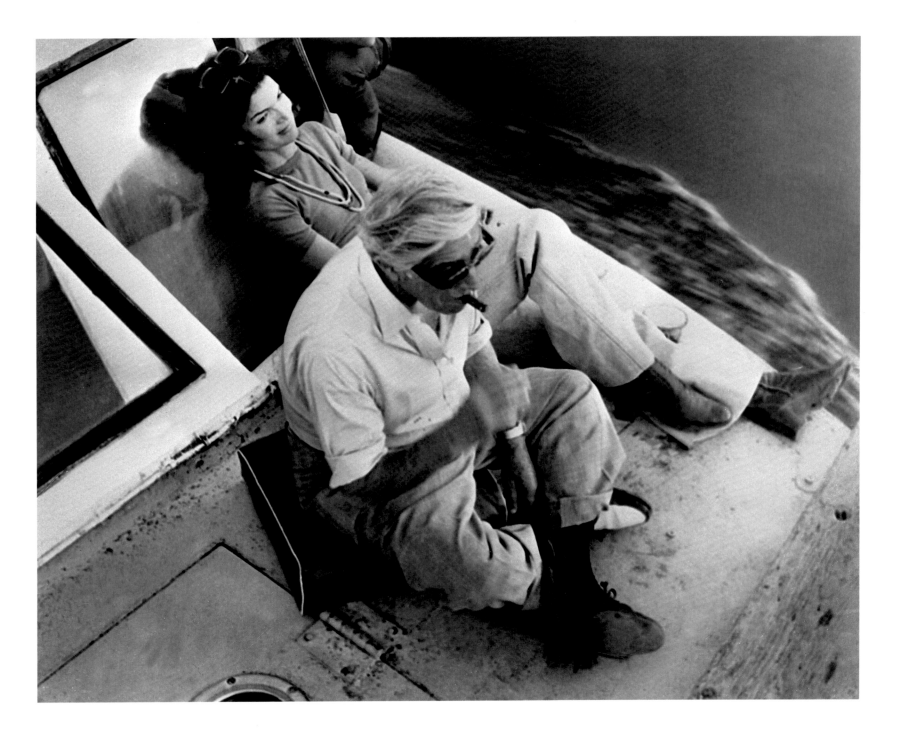

"She observed the conventions, but underneath a shy exterior [she] developed [a] cool judgment of people and an ironical slant on life." Arthur Schlesinger, Jr.

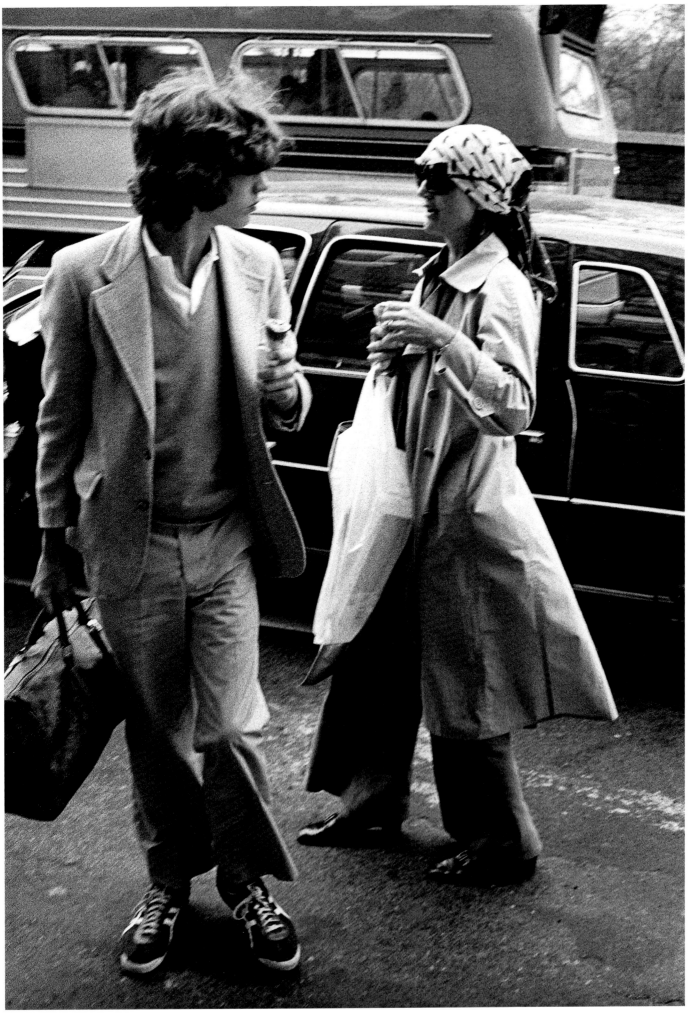

April 3, 1976 / New York, NY / Jackie and John Kennedy, Jr. returning from Jamaica

225

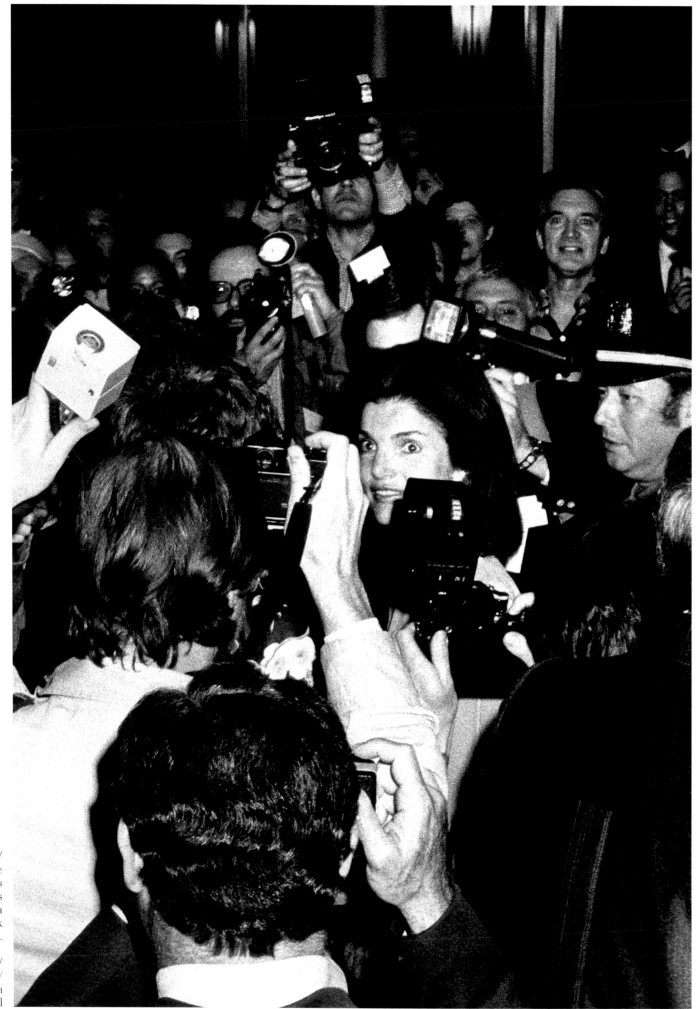

May 9, 1976 /
New York, NY / At The
Metropolitan Opera, Jackie is
surrounded by photographers
at the Star Spangled Gala
Benefit for the New York
Public Library.

June 7, 1976 /
New York, NY /
Jackie Onassis at a fashion
show at The Pierre Hotel

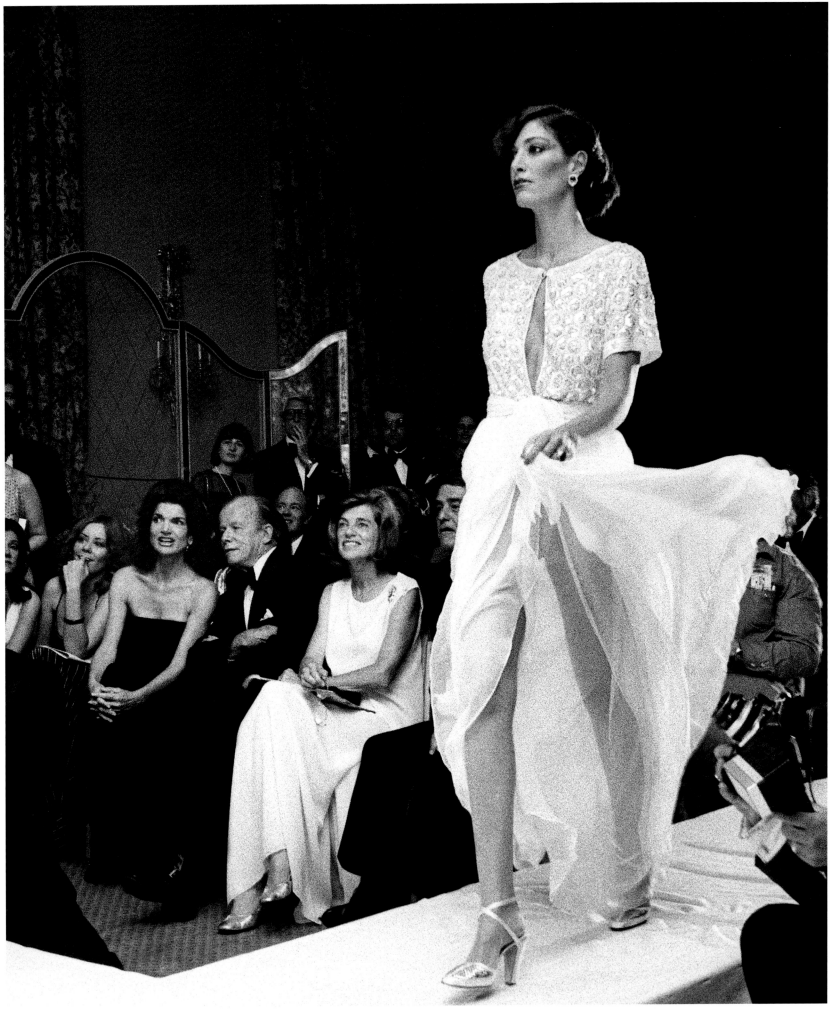

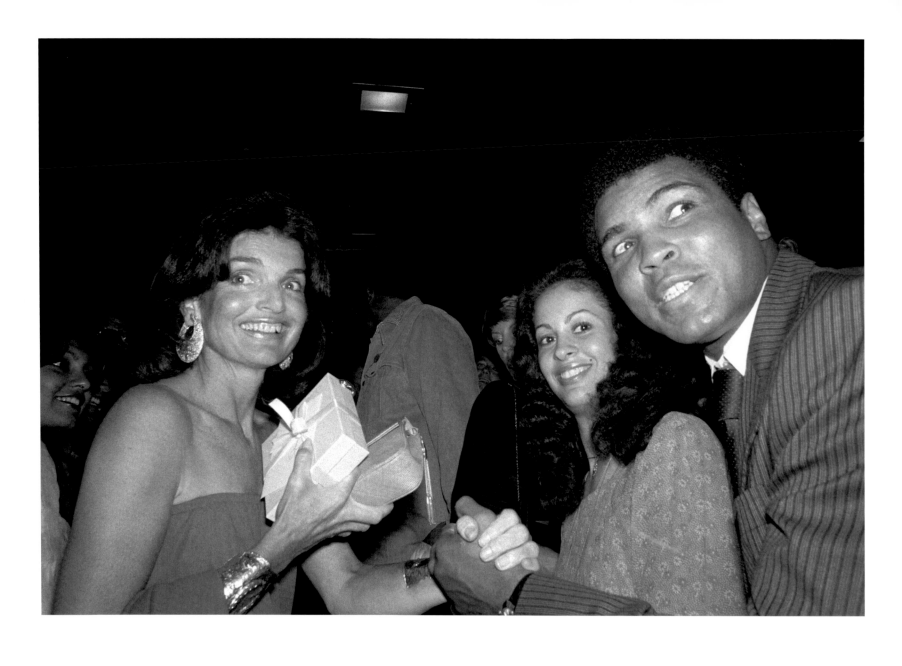

August 26, 1977 / Forest Hills, Queens, NY / Jackie greeting world heavyweight boxing champion Muhammad Ali and his wife, Veronica, at a party held at the Rainbow Room to kick off festivities for the Robert F. Kennedy Tennis Tournament. Proceeds from the charity affair went to help underprivileged children.

August 26, 1977 / Forest Hills, Queens, NY / Jackie dancing with Muhammad Ali at the annual Robert F. Kennedy Tennis Tournament party at the Rainbow Room

1970 / Paris, France /
Jackie in the the streets of Paris

August 26, 1978 / Forest Hills, Queens, NY / Jackie at the Robert F. Kennedy Tennis Tournament

March 21, 1975 / Skorpios, Greece / Jacqueline Kennedy Onassis at the funeral of her second husband, Greek billionaire shipping magnate Aristotle Onassis. Onassis died of pneumonia on March 15, shortly after being diagnosed with myasthenia. With her is her son, John F Kennedy, Jr.

March 15, 1975

"The first time you marry for love, the second for money, and the third for companionship." Jackie

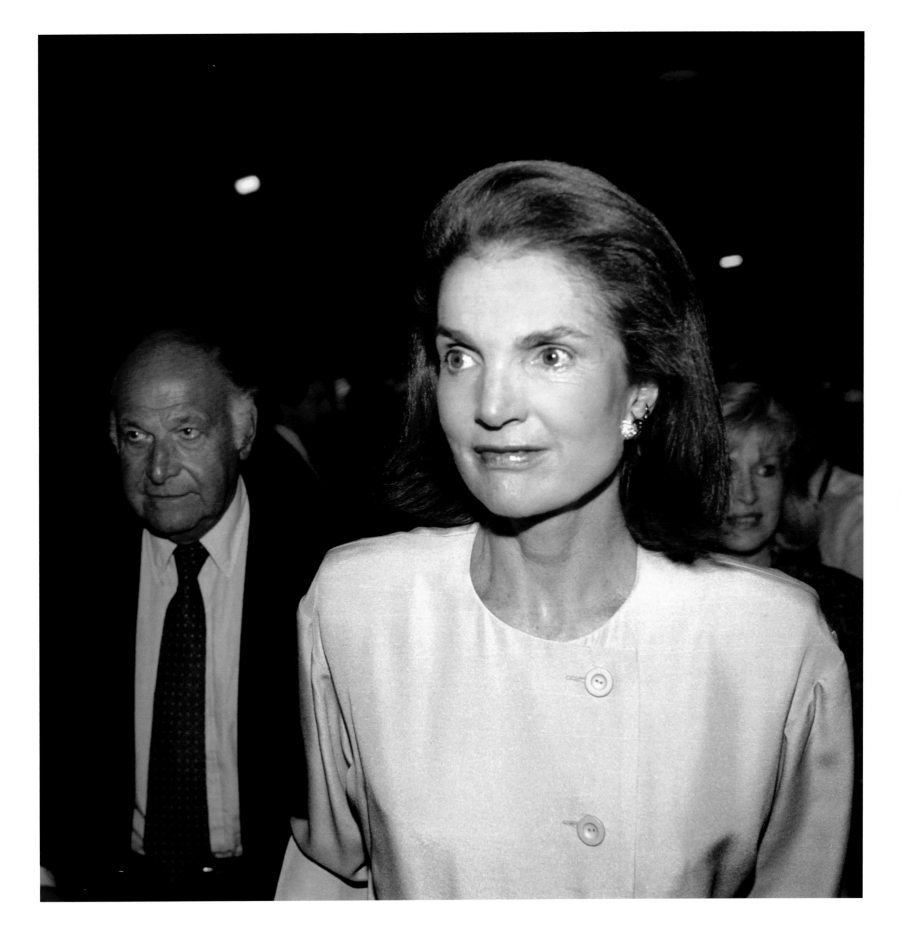

October 31, 1989 / New York, NY / Jackie Onassis and Maurice Tempelsman leave the Promenade Theatre after attending *Love Letters*, a Broadway play

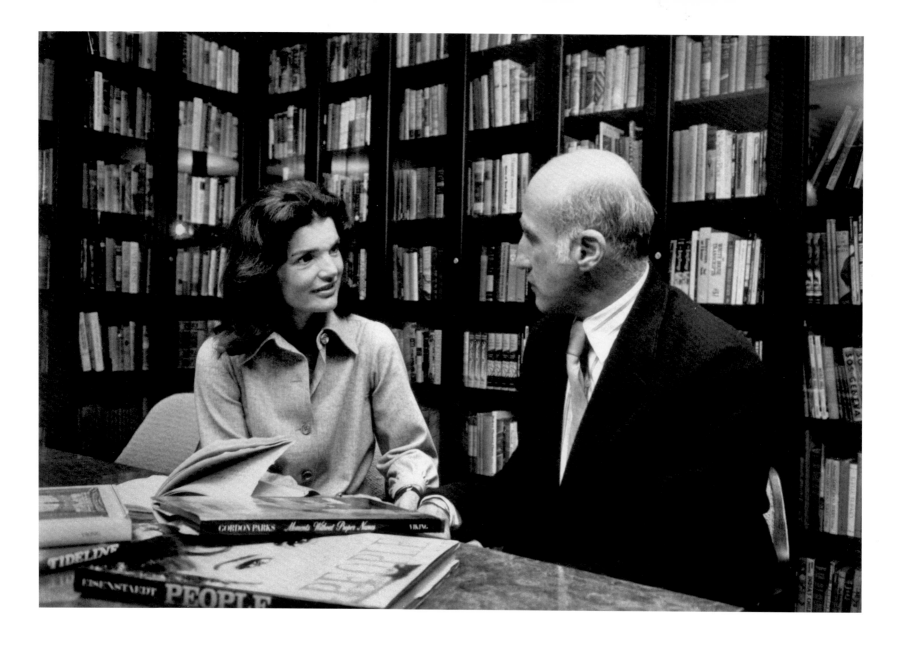

September 22, 1975 / New York, NY / Jackie Kennedy's first day as associate editor for Viking Press. Tom Guinzburg, the president of Viking Press, first introduced Jackie to her fellow employees and arranged for her to be photographed with him by Alfred Eisenstaedt. According to Guinzburg, forty-nine, a longtime friend of Jackie's, the forty-six–year-old mother of Caroline, seventeen, and John Jr., fourteen, will concentrate on "initiating books, finding ideas, and writers."

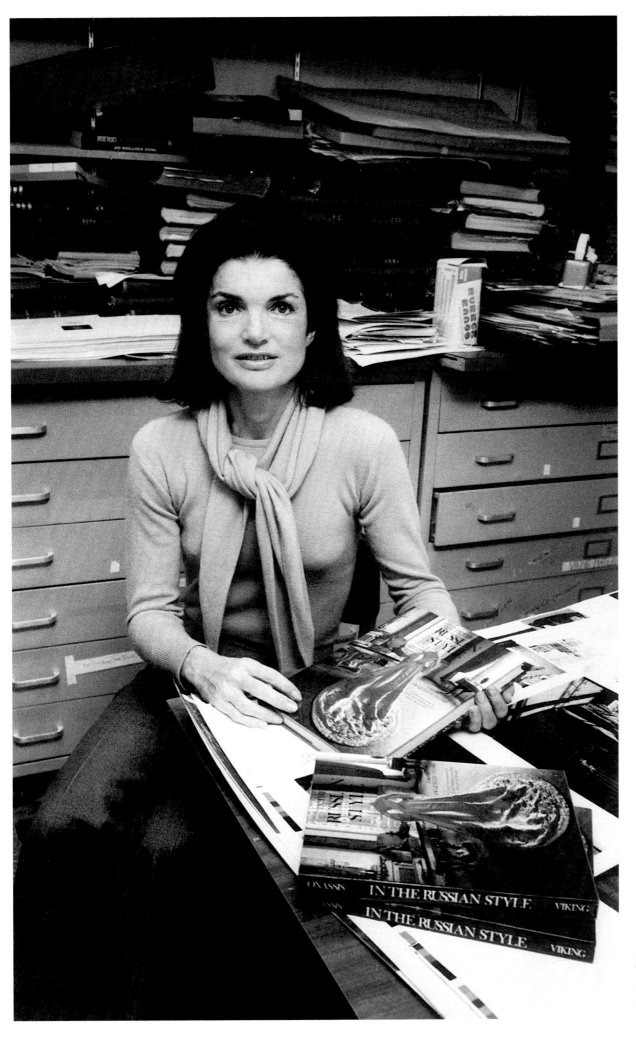

January 14, 1977 / New York, NY / Jackie Onassis in her office at Viking Press as she talked with newsmen about the first book she wrote and edited. She told newsmen, "I love the work I do."

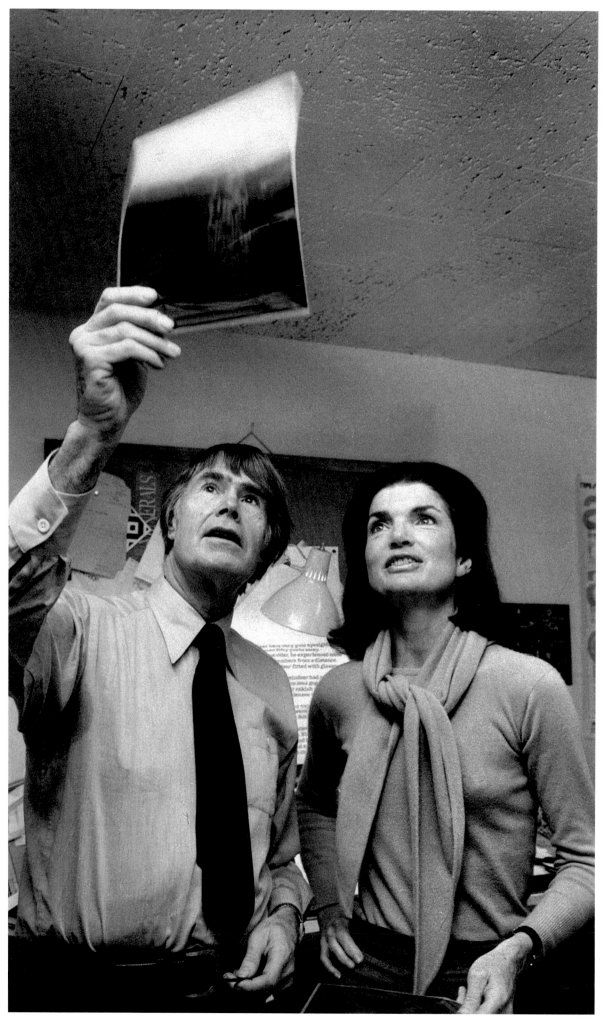

January 13, 1977 / New York, NY / Jackie Onassis and book designer Bryan Holme checking out one of the photos for the book *In The Russian Style*, which she edited and wrote for Viking Press. The book emphasizes the elaborate costumes of the Tsarist court and aristocracy and the surprisingly rich garb of bourgeois landowners.

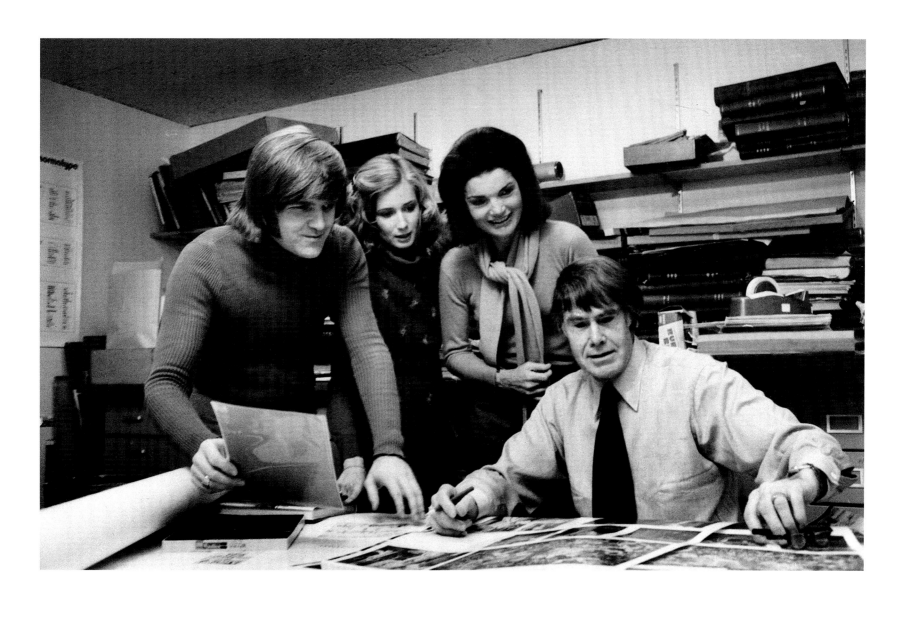

January 17, 1977 / New York, NY / Christopher Holme, Gael Towey Dillon, Jackie Onassis, and Bryan Holme (from left to right) in the studio books department at Viking Press

November 3, 1976 / New York, NY / Jackie Onassis during a tribute at Gallagher's to the late Josephine Baker. Jackie was co-chairwoman of this tribute, shown here with ninety-three–year-old jazz pianist Eubie Blake. Celebrities gathered from around the world to pay tribute to the late Miss Baker on November 7, an event that was staged at The Metropolitan Opera.

November 14, 1977 / New York, NY / Conductor/composer Leonard Bernstein kissing Jackie Onassis on the cheek as he greets her at a Studio 54 party following the gala premiere of the film *The Turning Point*. In the background is Oliver Smith of the American Ballet Theatre.

"All my greatest interests—in literature and art, Shakespeare and poetry—were formed because I was fortunate enough to find superb teachers in those fields."

Jackie

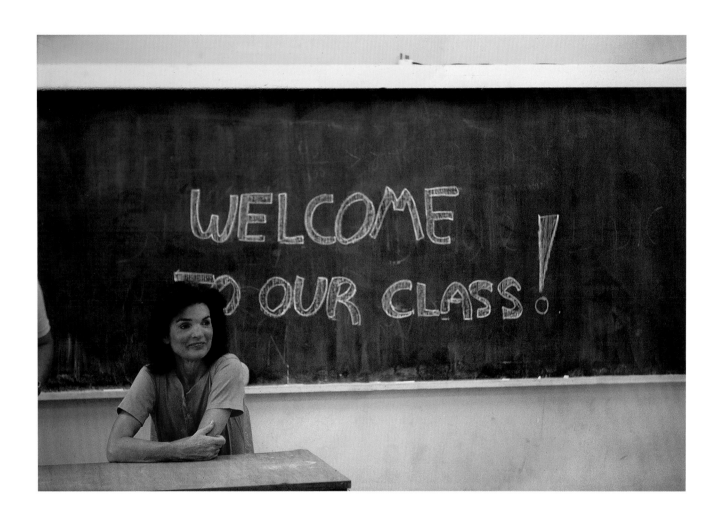

May 1978 / Israel / Jackie visiting a classroom during a trip to Israel

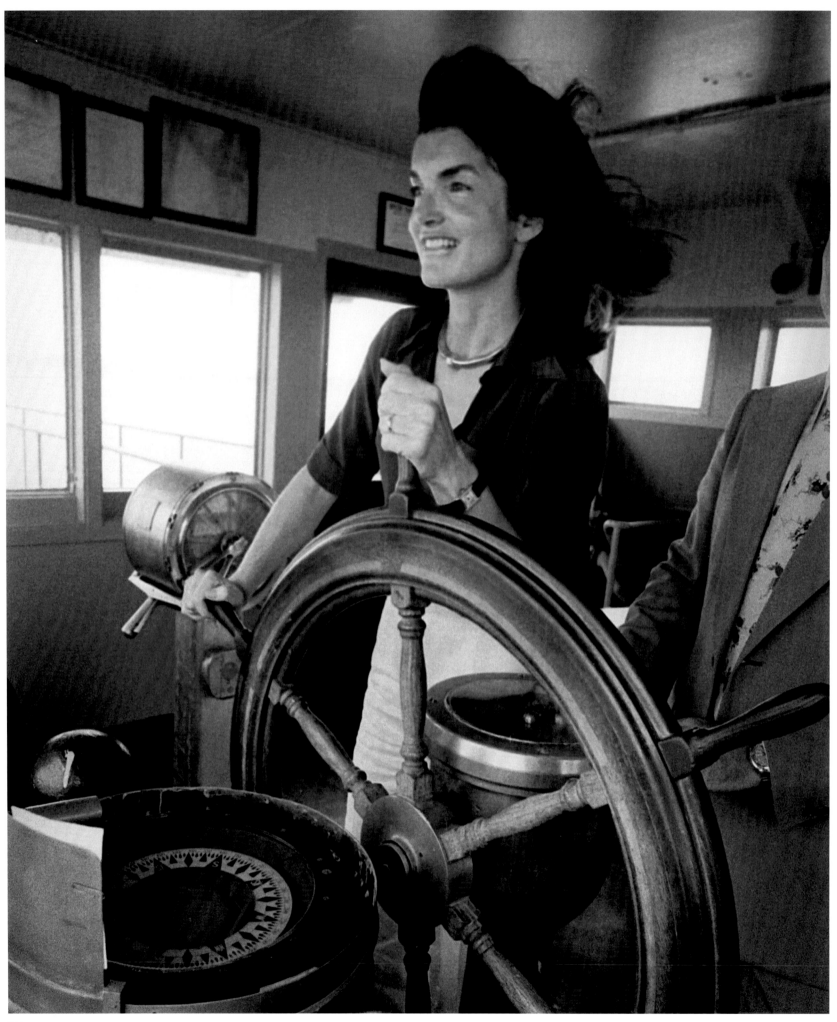

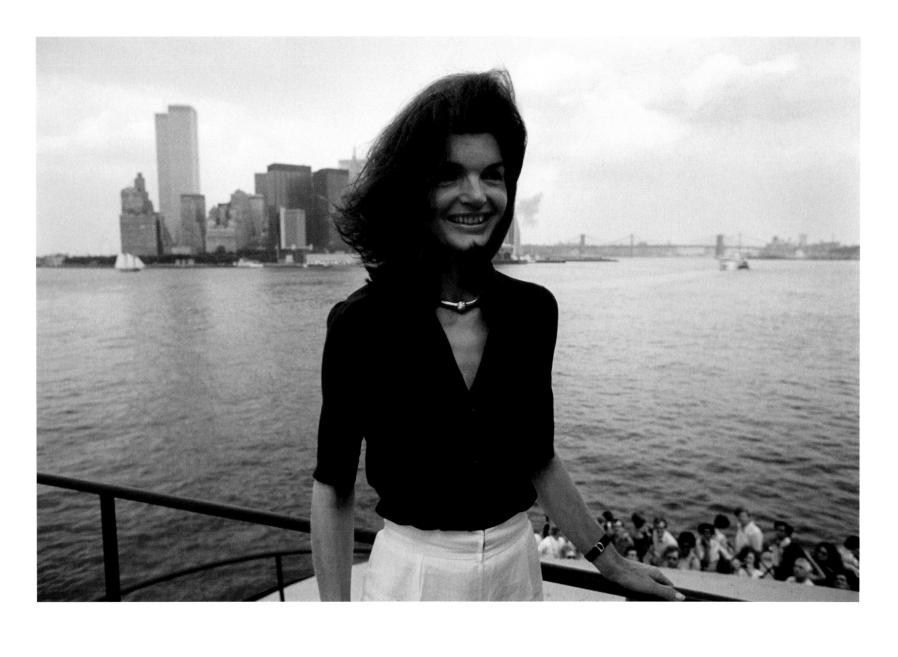

July 30, 1976 / New York, NY / Jackie taking a turn at the wheel onboard a Staten Island ferry as she returns to Manhattan following a tour of the Snug Harbor Cultural Center on the island's north shore

July 30, 1976 / New York, NY / Jackie Onassis in the New York Harbor as she returns to the Big Apple from Staten Island

"Nothing ever looked wrong on her." Tish Balridge

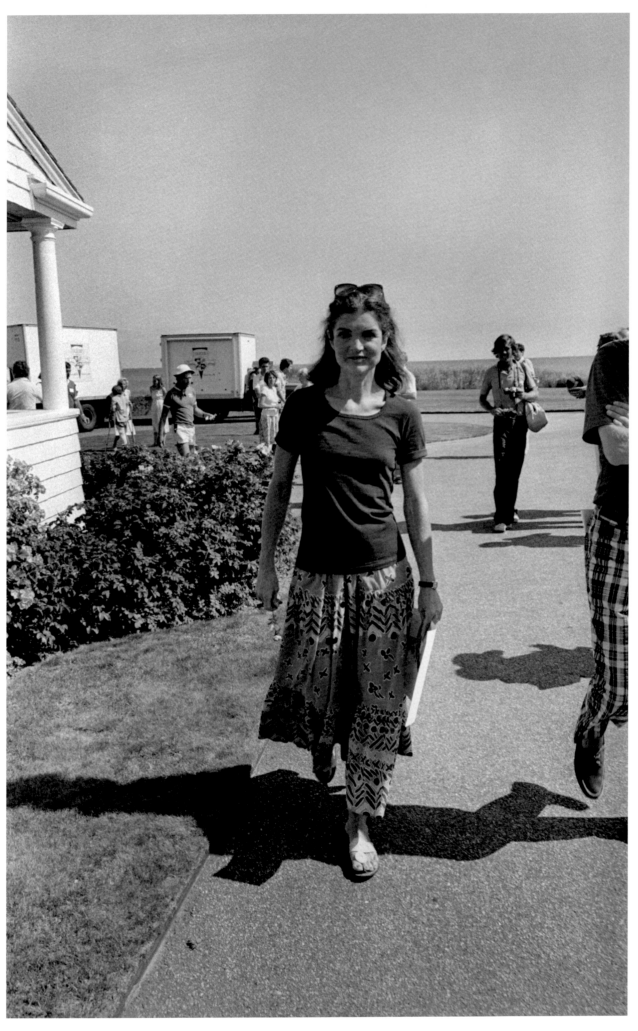

July 12, 1980 / Hyannis Port, MA /
Jackie Onassis, wearing a jersey print
peasant skirt and sandals, walking
in the Kennedy compound during the
gathering of some Kennedy family
members and friends

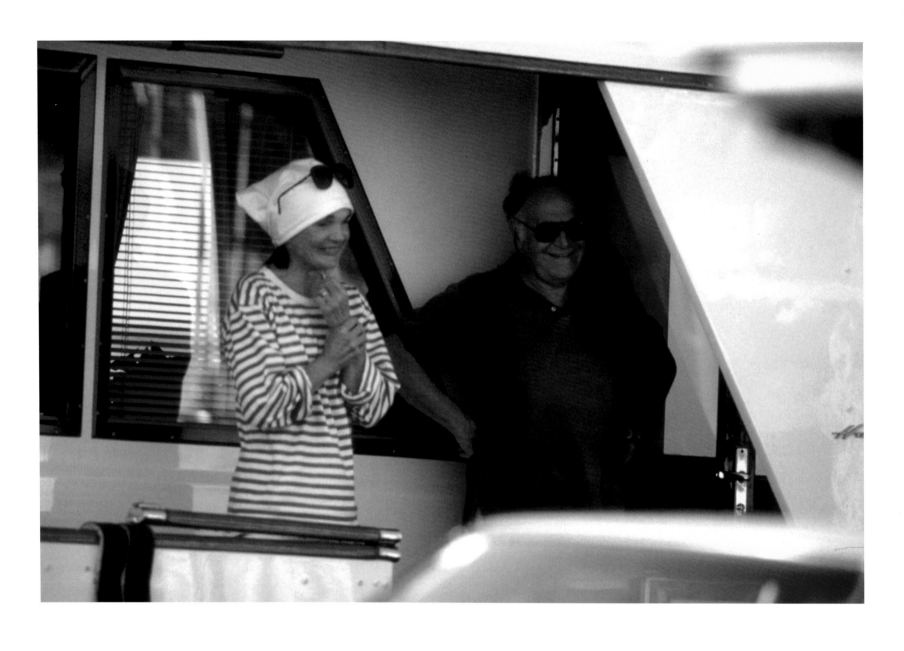

September 3, 1993 / Martha's Vineyard, MA / Jackie Onassis and Maurice Tempelsman on his boat, the Relemar

August 8, 1987 / Cape Cod, MA / Jackie Onassis taking a break from her editing job at Doubleday to relax with boyfriend Maurice Tempelsman in Martha's Vineyard. While Maurice Tempelsman drives the boat, she goes waterskiing near her home in Menemsha, MA.

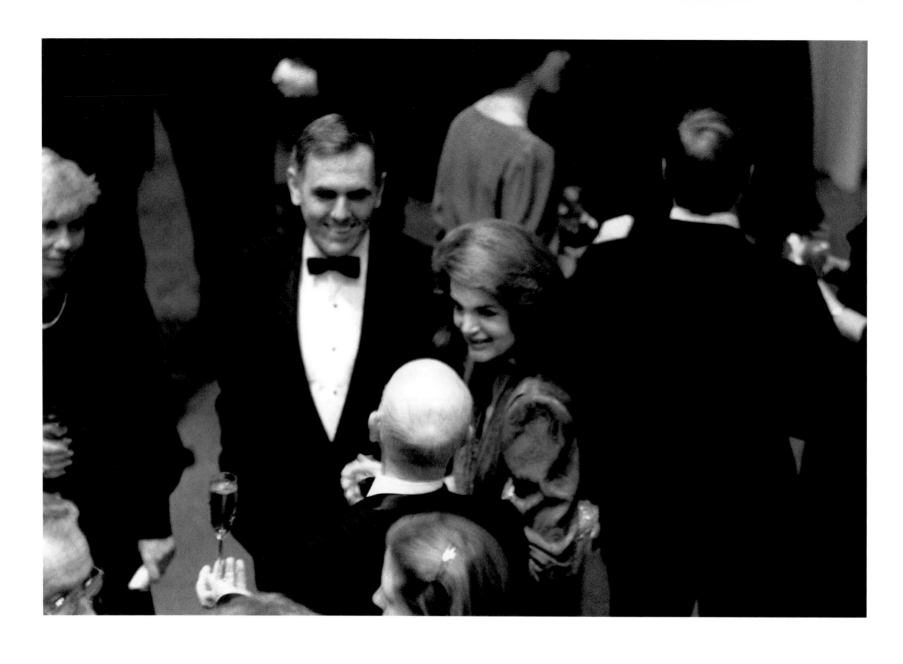

October 4, 1985 / Boston, MA / Jackie talking to the former mayor of Boston, Raymond Flynn, and Dave Powers, the curator of the John F. Kennedy Library and Museum at the University of Massachusetts at Boston, during a fund-raising dinner for the JFK Library Foundation

"Three attributes to describe my mother? Love of words, the bonds of home and family, and her spirit of adventure." John F. Kennedy, Jr.

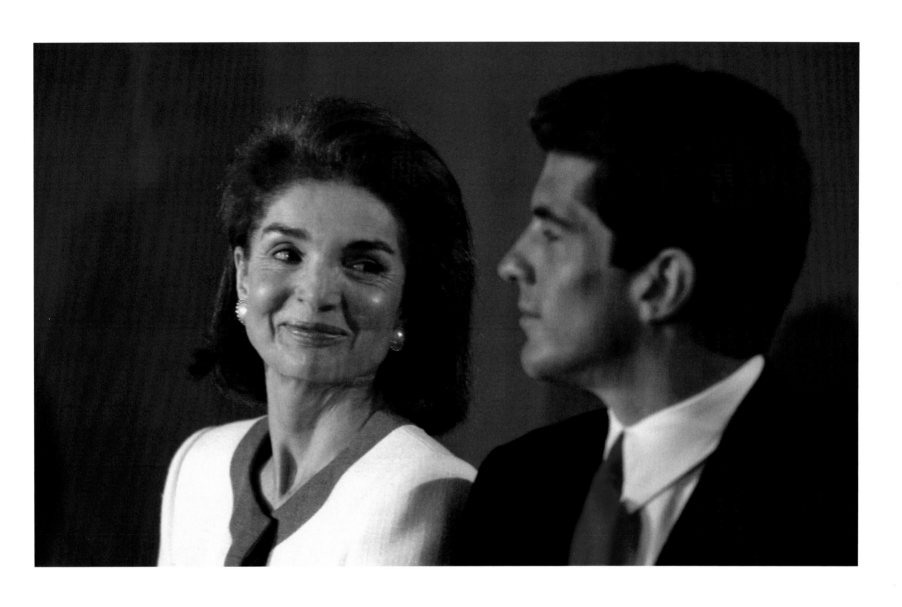

May 29, 1991 / Boston, MA / Jackie Onassis and her son, John F. Kennedy, Jr.

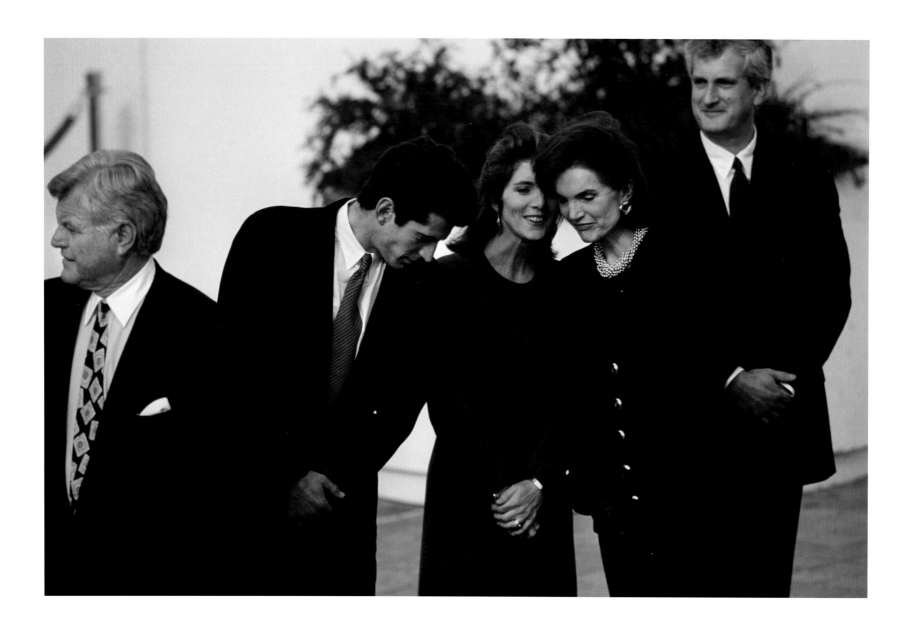

October 29, 1993 / Boston, MA / Ted Kennedy, John F. Kennedy, Jr., Caroline Kennedy, Jackie, and Caroline's husband Edwin Schlossberg at the JFK Library

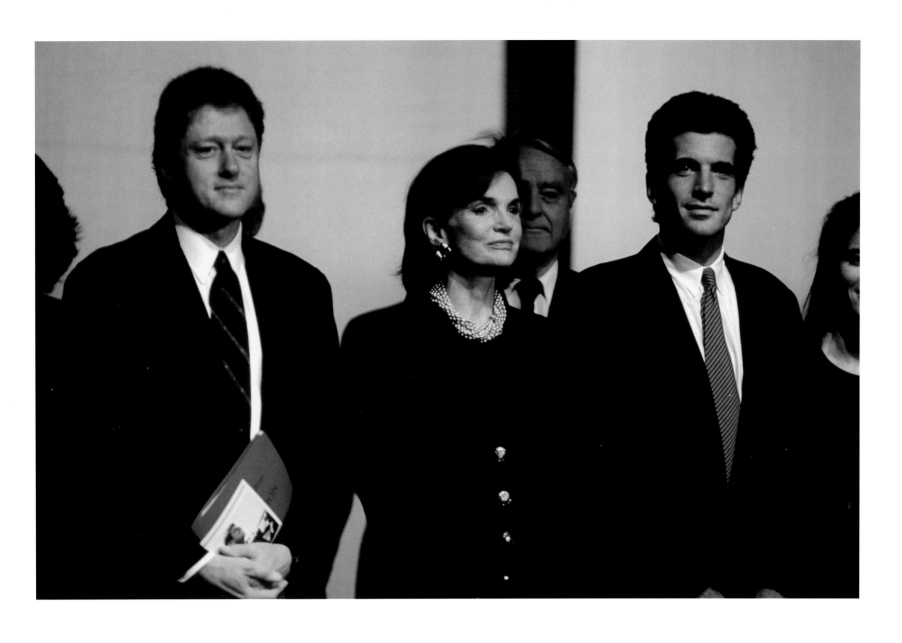

October 29, 1993 / Boston, MA / Bill Clinton, Jackie, and John F. Kennedy, Jr. at the JFK Library

September 3, 1993 / Martha's Vineyard, MA / Jackie Onassis with her granddaughters, Rose and Tatiana, on Martha's Vineyard. After a walk on the dock they go to a relaxing area near the boats to eat ice cream.

256

March 6, 1994 / New York, NY / Jackie Onassis and John Kennedy, Jr. walking together and sharing conversation in Manhattan

January 26, 1989 / New York, NY / Jackie Onassis walking with her daughter, Caroline, Caroline's husband, Ed Schlossberg, and their daughter Rose. This is the first time Jackie is photographed with her granddaughter.

April 24, 1994 / New York, NY / Jackie Onassis and Maurice Tempelsman in Central Park

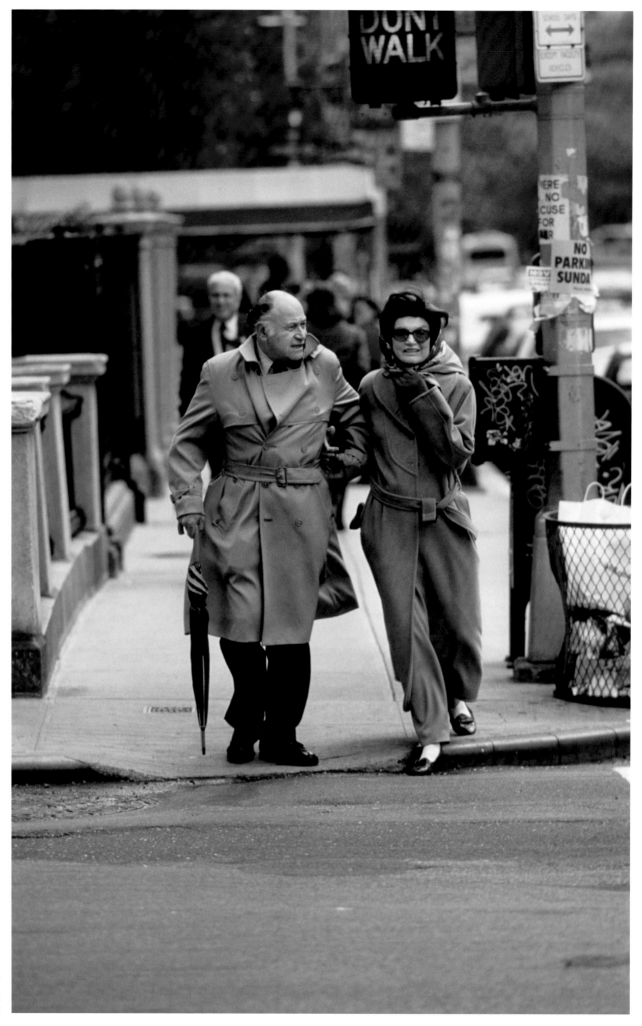

May 12, 1994 / New York, NY /
Jackie Onassis and Maurice Tempelsman
on the streets of Manhattan

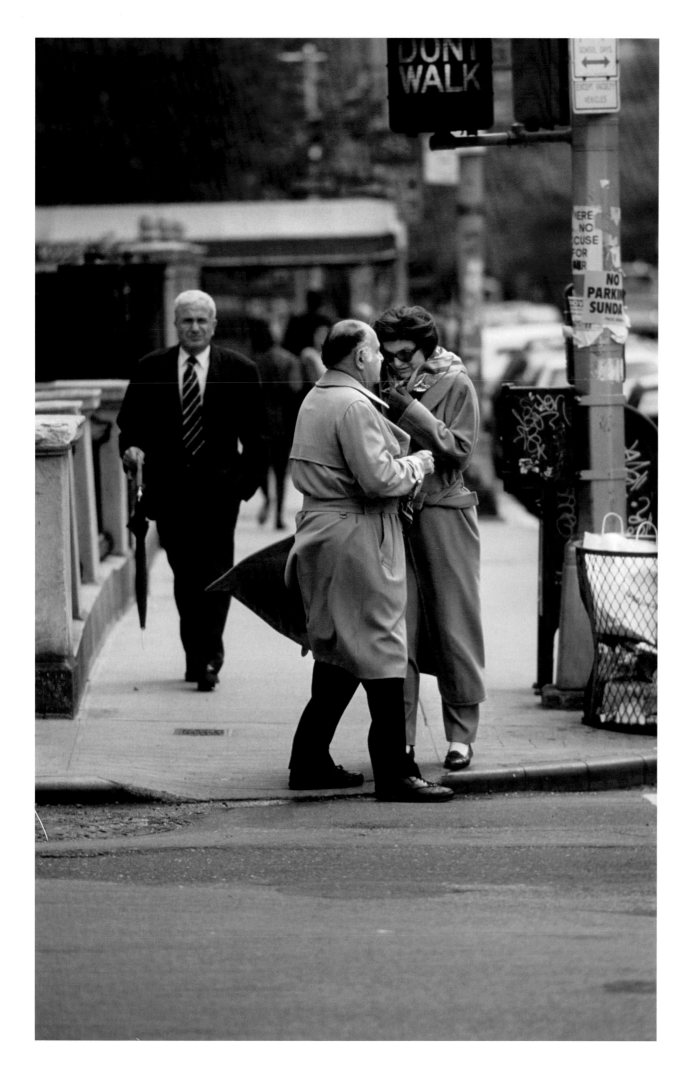

May 19, 1994

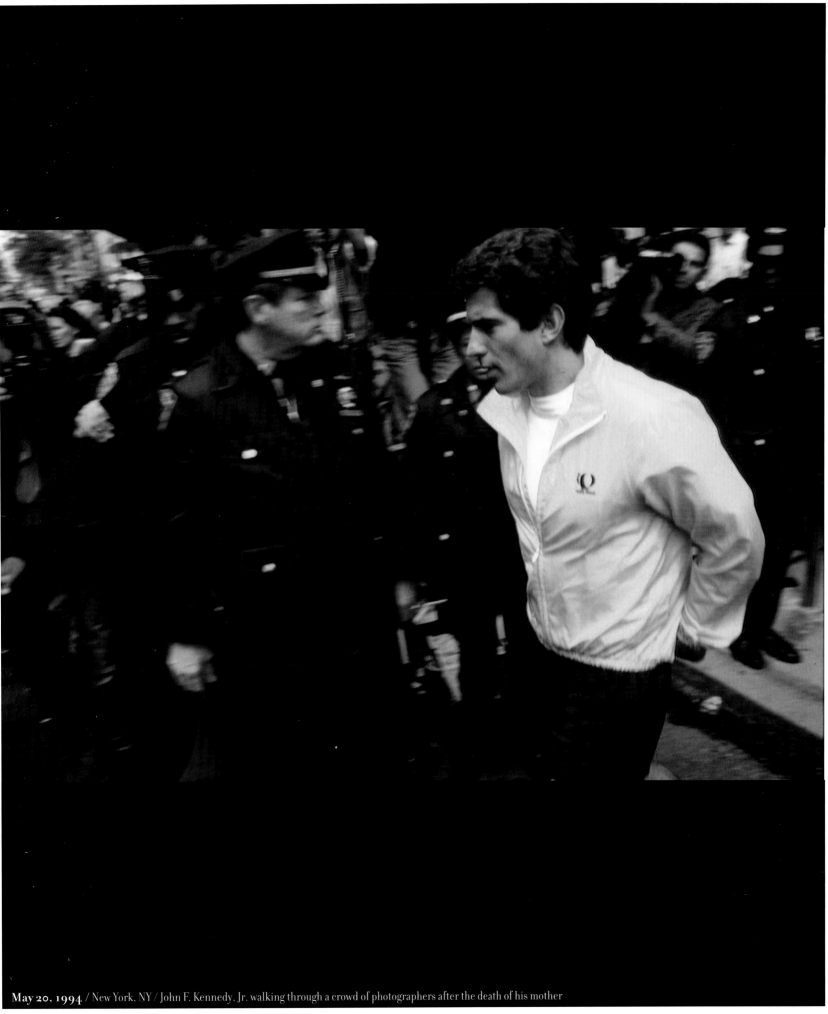

May 20, 1994 / New York, NY / John F. Kennedy, Jr. walking through a crowd of photographers after the death of his mother

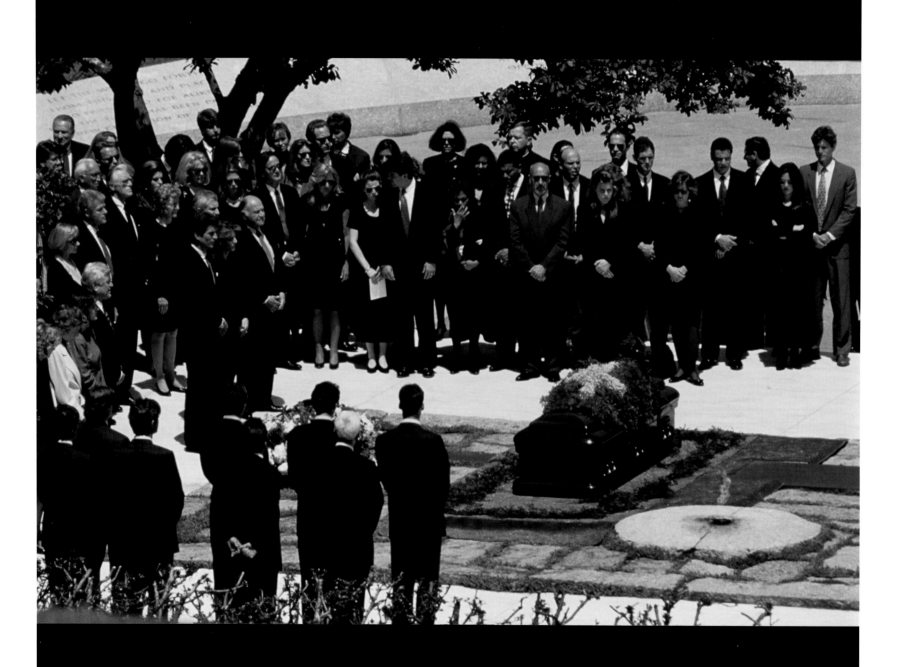

May 23, 1994 / Arlington, VA / John F. Kennedy, Jr. and Caroline Kennedy Schlossberg standing with family and friends during the funeral for their mother at Arlington Cemetery

May 23, 1994 / Arlington, VA / Lee Radziwill at Jacqueline's funeral, with President Bill Clinton and First Lady Hillary Clinton departing

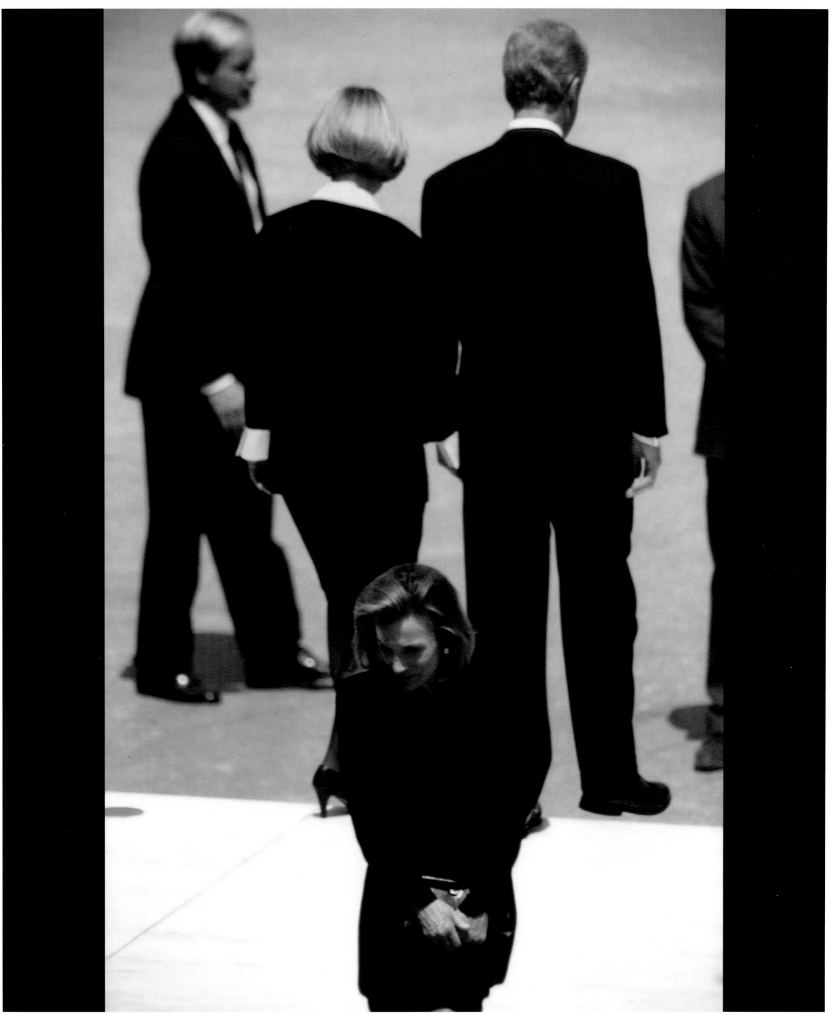

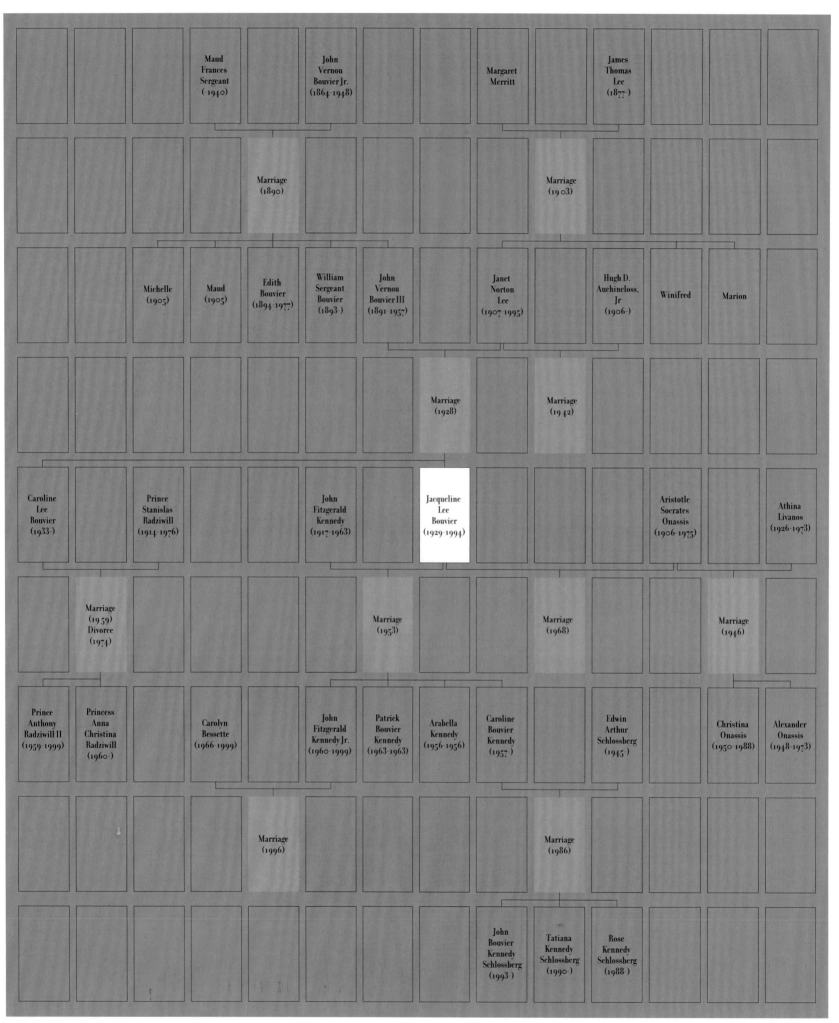

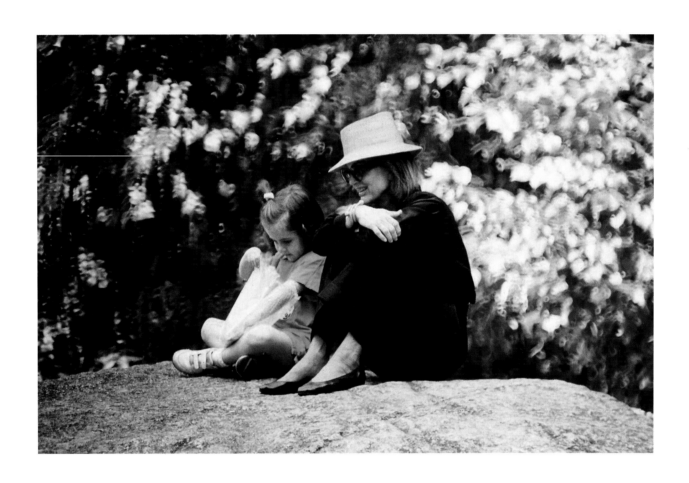

June 18, 1992 / New York, NY / Jackie Onassis with her granddaughter Rose in Central Park

Acknowledgements

To Anne Mosnier (1951–2004)
Thanks for your help, your infinite kindness and generosity

Pierre-Henri Verlhac dedicates this project to
Anne and Zélie Verlhac.
Anne, you are my inspiration.
Zélie, so bravely did you make it to this world.
Anne and I are very proud of you.

Yann-Brice Dherbier dedicates this book to
Pierre Goguelin, "My knowledge vault,"
my spiritual father. I miss you.

Pierre-Henri Verlhac and Yann-Brice Dherbier
would like to thank:
the Atalante team, Xavier Barral, and Daniel Regard
for seemless production;
Caroline Bouvier Kennedy,
Roberta Adao, Marie-Christine Biebuyck,
Françoise Carminati, Martine Detier, Diane Dufour,
Ron Galella, Michael D. Shulman, Maureen Geller,
Allan B. Goodrich, James B. Hill, and
Xavier Rousseau for digging "the" picture;
Joe Consolazio for his thermonuclear translation capacities;
Thomas Couteau, Fabrice Fournier, and Edouard de Pouzilhac

Credits: